Duffy, Damian.
 The hole : consumer culture : a graphic novel / by Damian Duffy,
John Jennings. -- 1st ed. -- Chicago : Front Forty Press, 2008.

 pages: 184; 27.94 cm x 21.59 cm

 ISBN: 978-0-9778689-2-6
 "Front Forty Press and Eye Trauma Comix present."--Cover.
 Summary: A science fiction horror story about the buying and
 selling of race in America, the simultaneous worship and
 degradation of African Americans in popular culture, and the
 bloody terror of boundaries being torn down.

 1. Race relations--Fiction. 2. Graphic novels. 3. Horror tales.
 4. Science fiction. I. Jennings, John. II. Title. III. Title: Consumer
 culture.

PN6728.H65 D84 2008 2007920945
741.5/973--dc22 0804

front forty press + eye trauma comix

present

THE
HOLE
CONSUMER CULTURE

01 02
OPEN
CLOSE

words by Damian Duffy

pictures by John Jennings

story by Damian Duffy+John Jennings

Dedication

Damian: For Jen, without whom neither this book nor my life would be possible.

Damian+John: For Legba, the great connector and opener of doors.

John: For Miriam, you truly are a nova in every way.

Holehearted thanks to: Front Forty Press, Michael Chaney, Prudence Gill, R.C. Harvey, Scott McCloud, Naveen Neelakantam, Dana Rush, Maurice Stevens, Dann Tincher, Daniel Yezbick, Eric Benson, Robb Springfield, Candace and Bill, Nan Goggin, Tom Kovacs, Jessica Gonzalez, Latreice Branson

This is not Voodoo...

The Hole: Consumer Culture is fiction. Like most fiction, it is part truth and part lie, with each acting in the service of the other.

Voodoo (Vodou, Vodun, etc.) is a real life religion, and, like all religions, it is a complex mixture of heritage and belief, ritual and faith, the universal and the personal.

Social, economic, and racial politics have lead American popular culture to cast Voodoo in a negative light, to say the least. *The Hole: Consumer Culture* is in part a discussion of the disjunct between these two realities, the felt reality of the religious practitioner and the projected reality of the industries of popular culture.

Some characters speak from one reality, some from the other. And some are trying to get them to merge.

Much like real life, not everything in *The Hole* is an accurate portrayal of the religion of Vodun. The difference, we hope, is that our inaccuracies serve to point to a greater truth, underlining the harmful lies used to build up the fictions surrounding race, class, gender, and other projected realities.

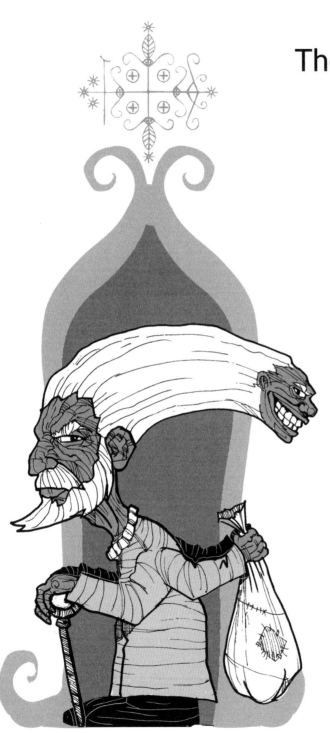

The Divine Traveler
Papa Legba from Africa to the Americas

Legba nan baye-a
Legba nan baye-a
Legba nan baye-a
Se ou ki pote drapo
Se ou k ap pare soley pou lwa yo

At every entryway, portal, and gate there is an ancient African god who observes, confuses, and/or helps all passersby. This same god is found at every crossroads, junction, or fork in the road that offers choices and necessitates a decision. Eshu-Elegba (or Elegbara) is the Yoruba god of opportunity and conflict. He is the gatekeeper who keeps track of all comings and goings. He is the communicator god who speaks all languages divine and earthly. Known as the "Guardian of the Crossroads," the "Opener of the Way," and "Lord of the Road," among other praise names, Eshu-Elegba offers innumerable choices and sits at the threshold of every decision. Eshu-Elegba embodies paradox; he is simultaneously young and old, constructive and destructive, wise and wanton. In stories about Eshu-Elegba, it is said that he turns right into wrong, wrong into right; he punishes you today for that which you will do tomorrow; he kills a bird yesterday with a stone he throws today. He constantly sends us paradoxical challenges. He may remove all obstacles while simultaneously blocking all pathways, forcing us to think and rethink our choices. He breaks all rules because he is beyond rules. Eshu-Elegba is the part of life that is insatiable; he never has enough and he always wants more. Any area of life that offers conflict and pleasure is where Eshu-Elegba is certain to be found. Accordingly, he loves sex and money.

From Yorubaland, the omnipresent Eshu-Elegba traveled eastward into contemporary Bénin where he became known as Legba. Then, in the hearts and minds of enslaved Africans, Eshu-Elegba and Legba journeyed across the Atlantic Ocean and re-manifested themselves as Papa Legba in Haiti, Eleggua in Cuba, and Exu in Brazil. Slaves were then baptized in the Catholic church and learned the lives of the saints. Because St. Peter was presented as the gate-keeper who holds the keys to heaven, Papa Legba was immediately associated with this saint in a seamless conflation. Because of Eshu-Elegba's contradictory persona, his African diaspora manifestations have also been associated with the Christian idea of the devil. On the flip side, it is assumed by some that when legendary blues guitarist Robert Johnson claimed to have met "the devil at the crossroads," he was referring to Legba's divine intervention in turning him into a musical genius.

The eternally contemporary Eshu-Elegba, and his transatlantic remixes, represent a twenty-first century phenomenon without which the world would stand still. He is the past/present/future at once. He is a powerful ally and a challenging teacher. He may tempt you with trouble, but only to teach you a much-needed lesson. If you are lost, he can help you find your way. May Eshu-Elegba-Legba-Eleggua-Exu-Papa Legba open all doors and guide you on a safe journey into The Hole: Consumer Culture.

Dana Rush, Ph.D.
African and African Diaspora Art History
University of Illinois at Urbana Champaign
Written with great inspiration from John Mason.

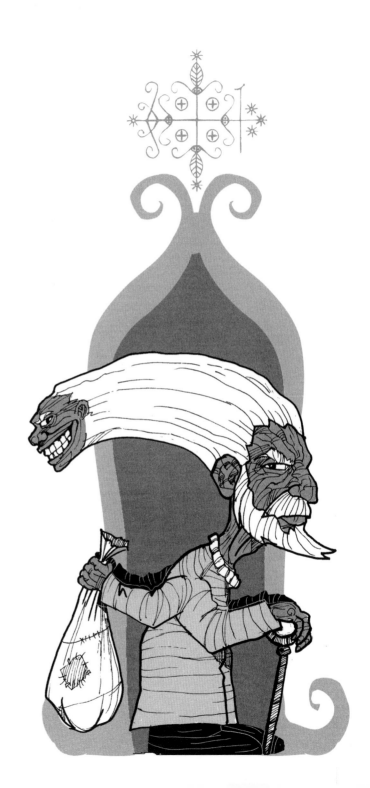

THE FOLLOWING MESSAGE IS SPONSORED BY

THE CHURCH OF THE LOVING SYSTEM

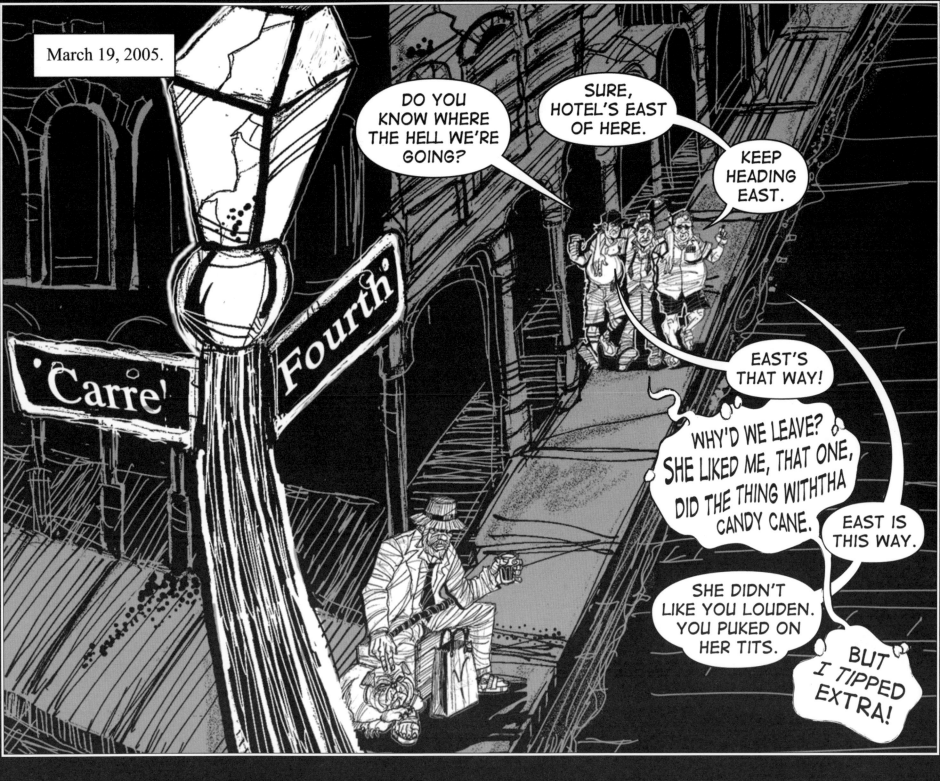

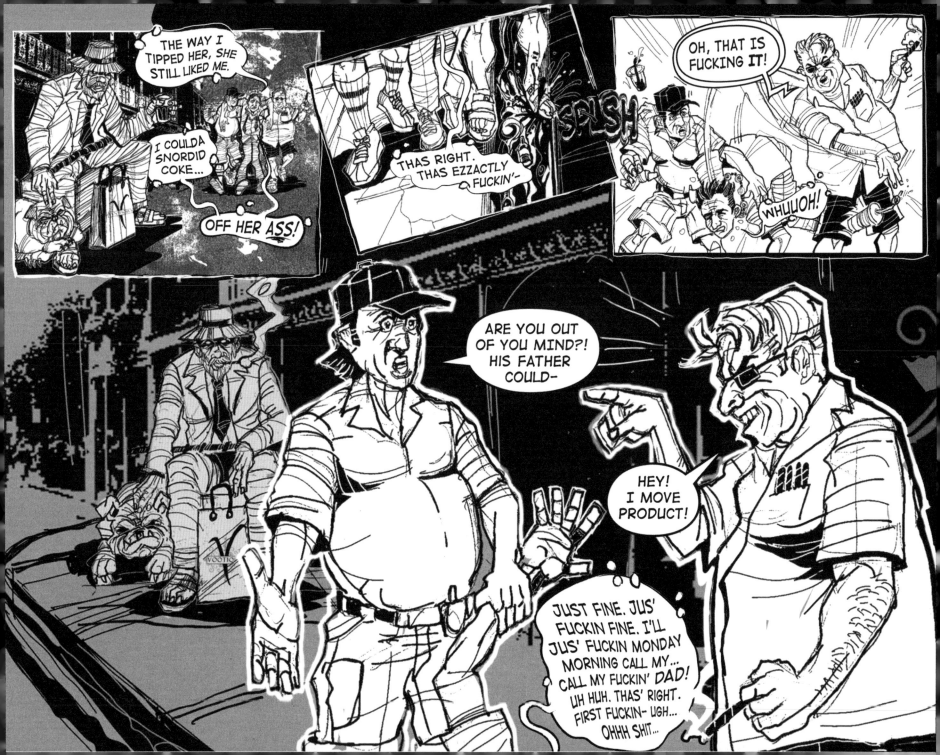

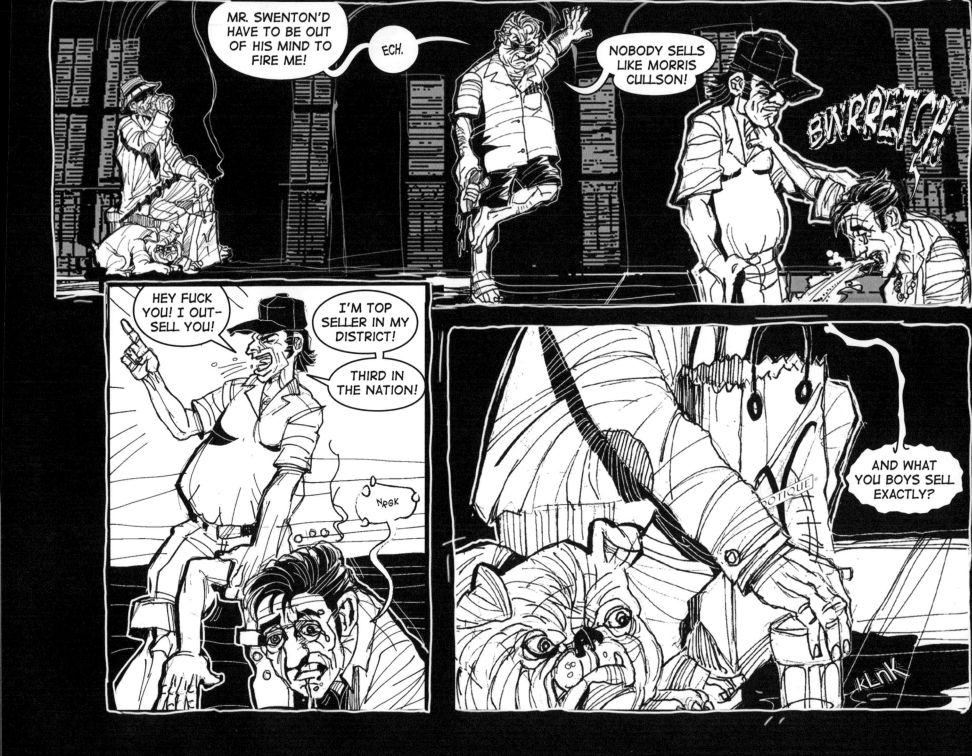

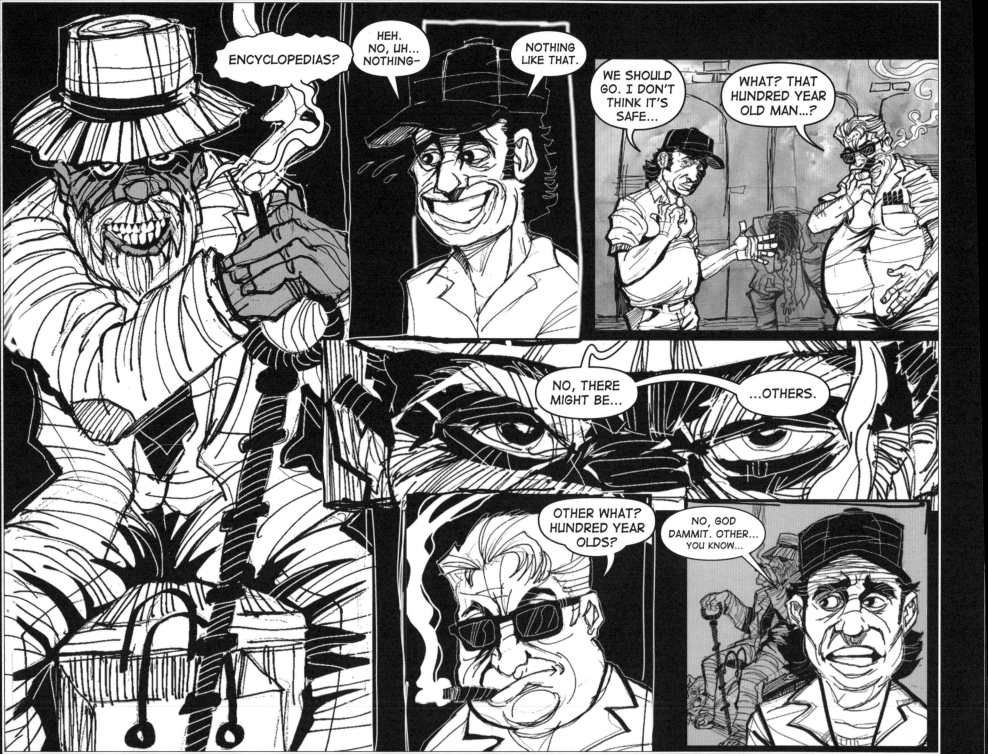

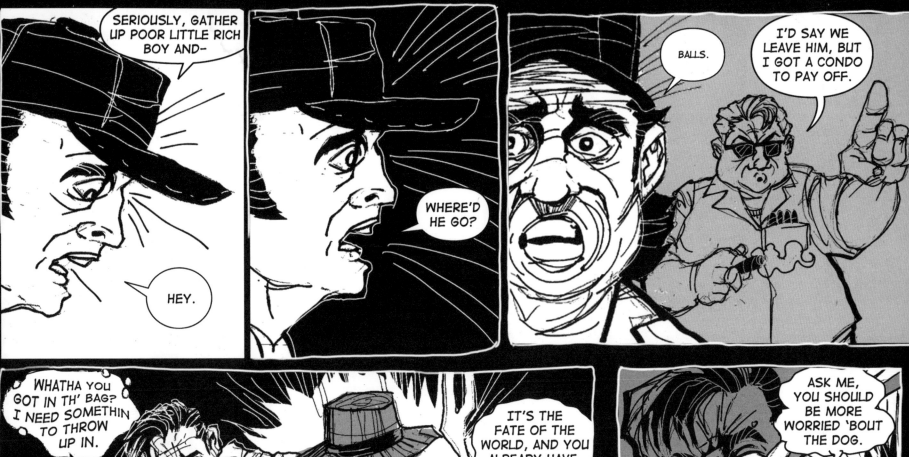

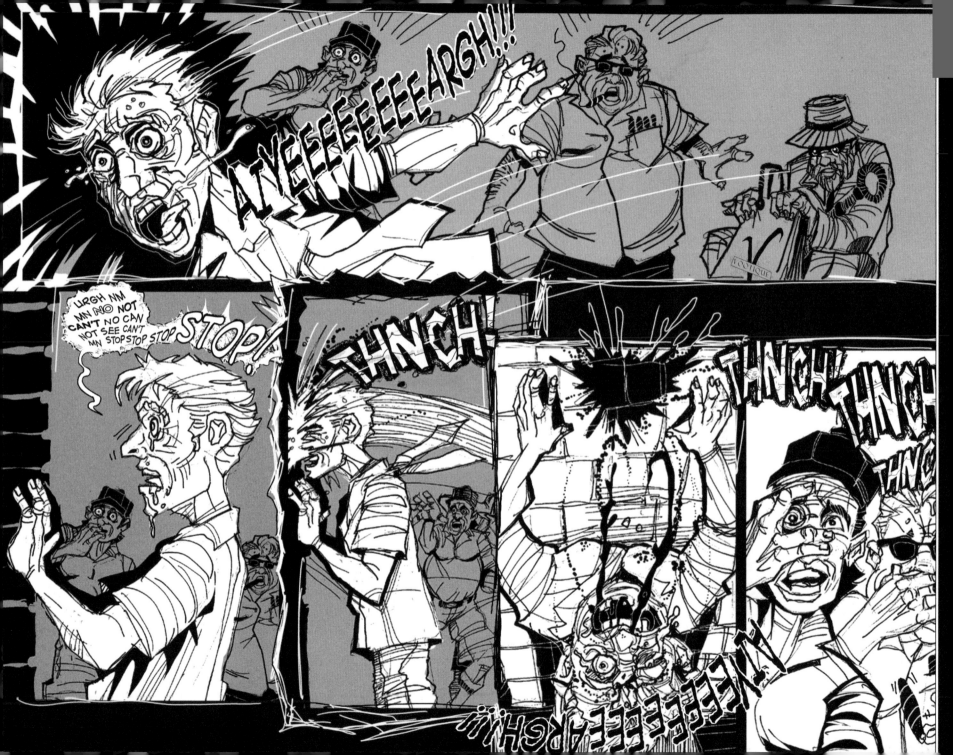

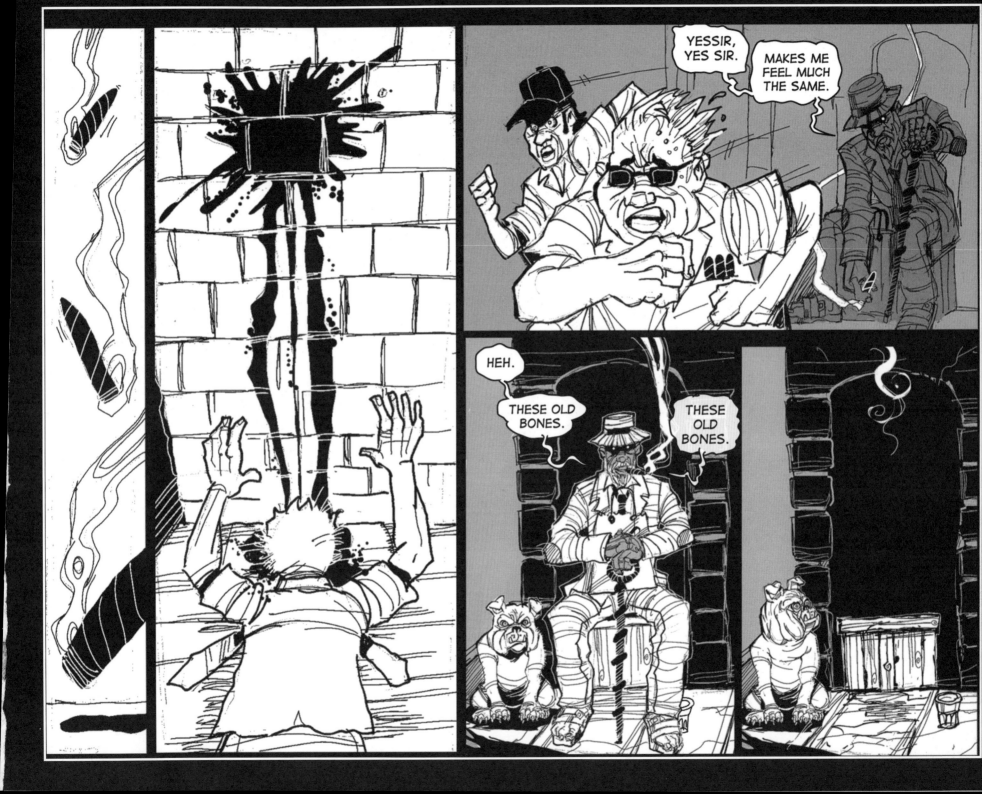

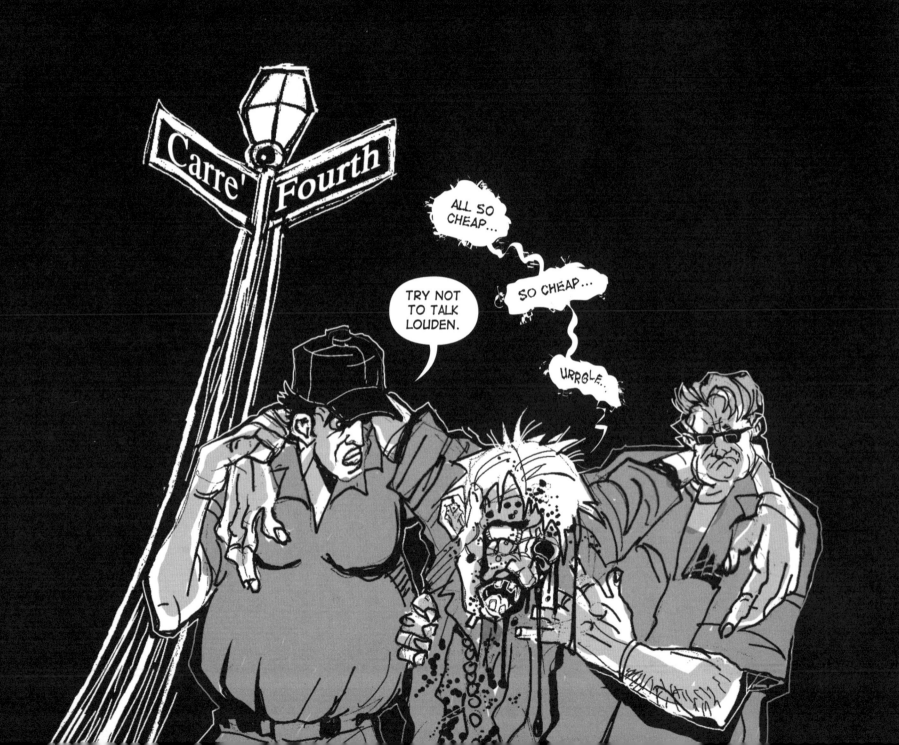

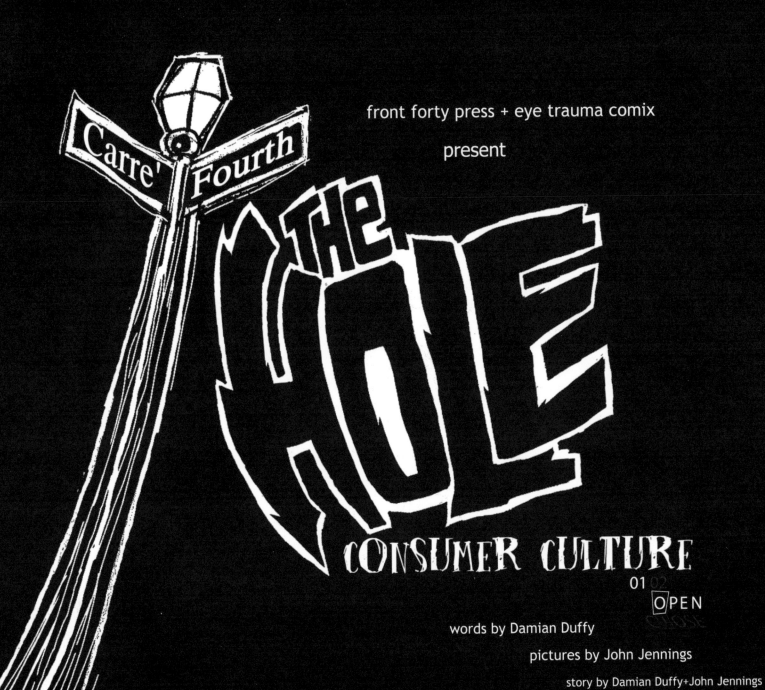

front forty press + eye trauma comix

present

THE HOLE

CONSUMER CULTURE

01 02
OPEN

words by Damian Duffy

pictures by John Jennings

story by Damian Duffy+John Jennings

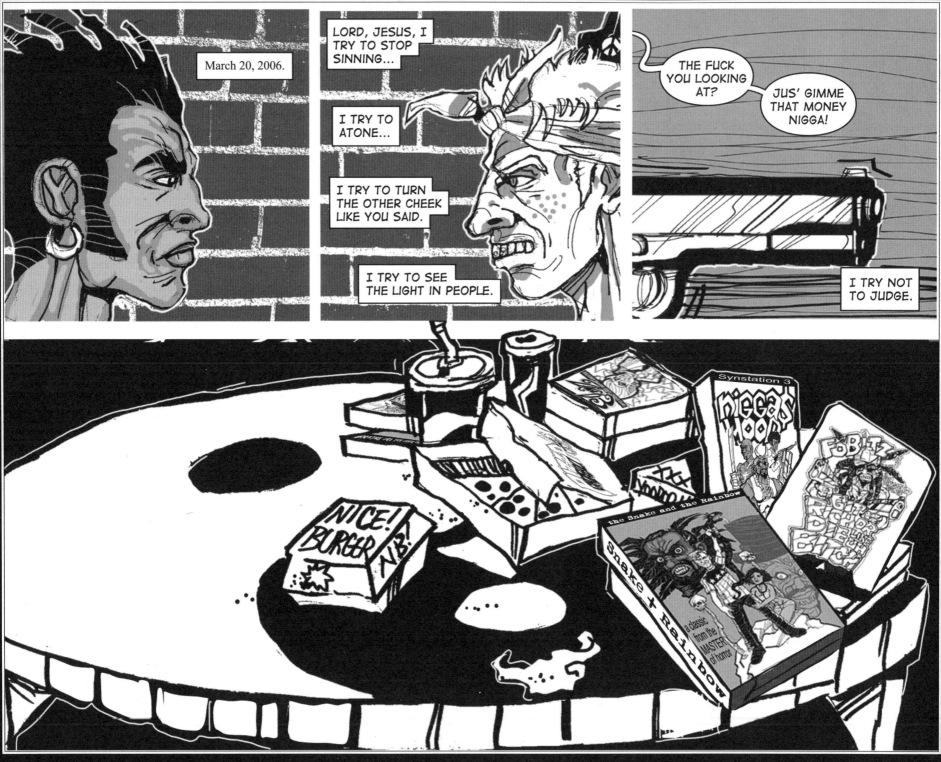

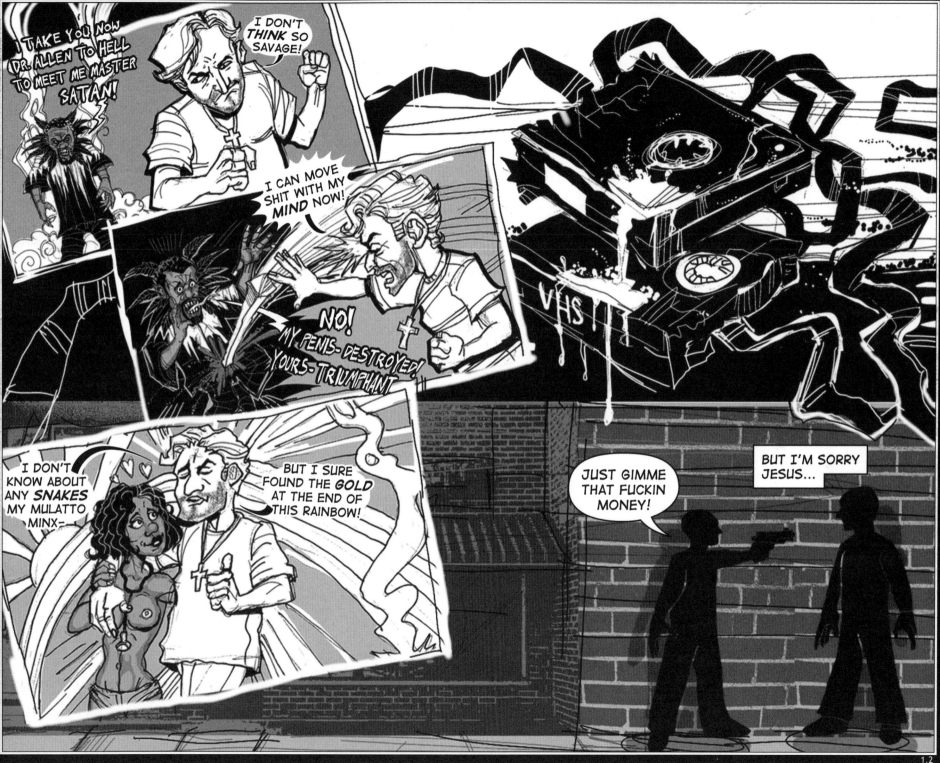

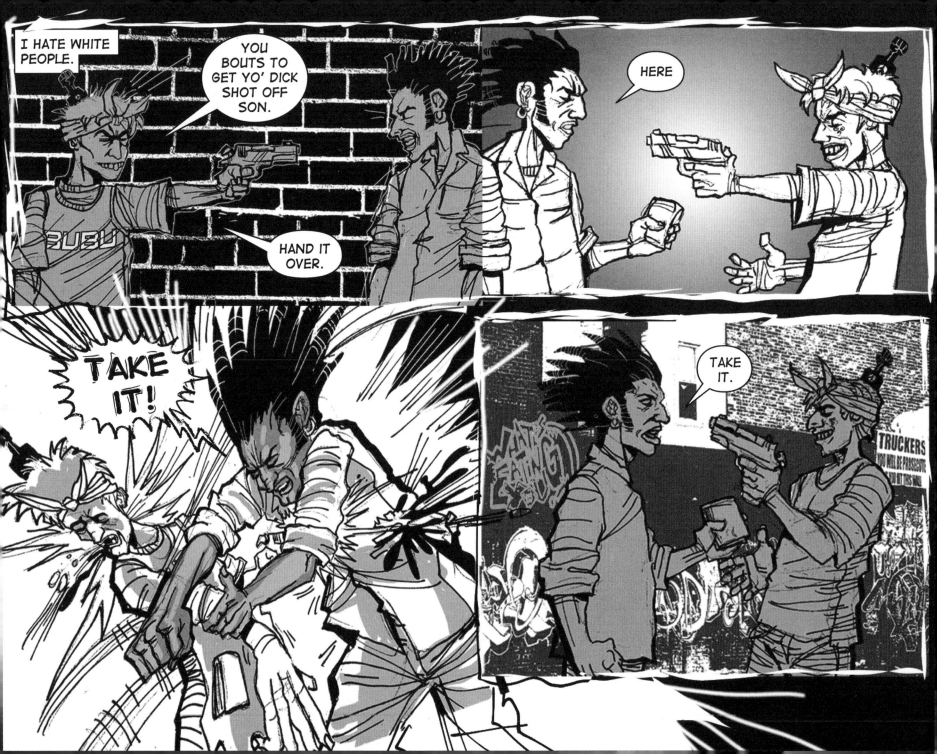

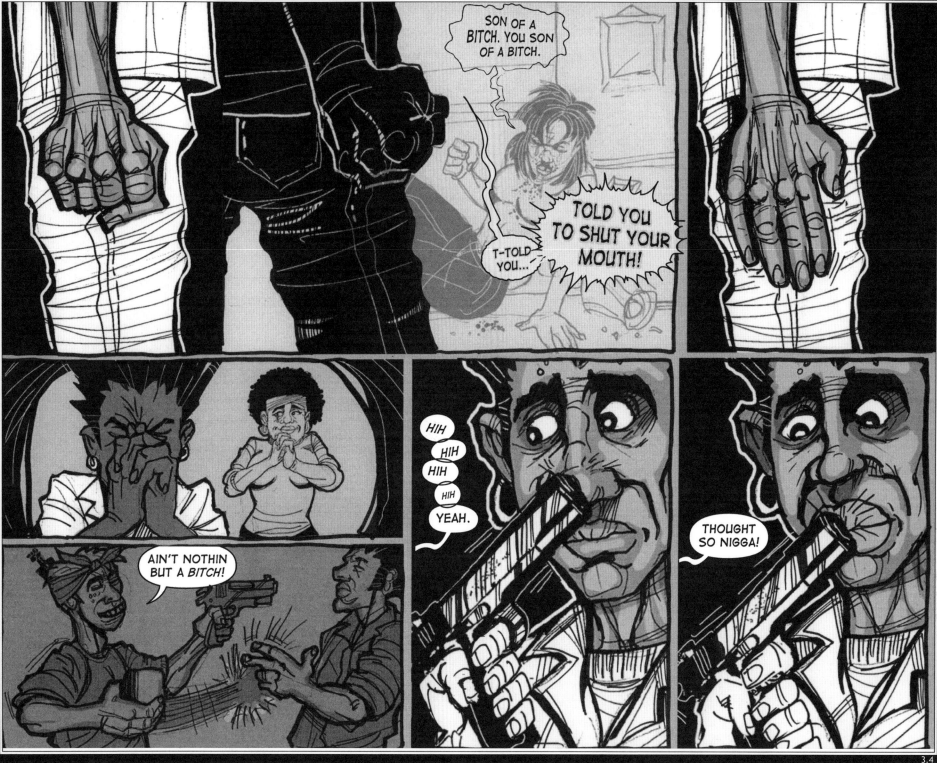

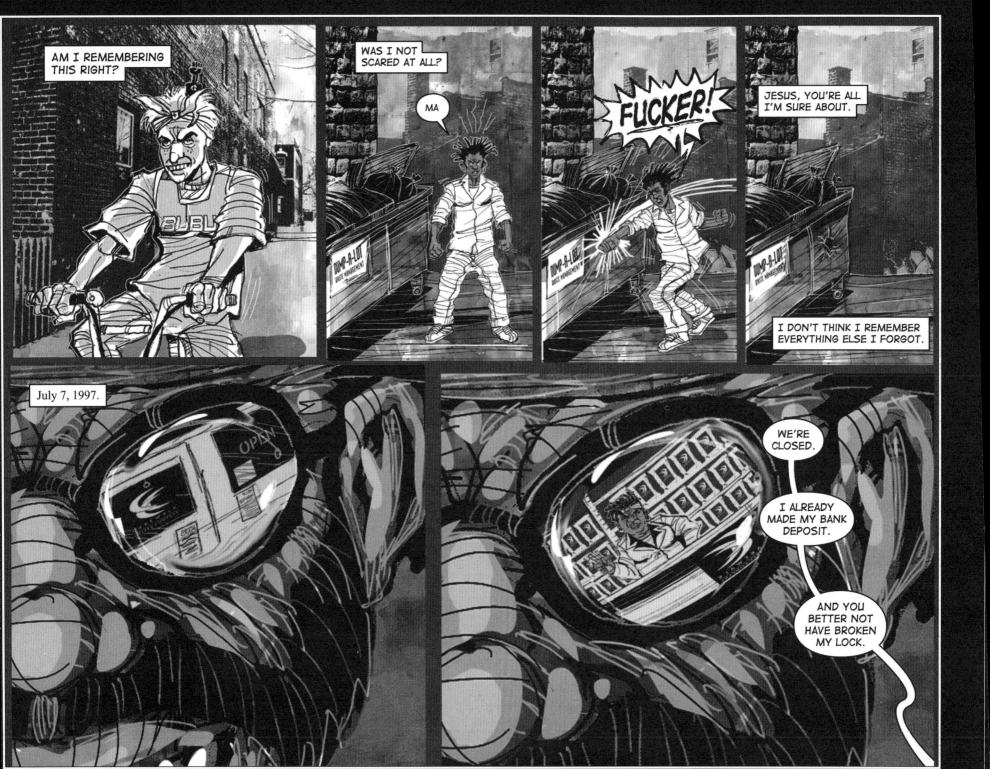

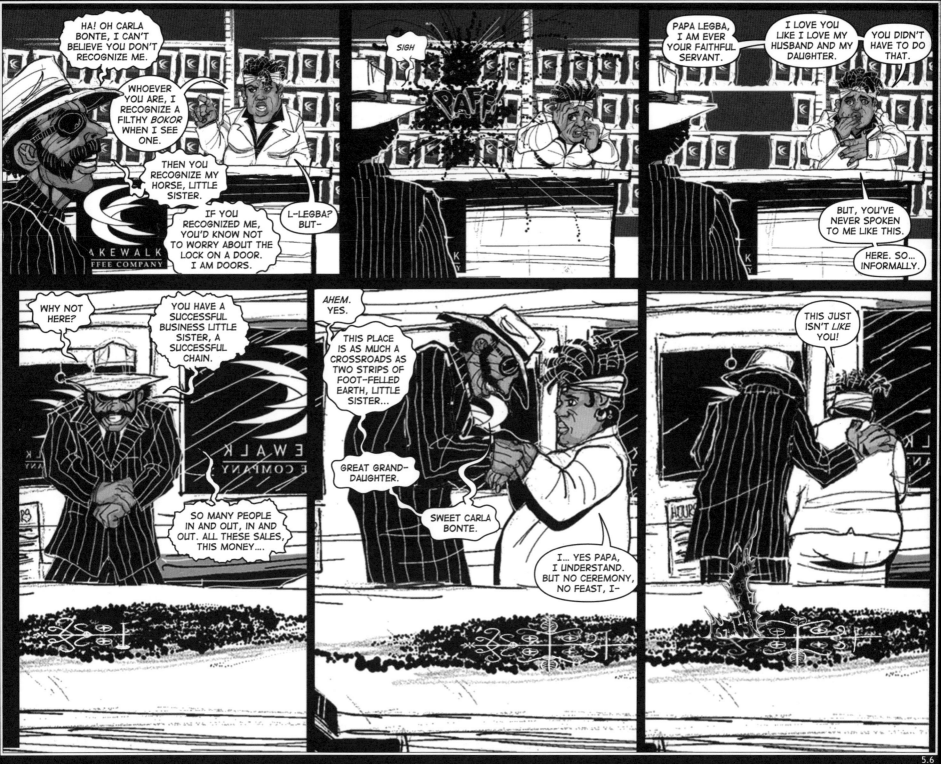

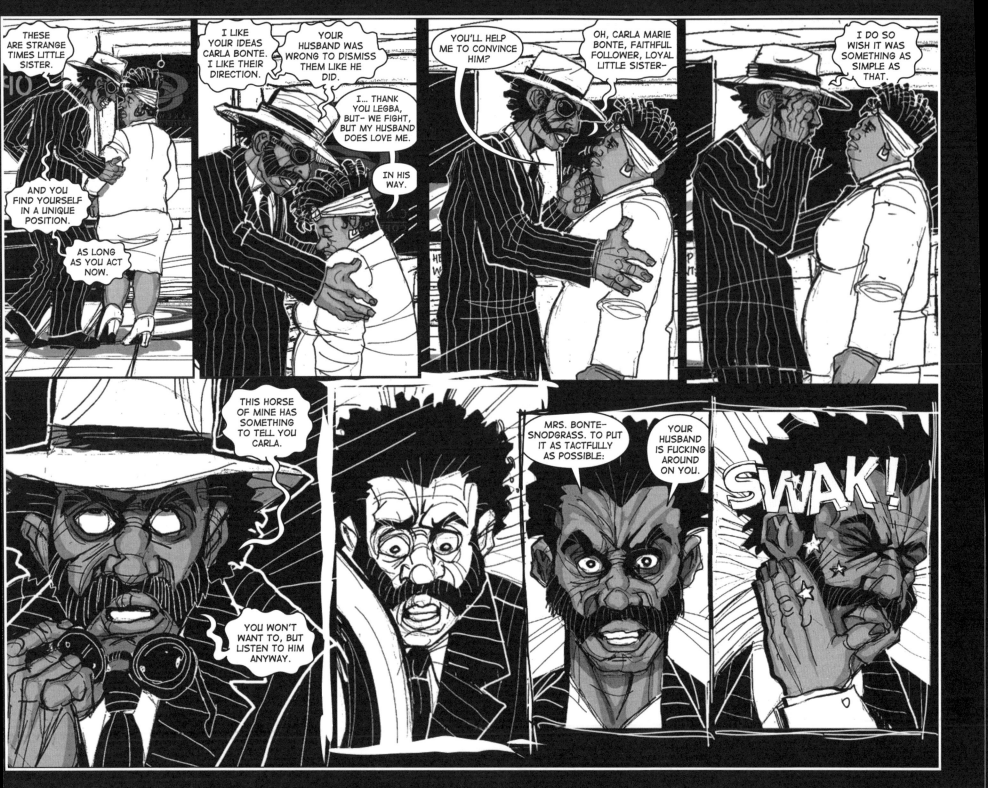

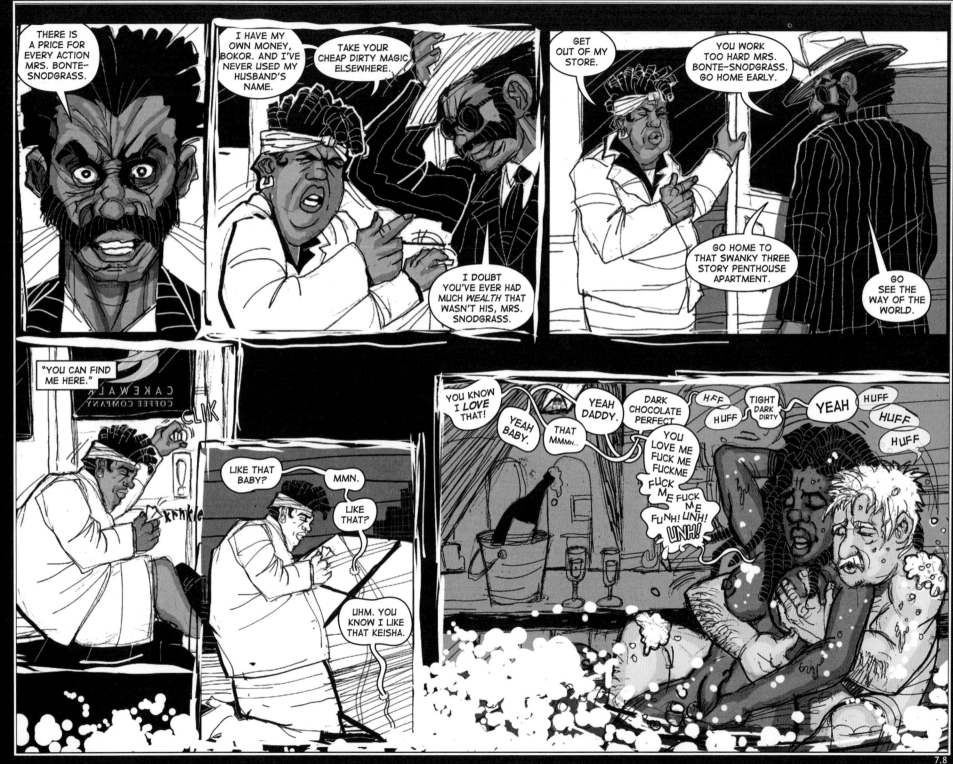

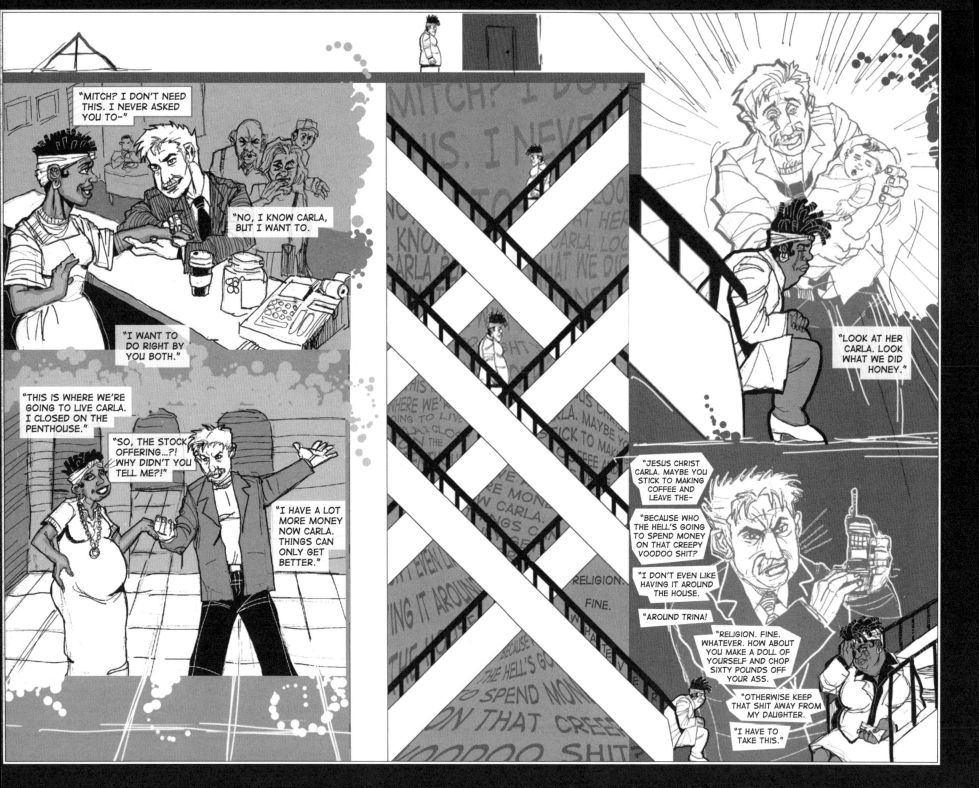

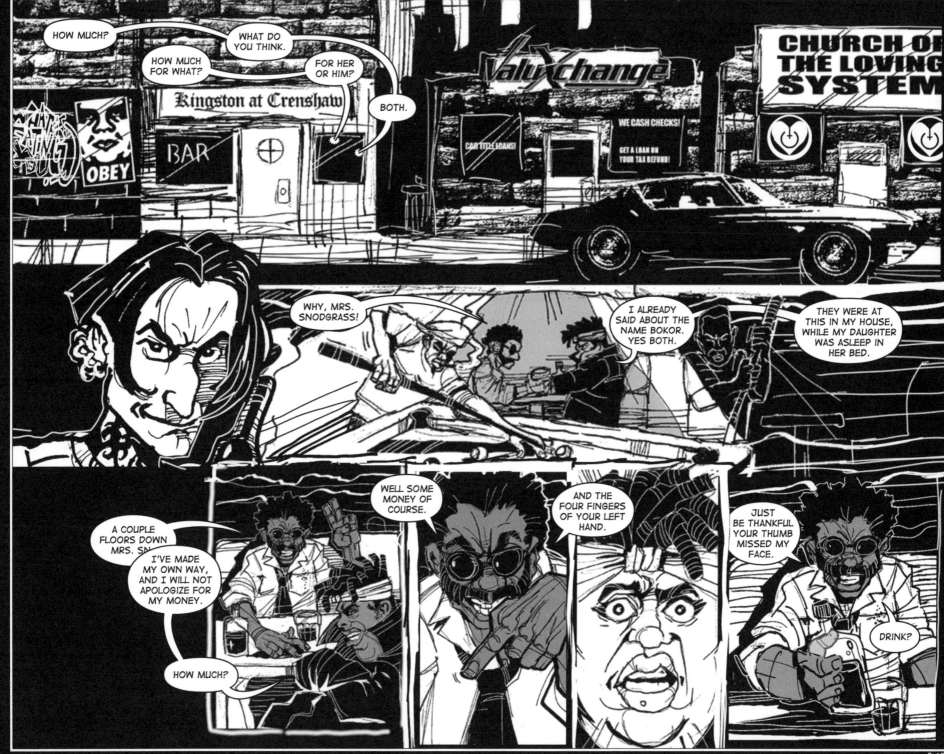

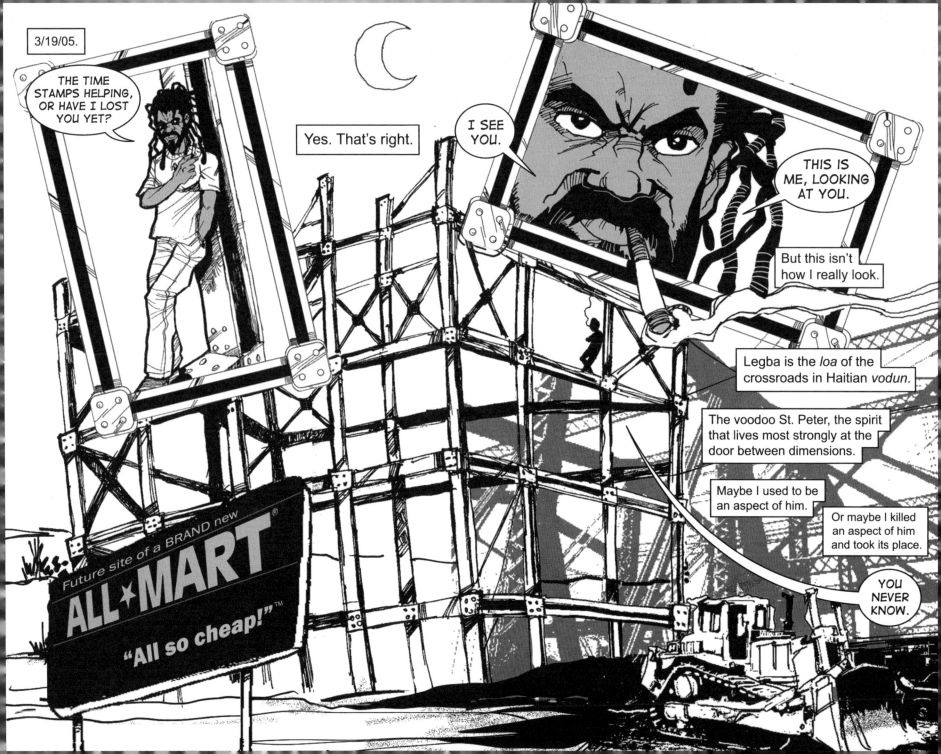

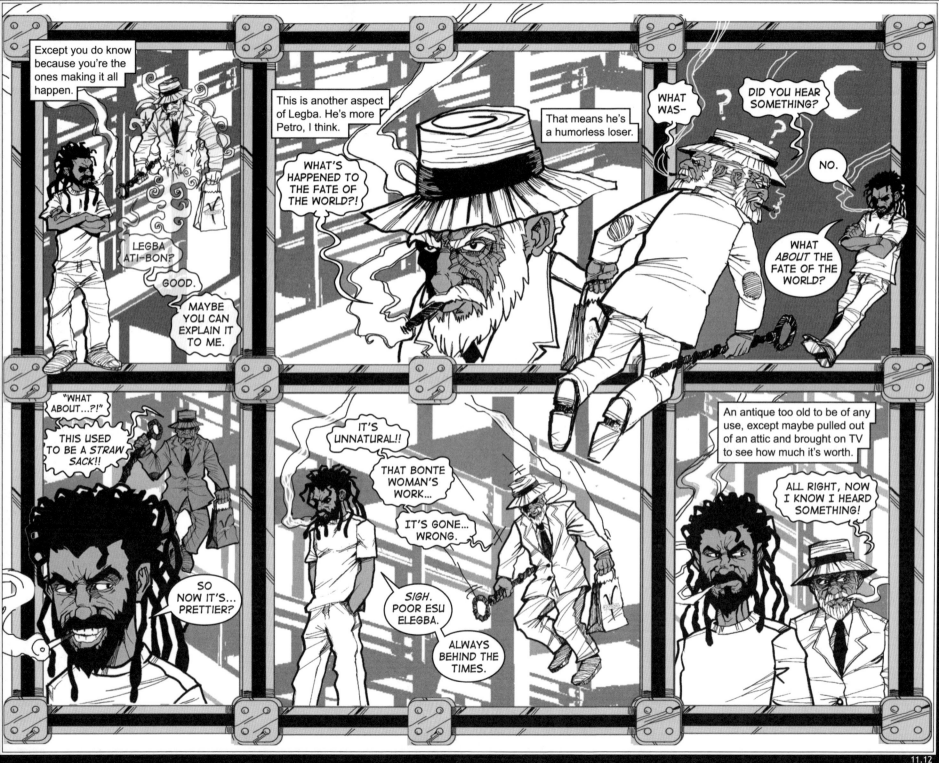

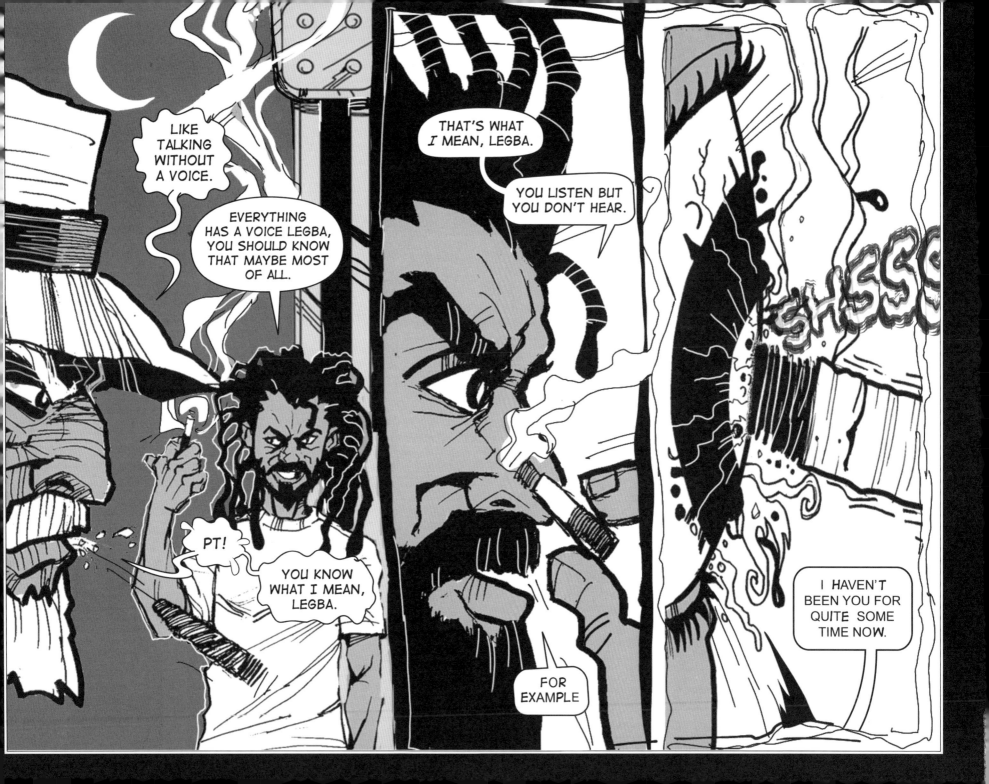

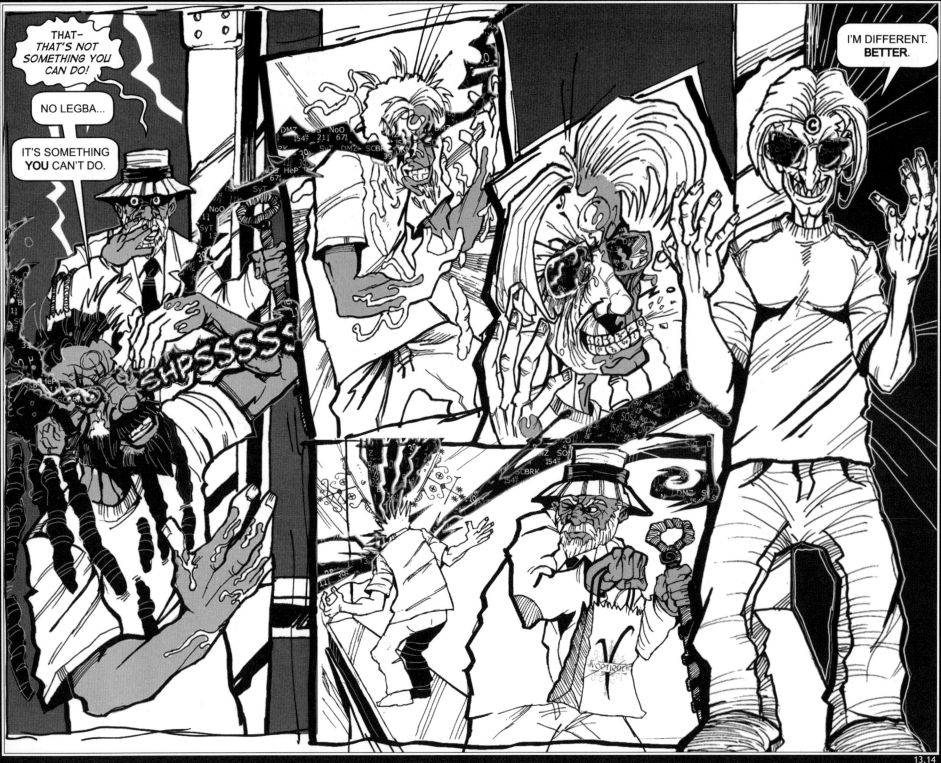

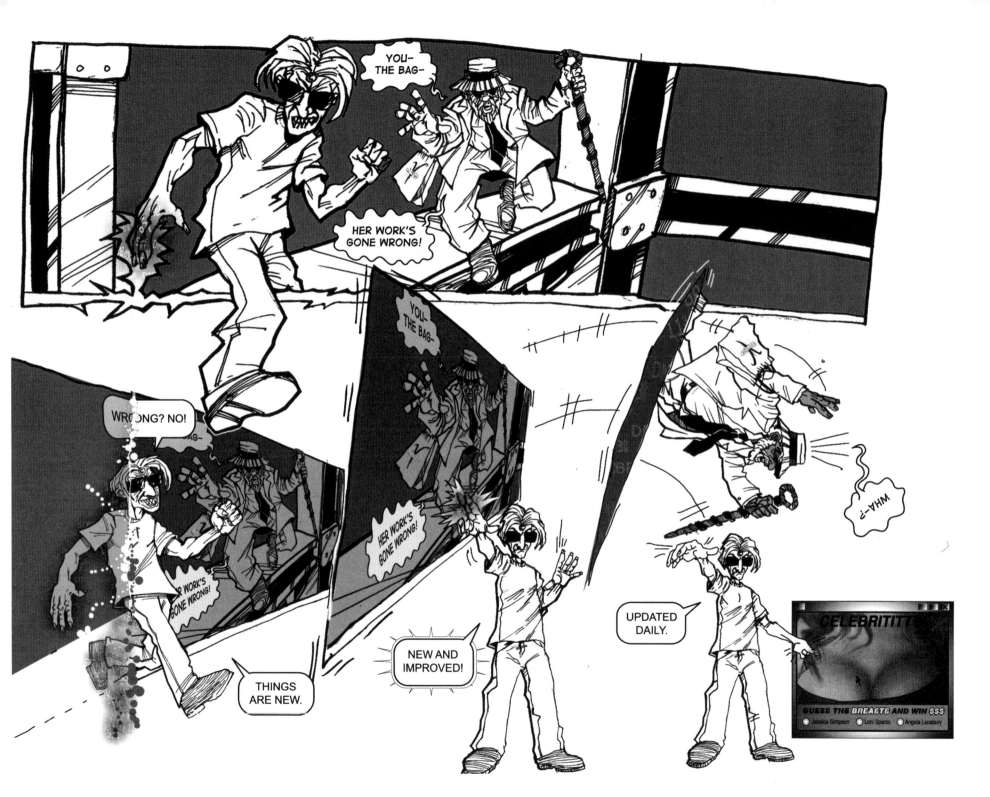

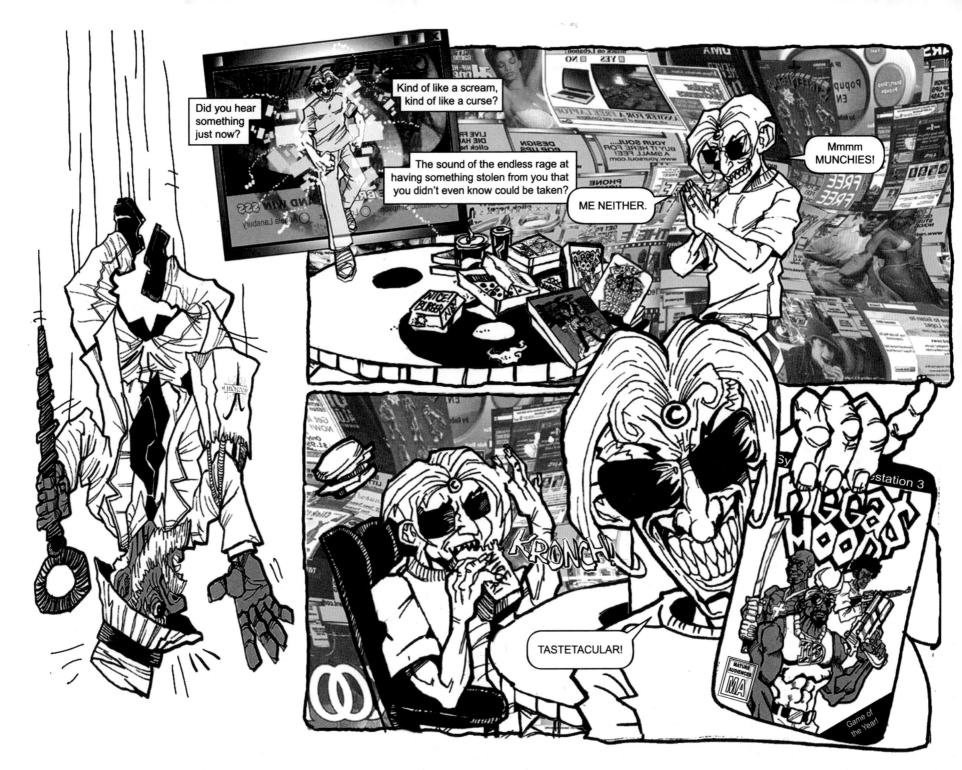

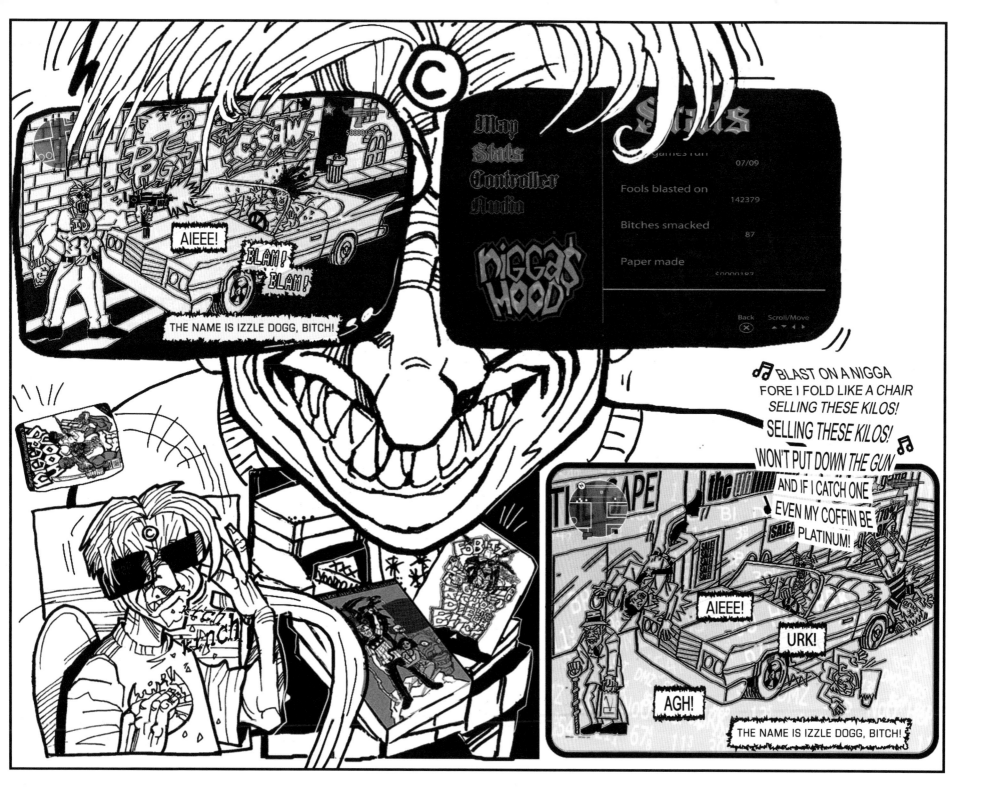

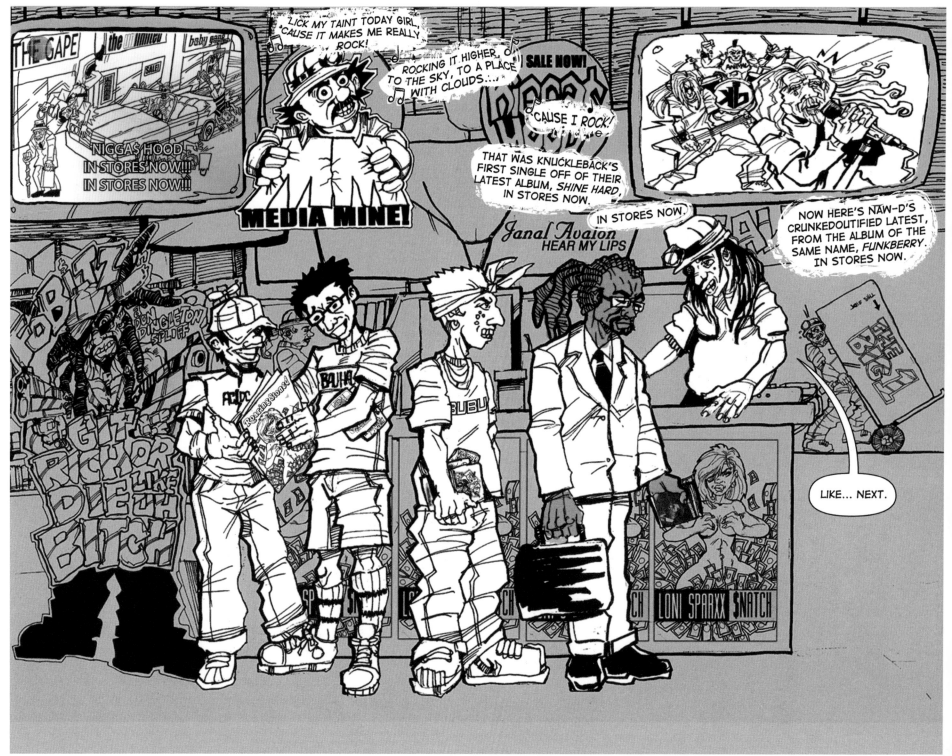

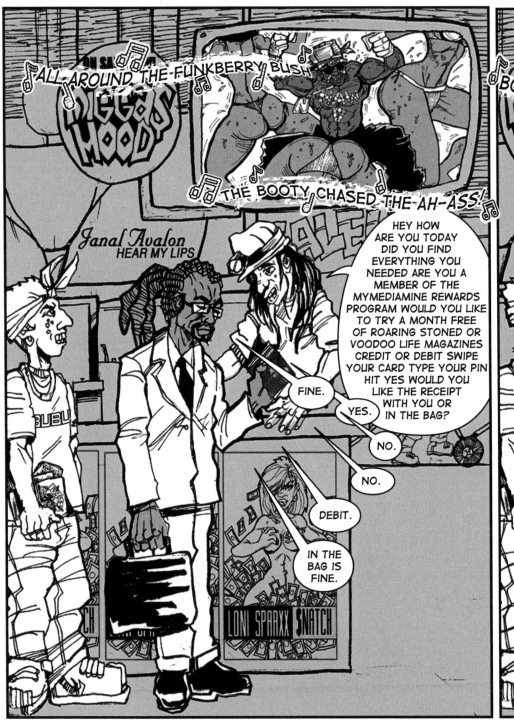
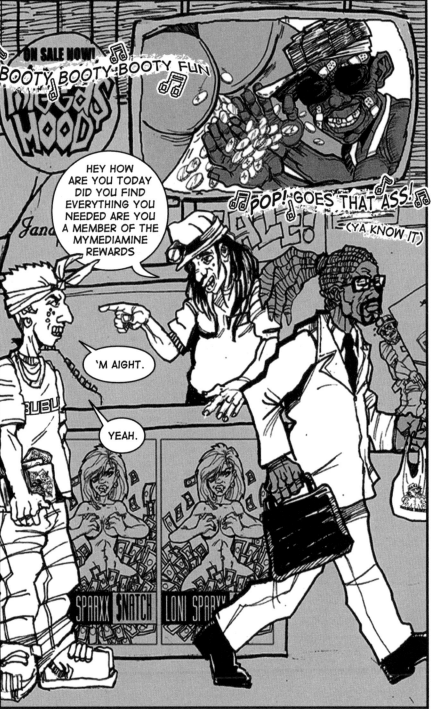

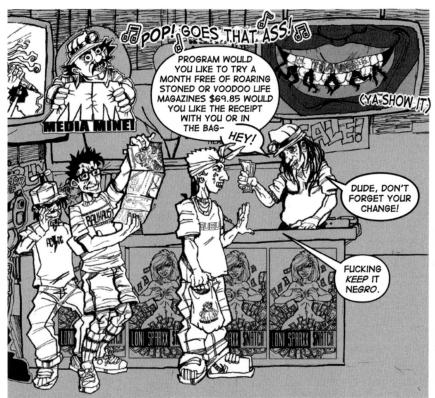

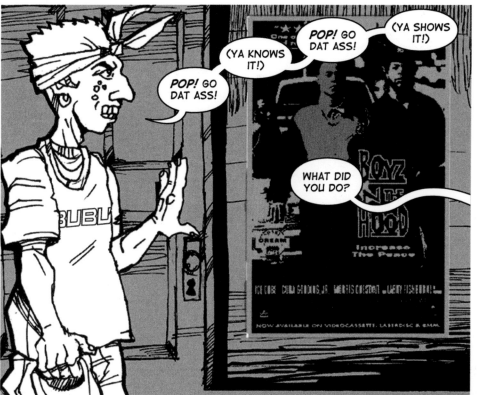

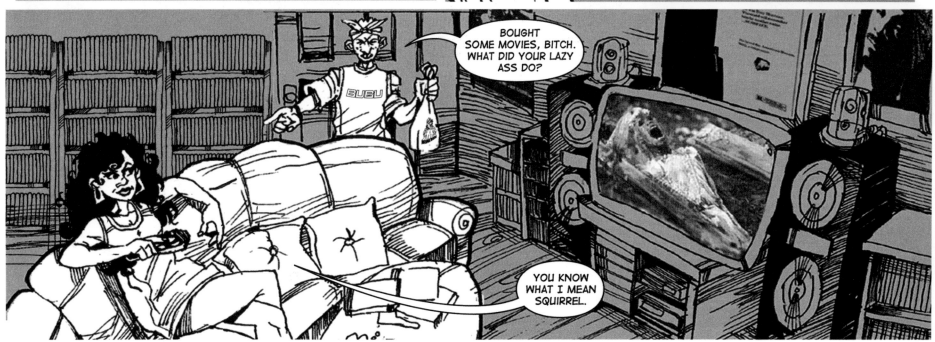

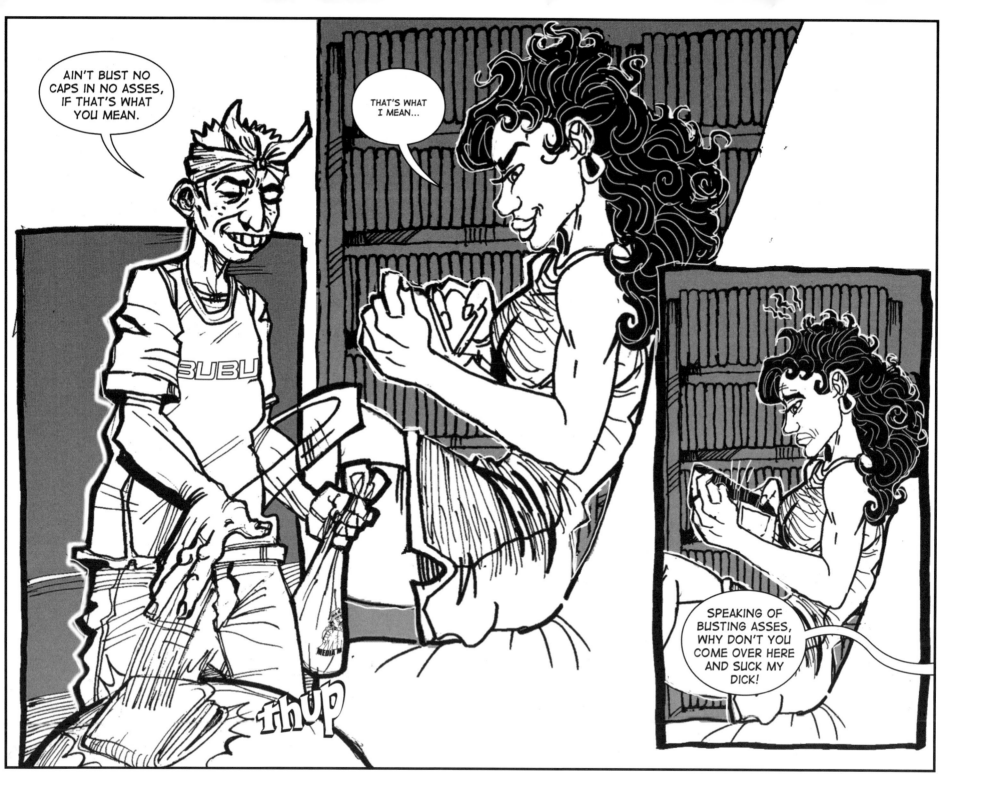

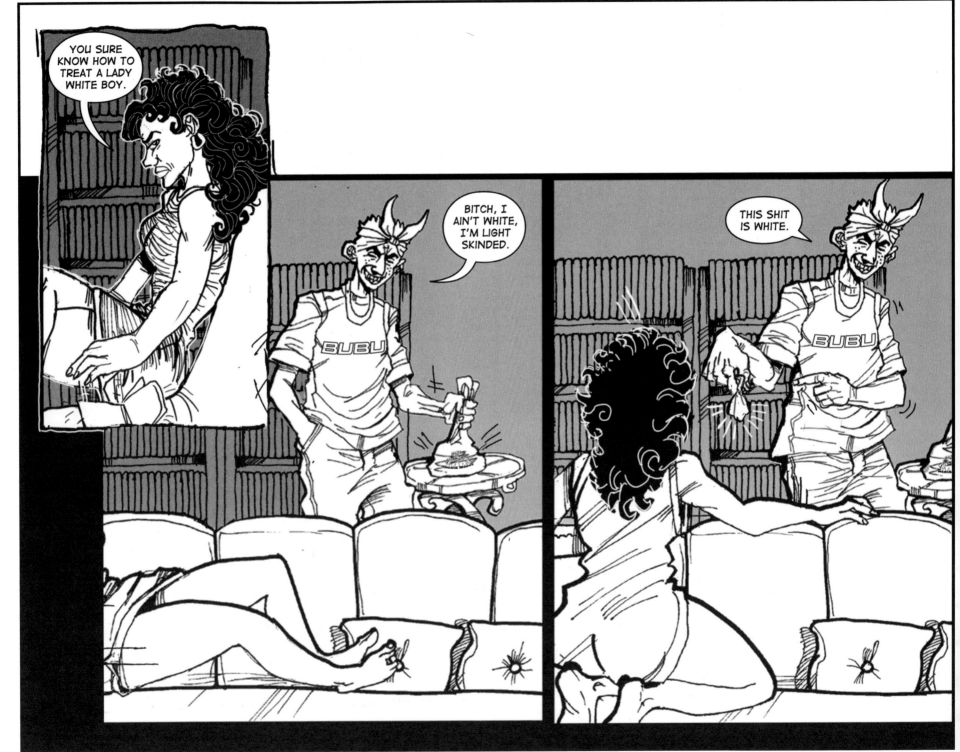

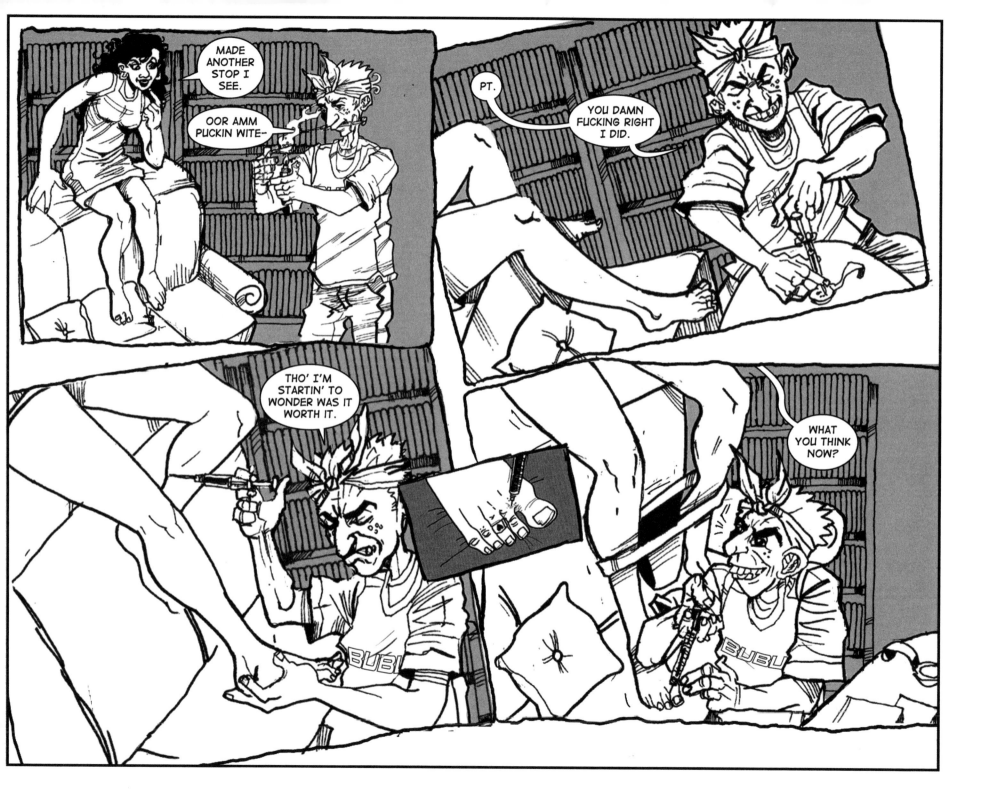

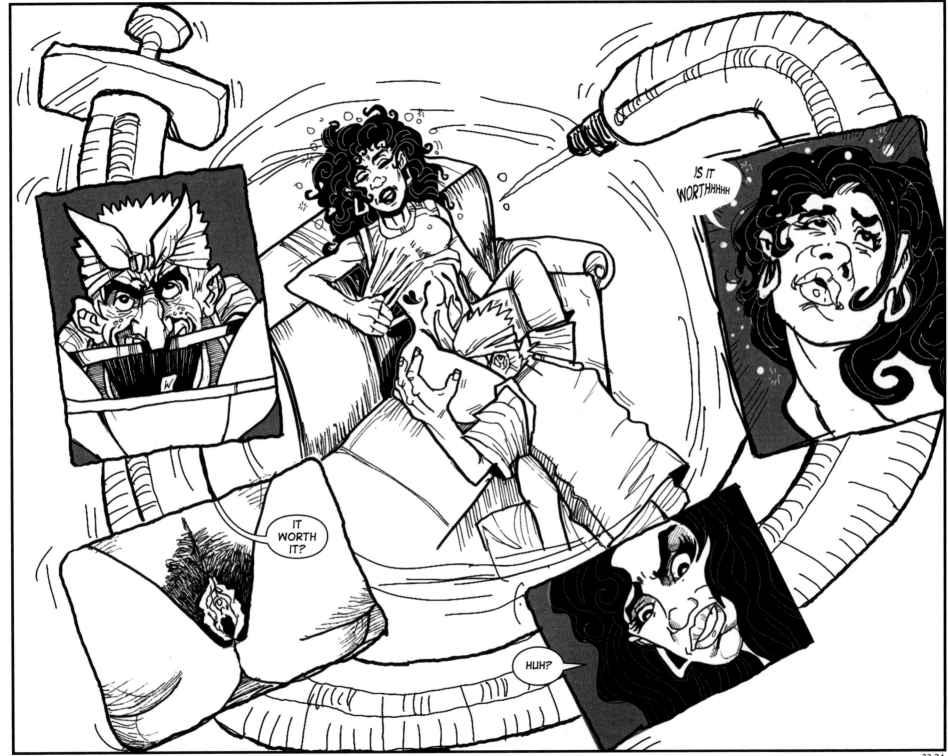

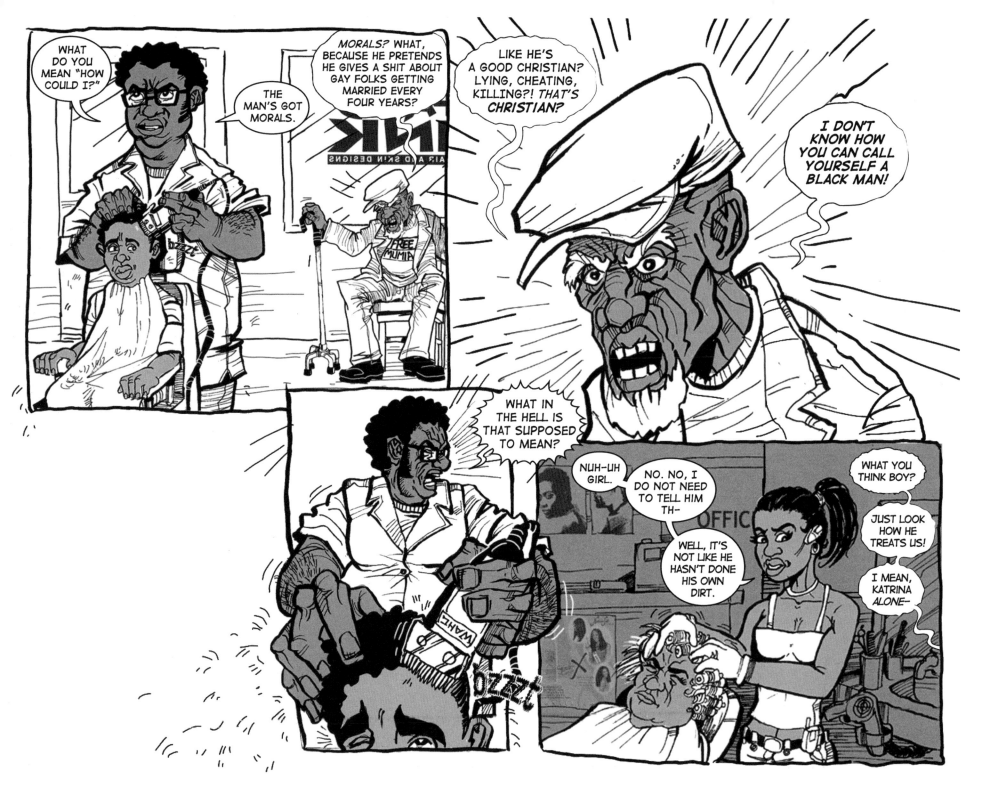

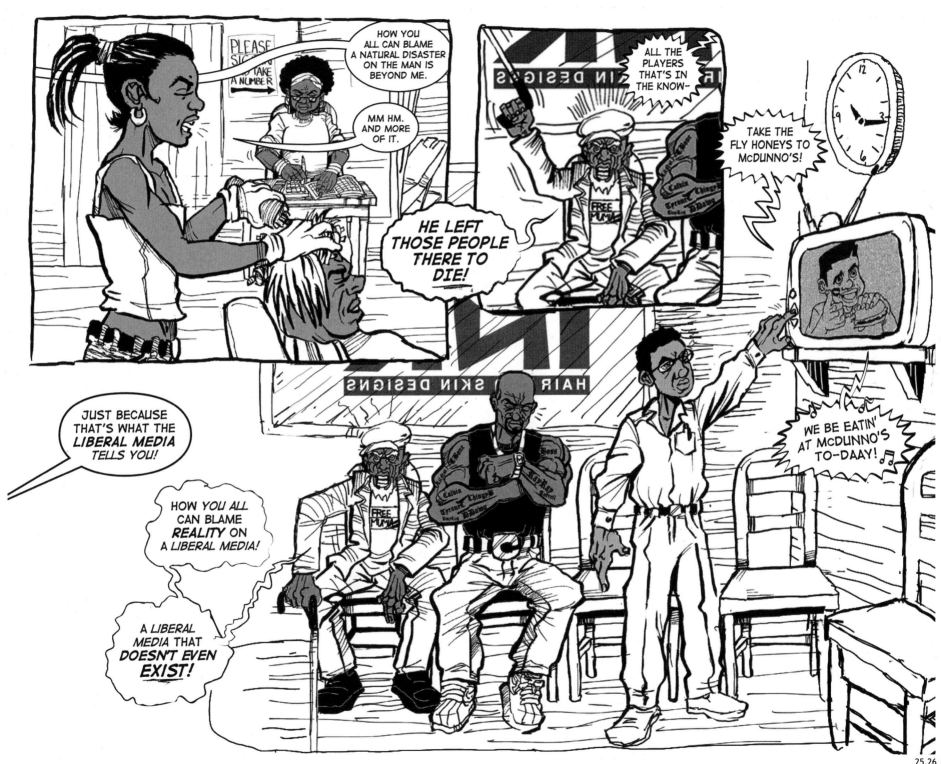

25.26

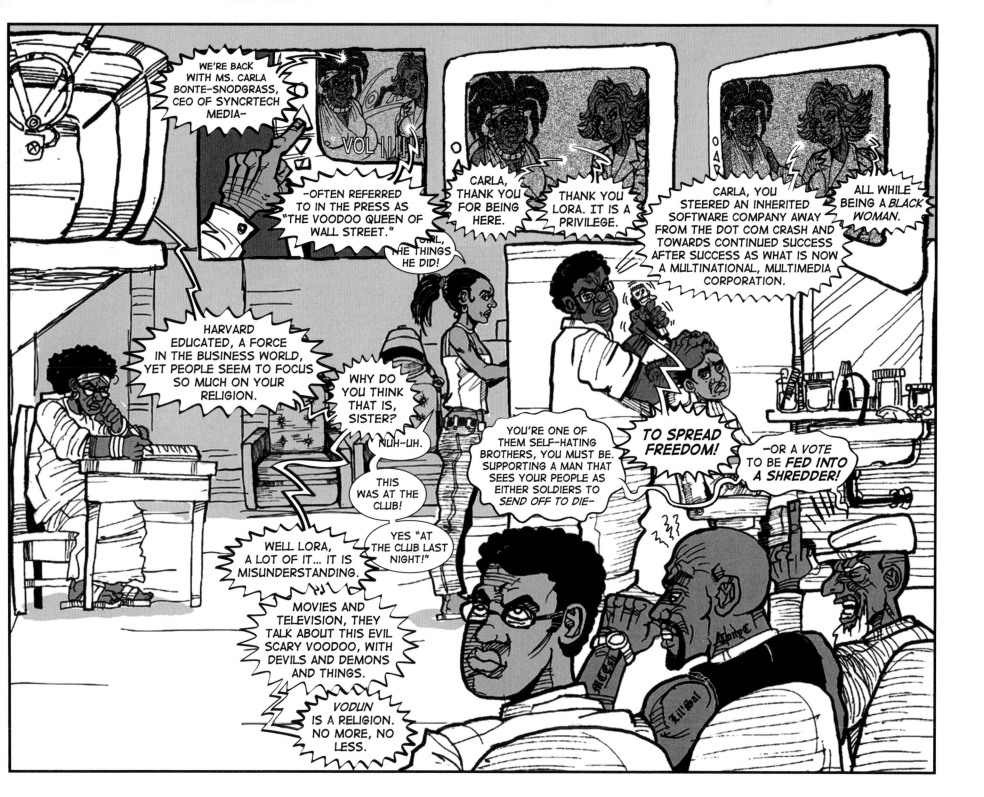

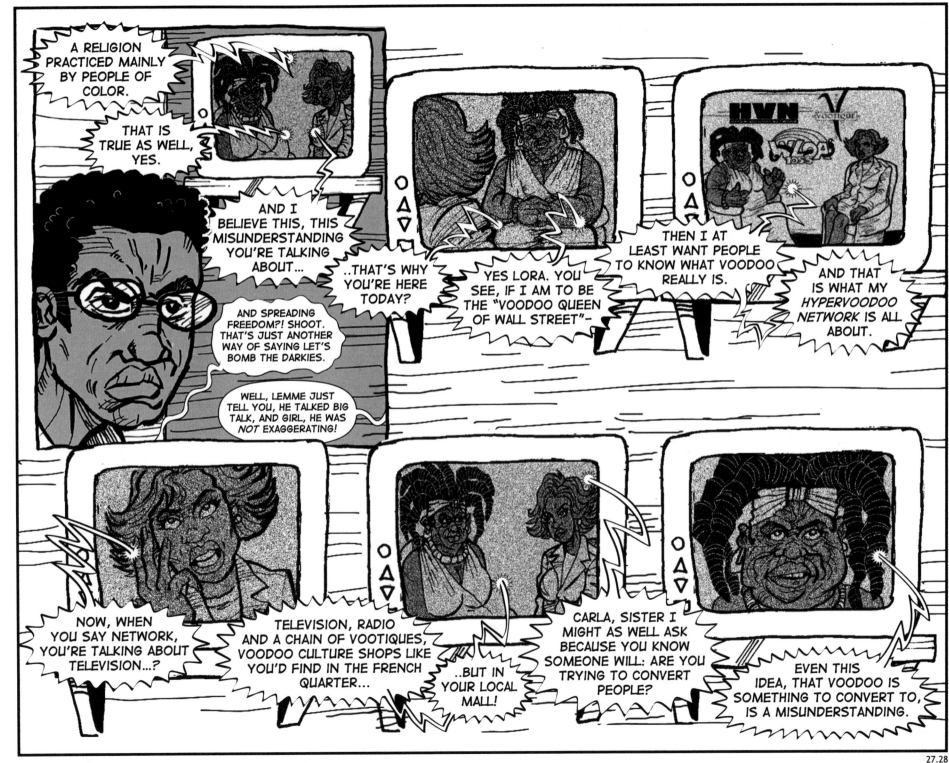

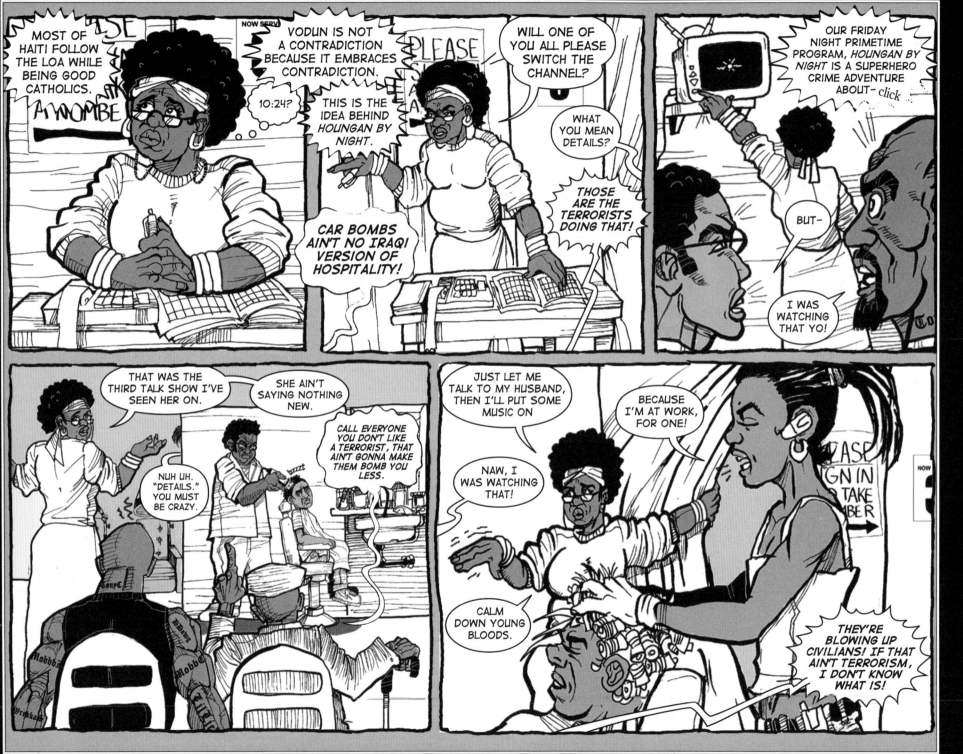

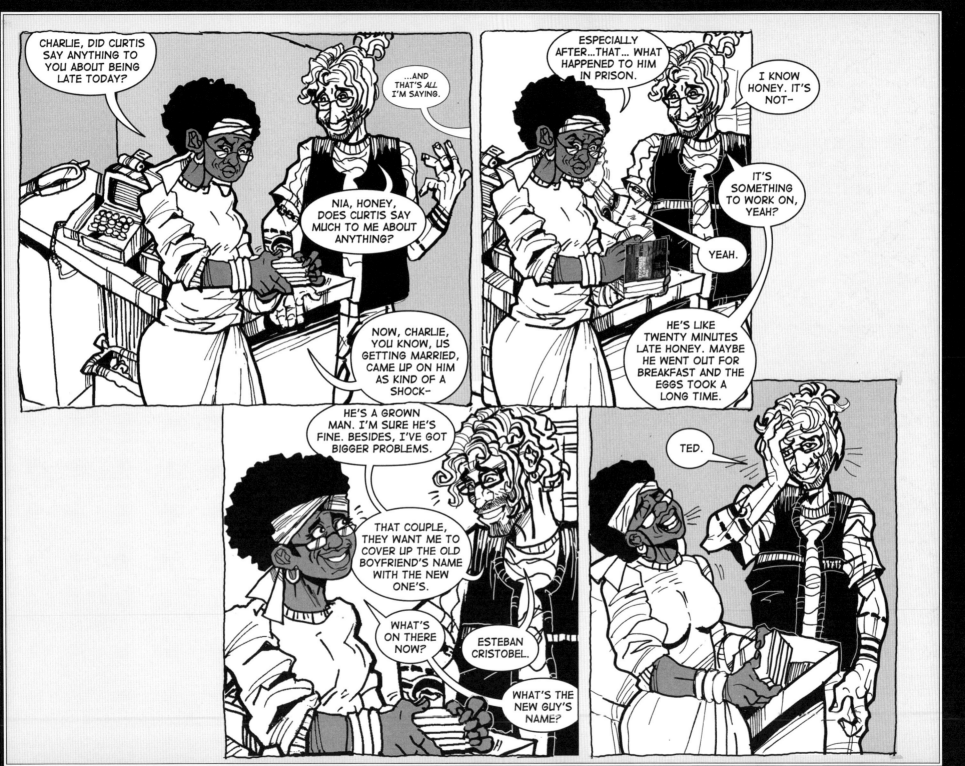

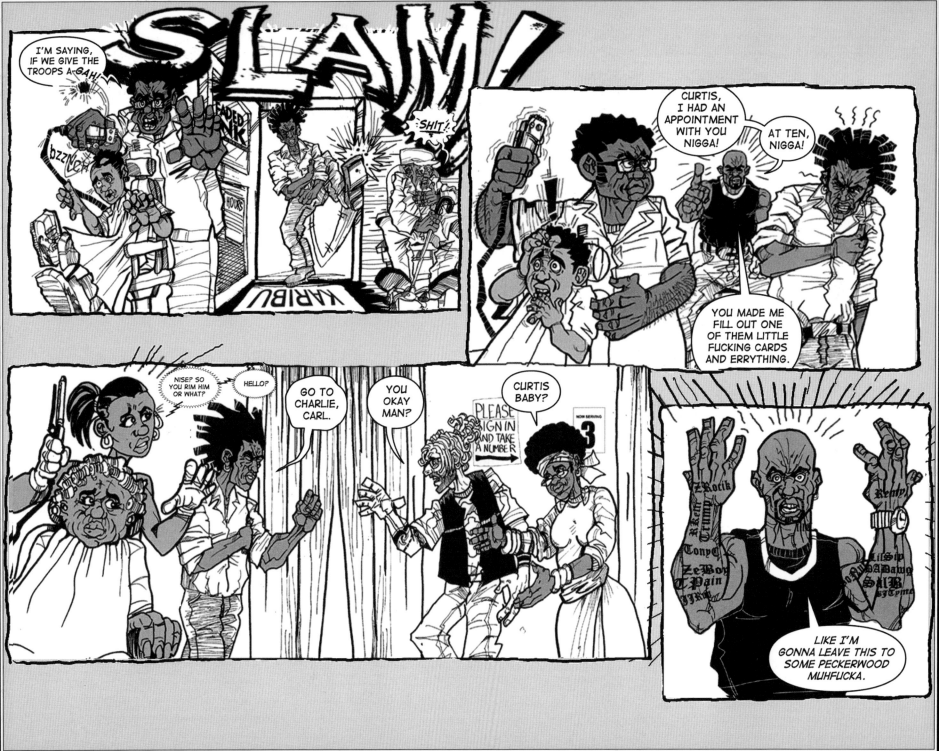

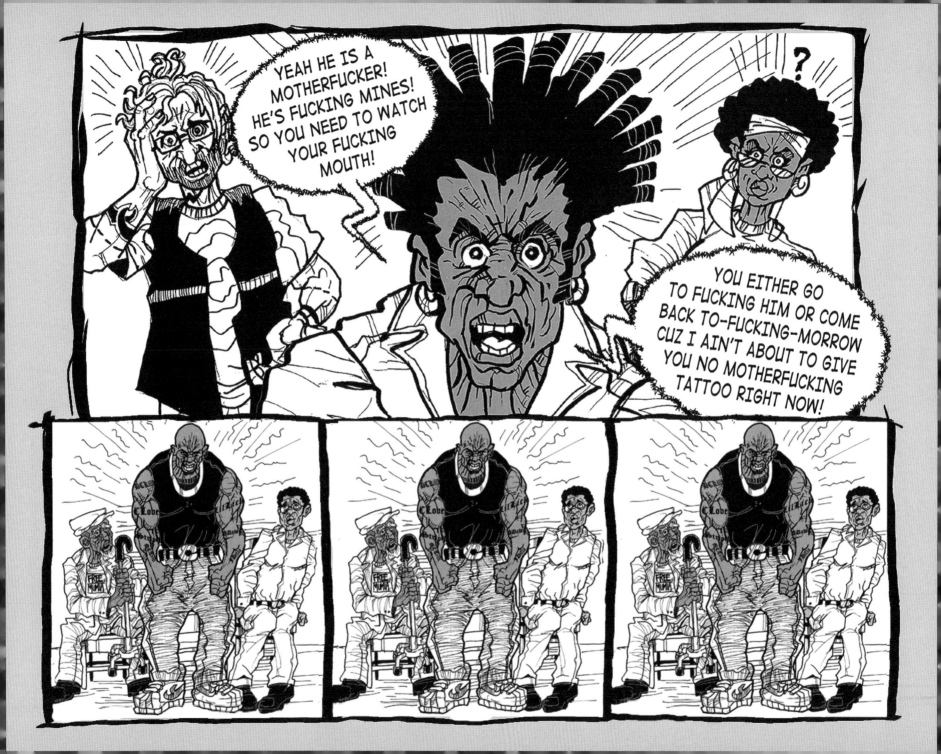

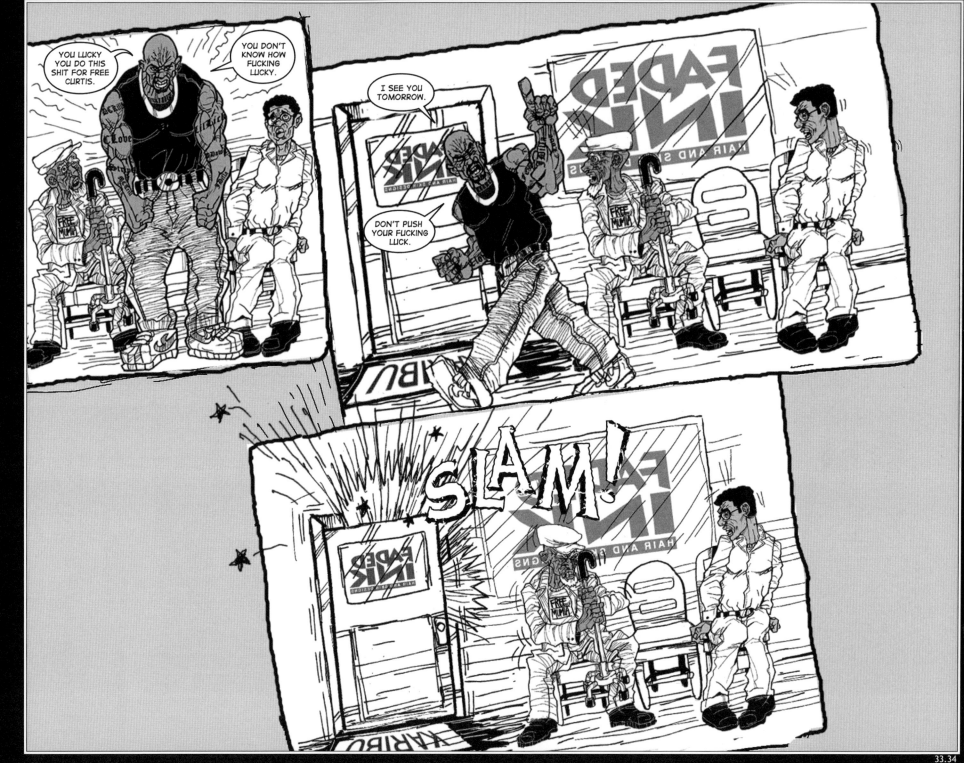

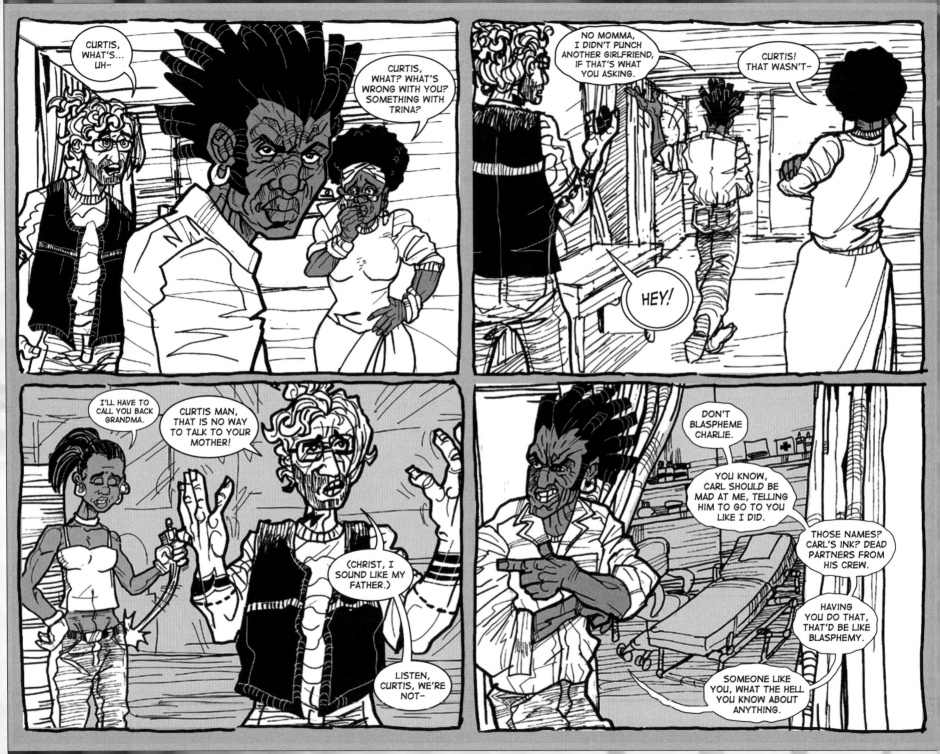

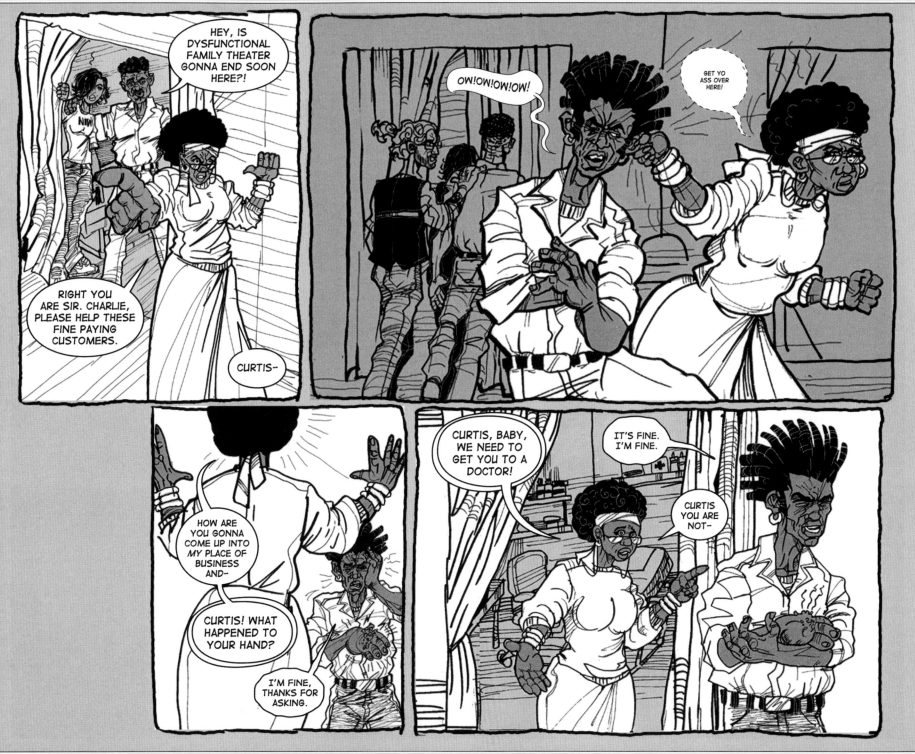

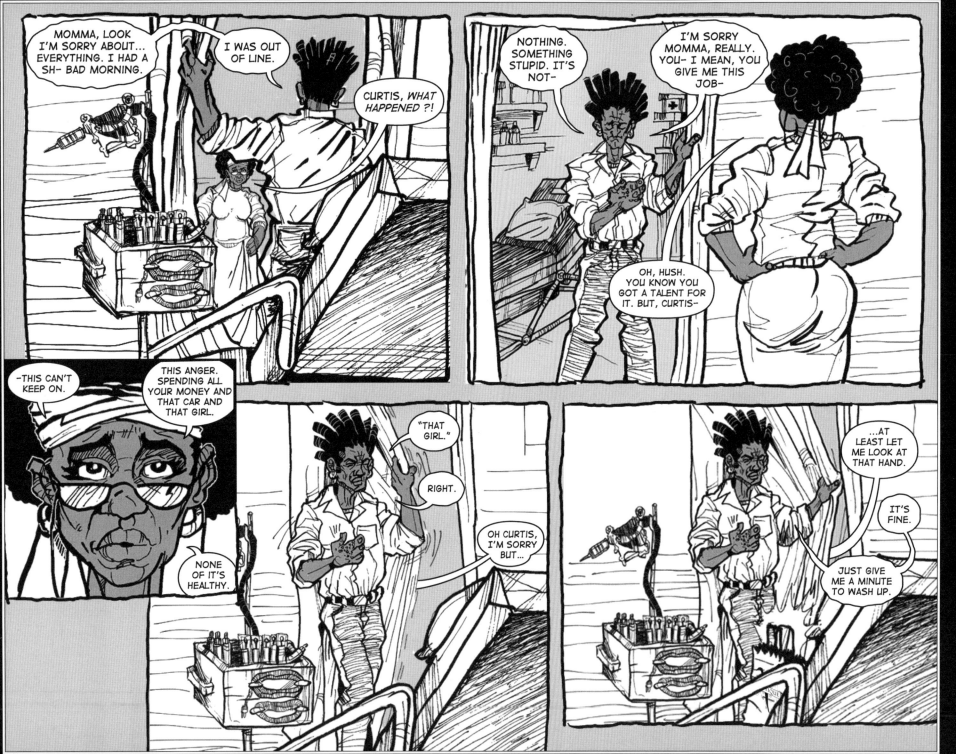

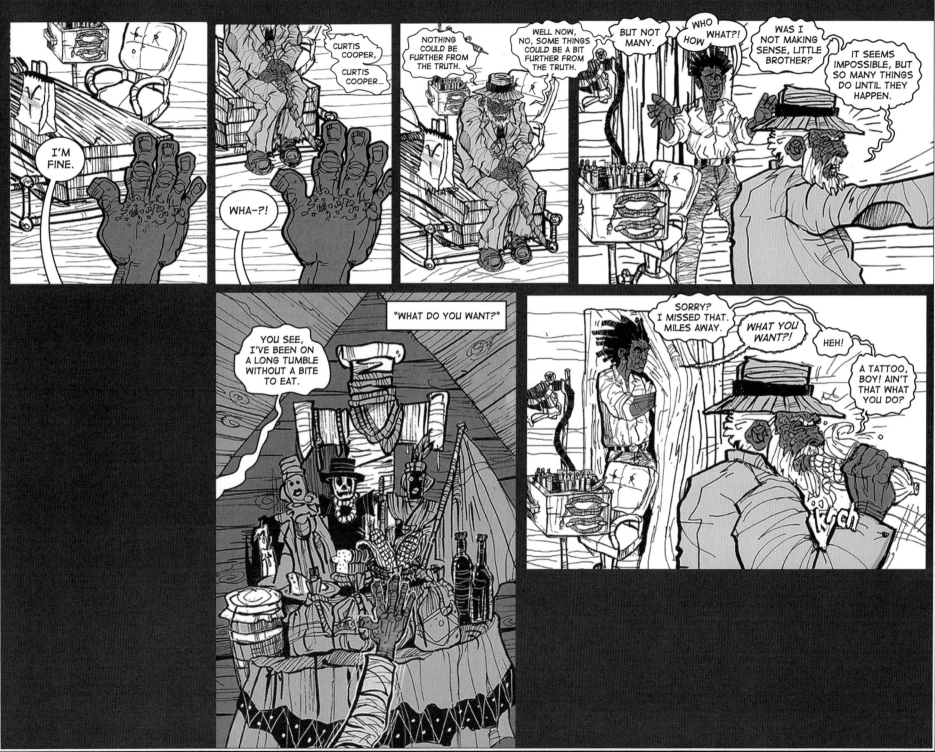

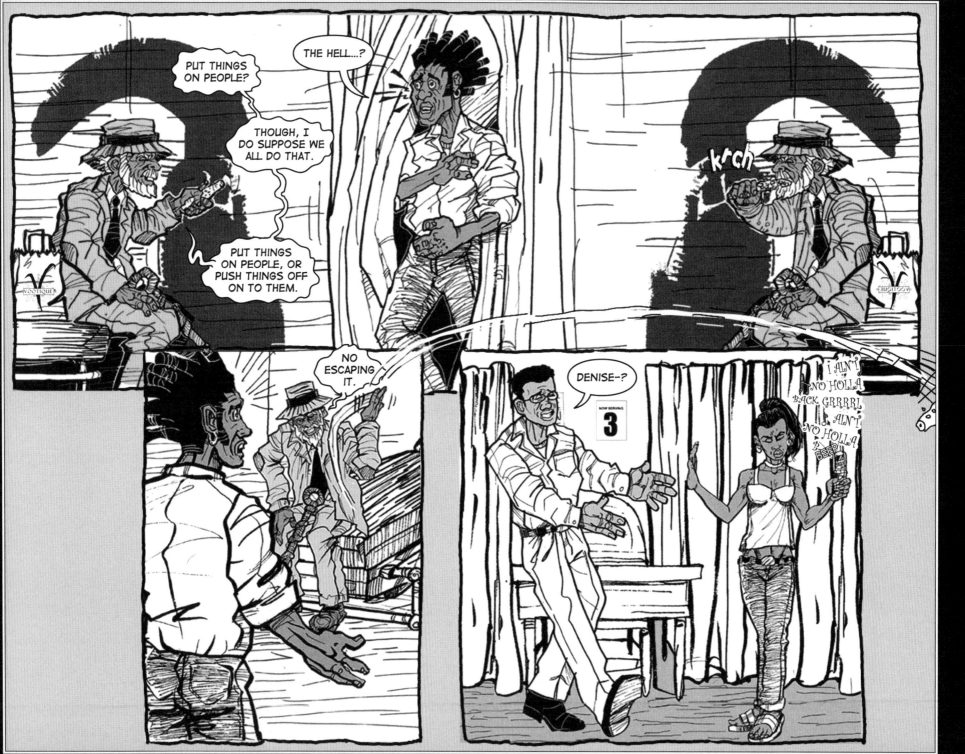

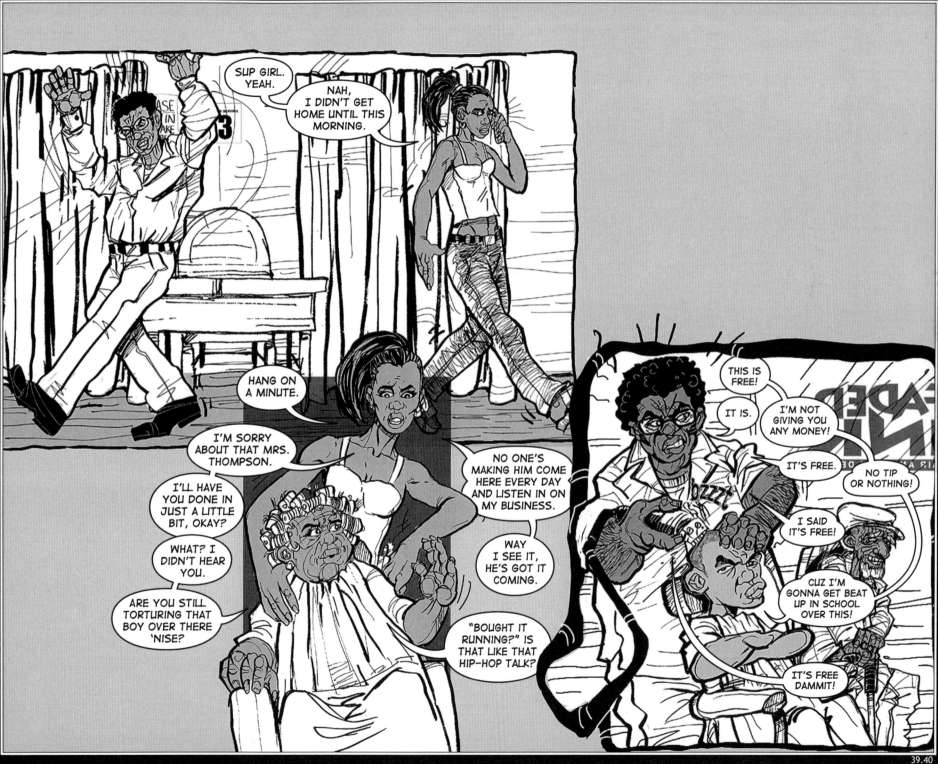

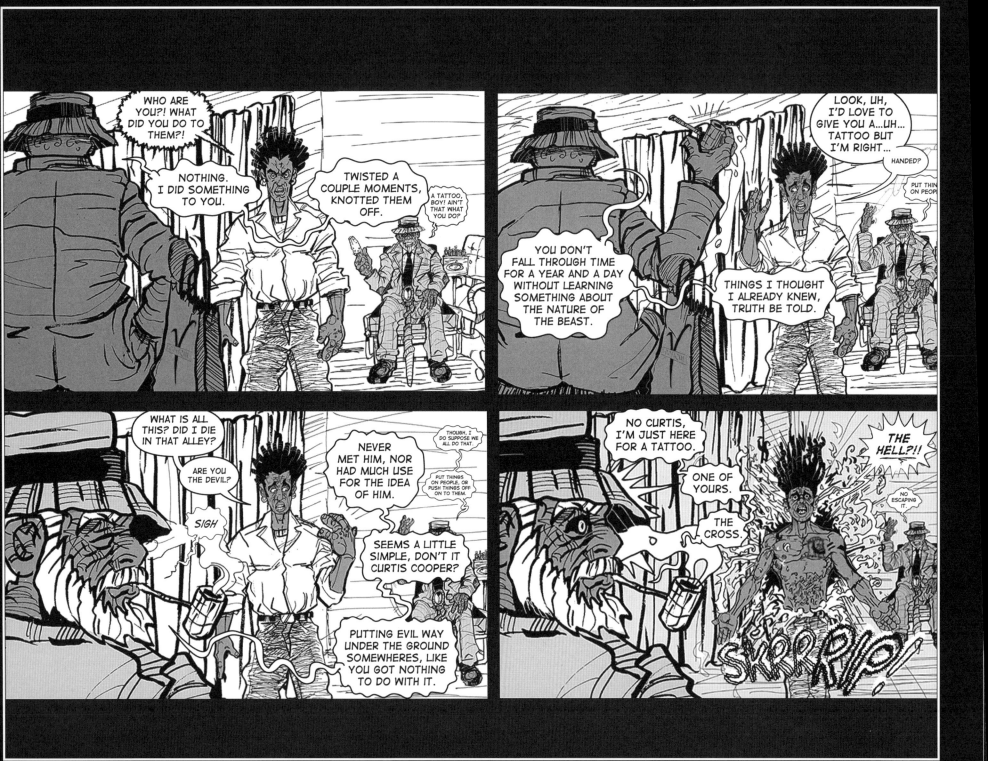

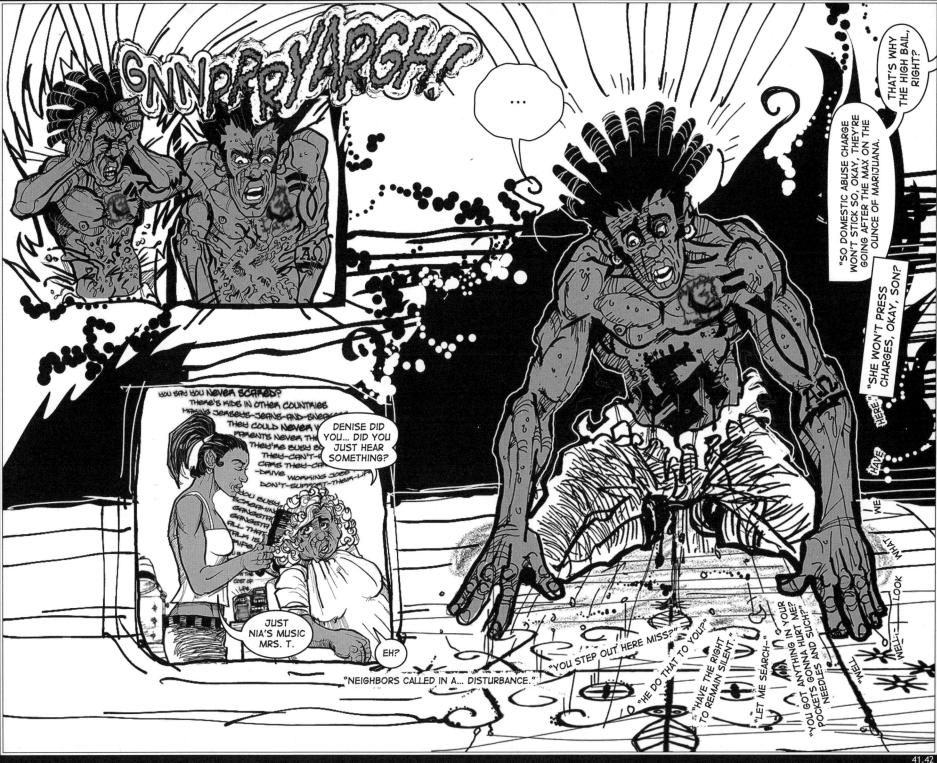

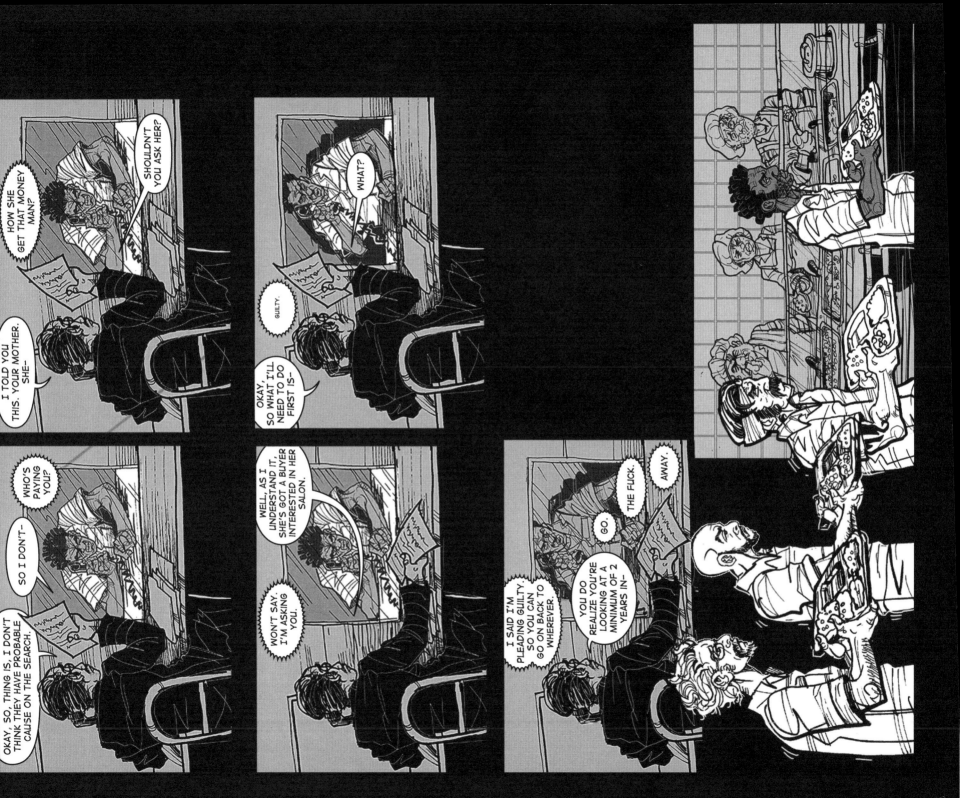

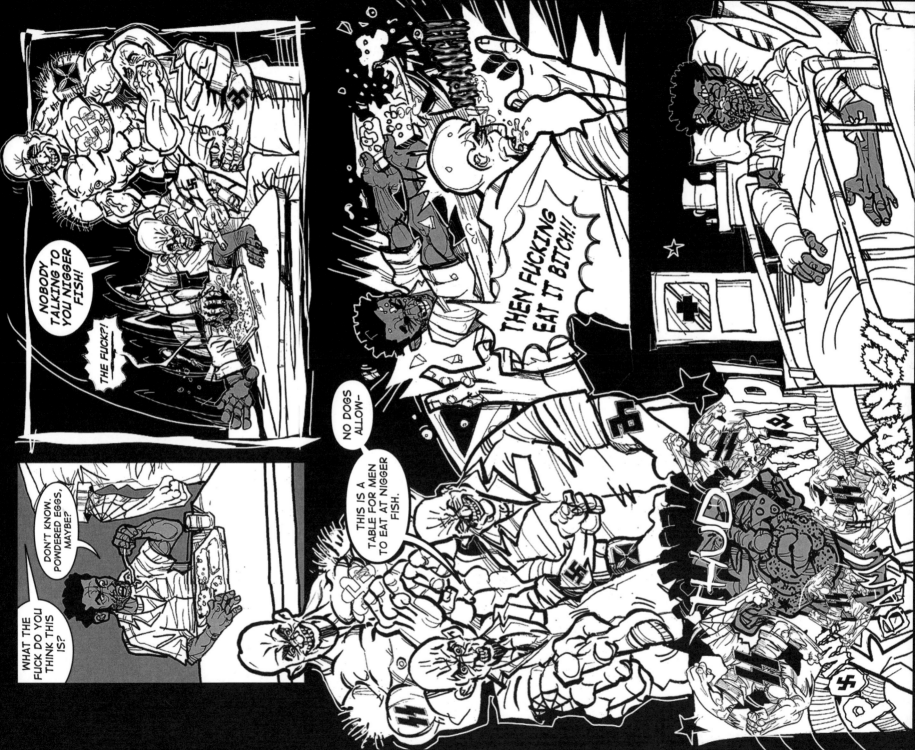

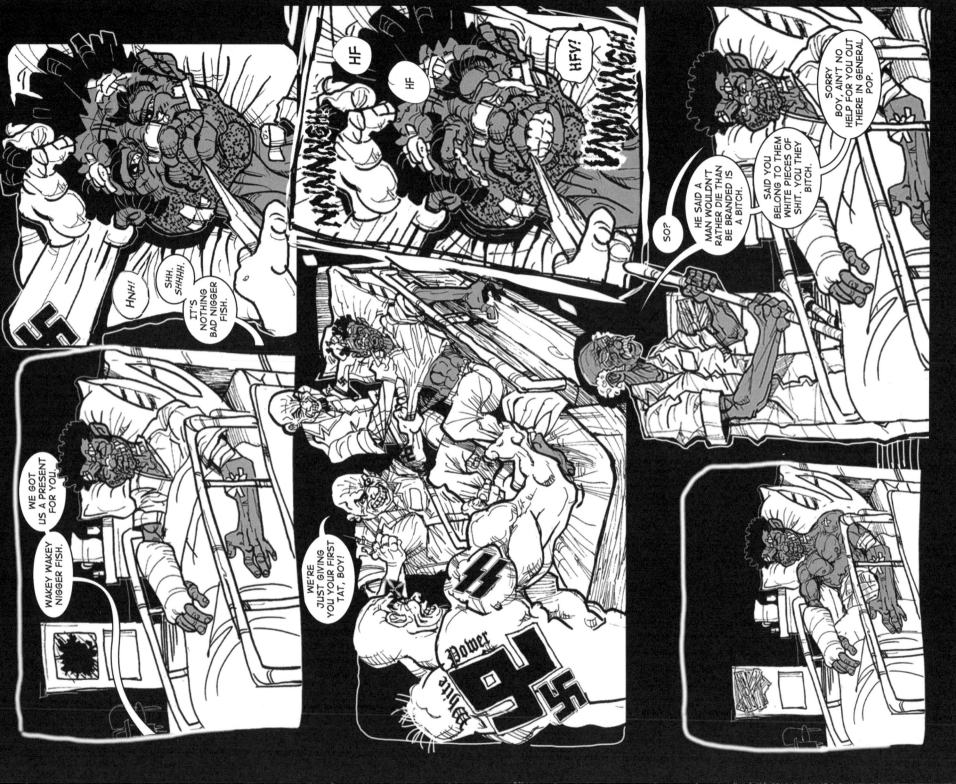

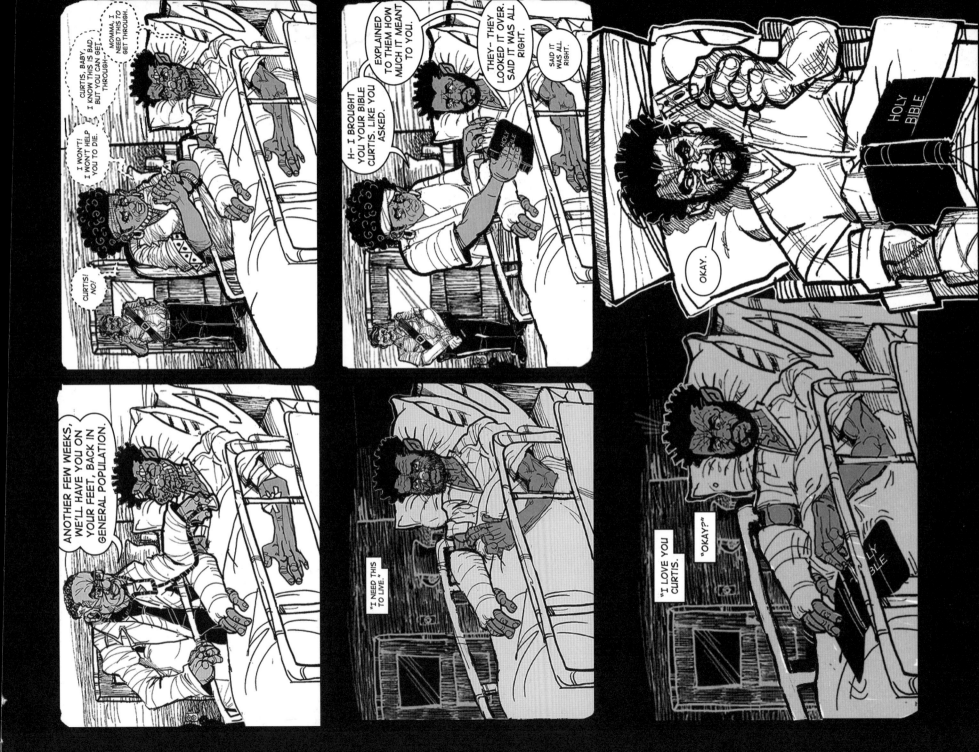

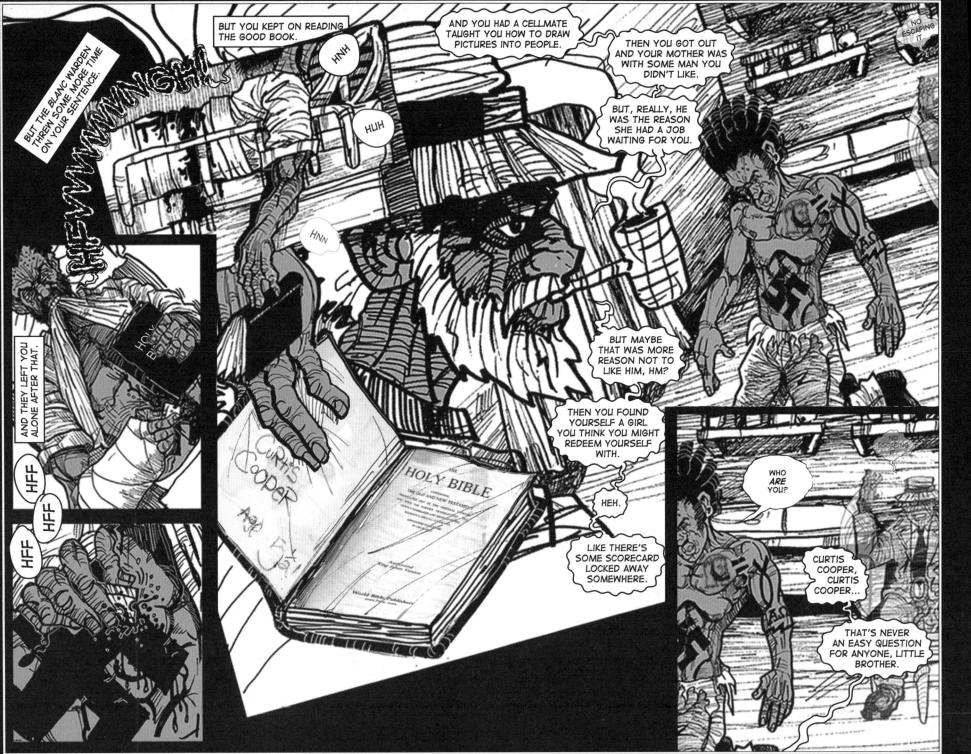

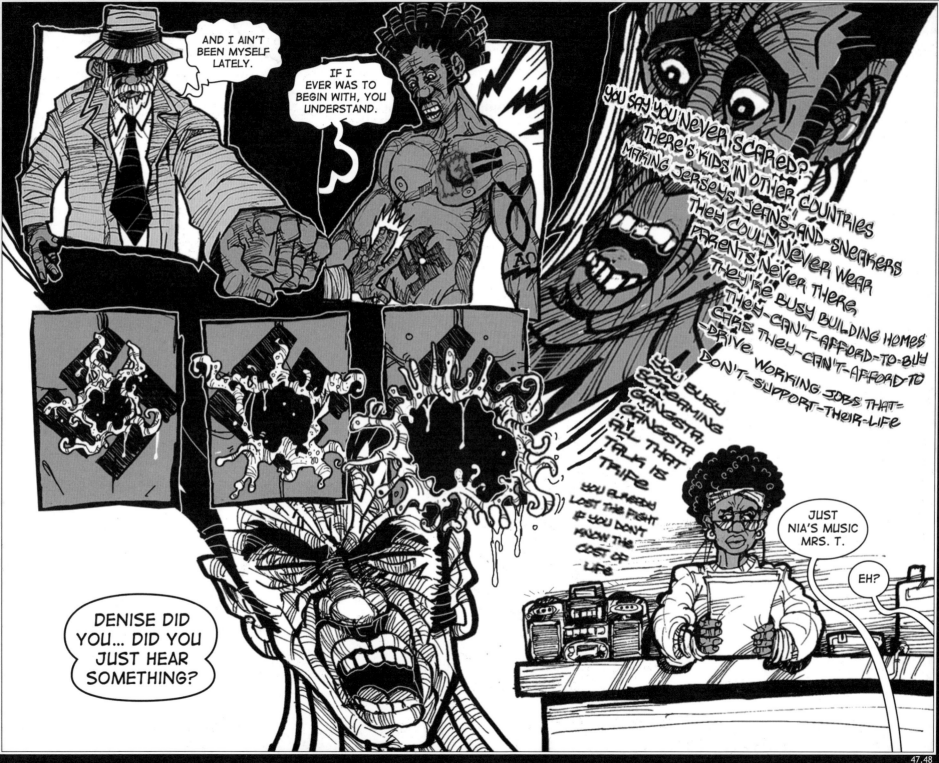

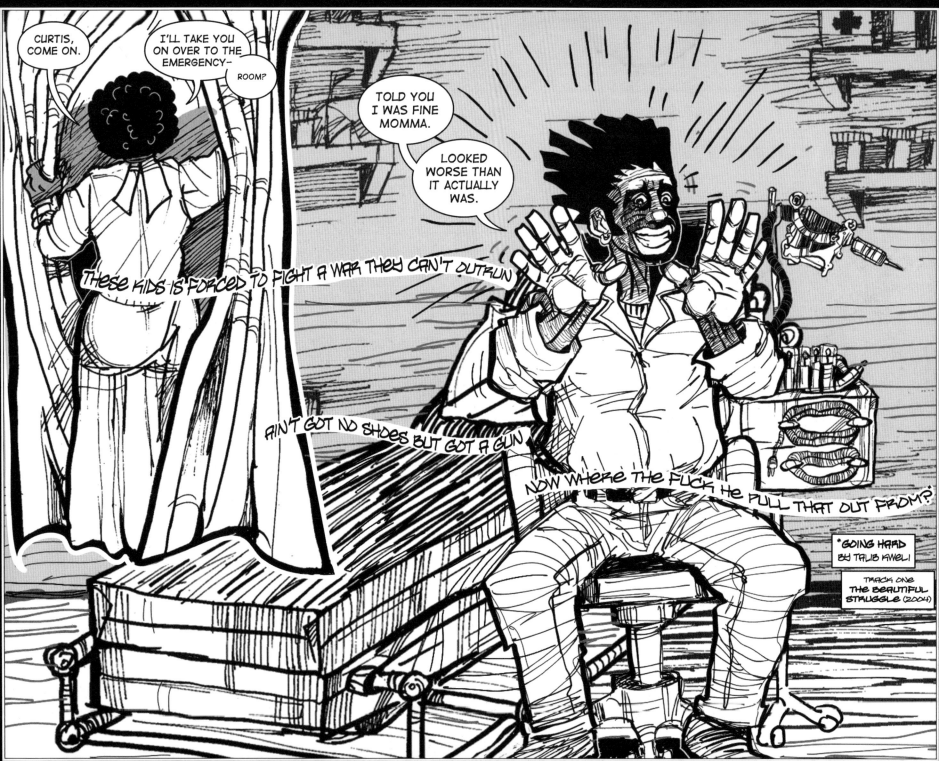

*GOING HARD
BY TALIB KWELI

TRACK ONE
THE BEAUTIFUL
STRUGGLE (2004)

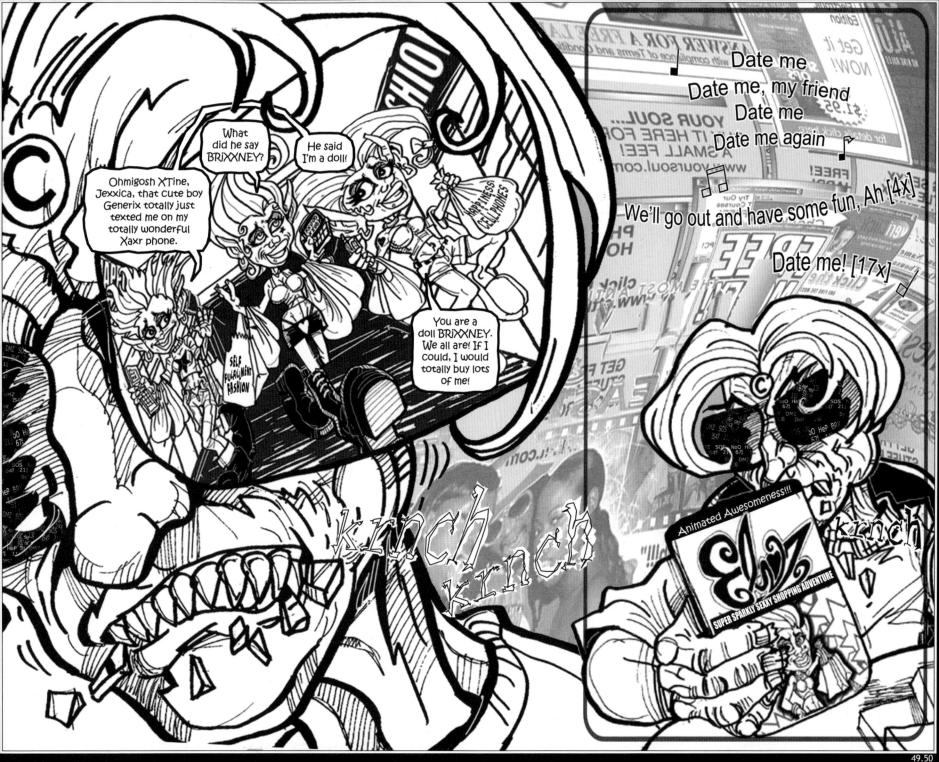

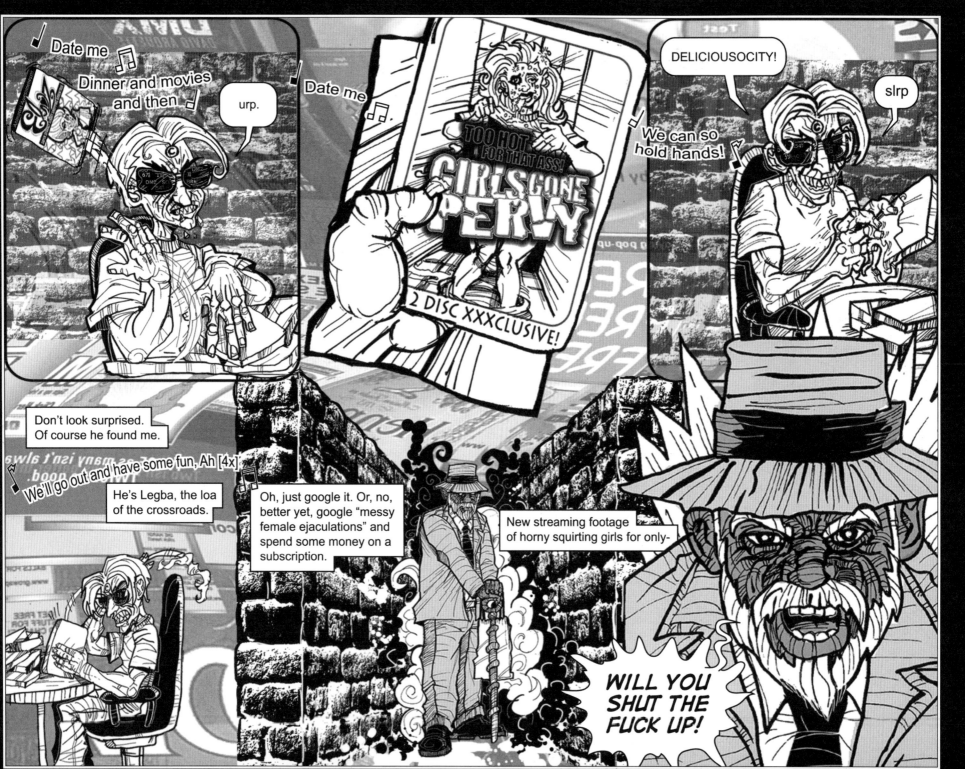

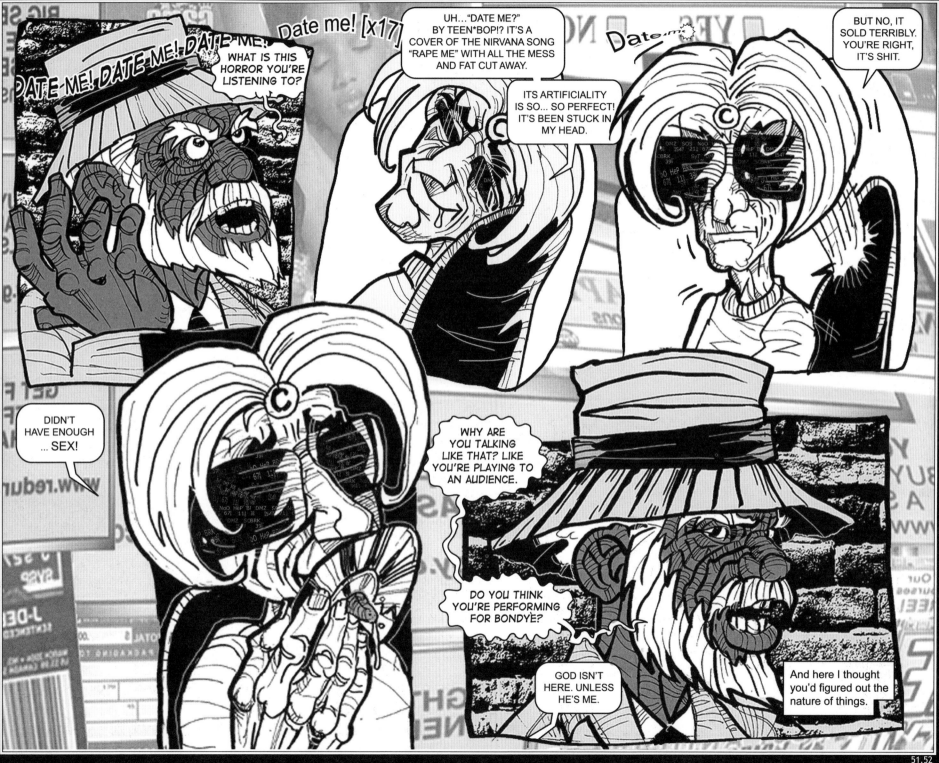

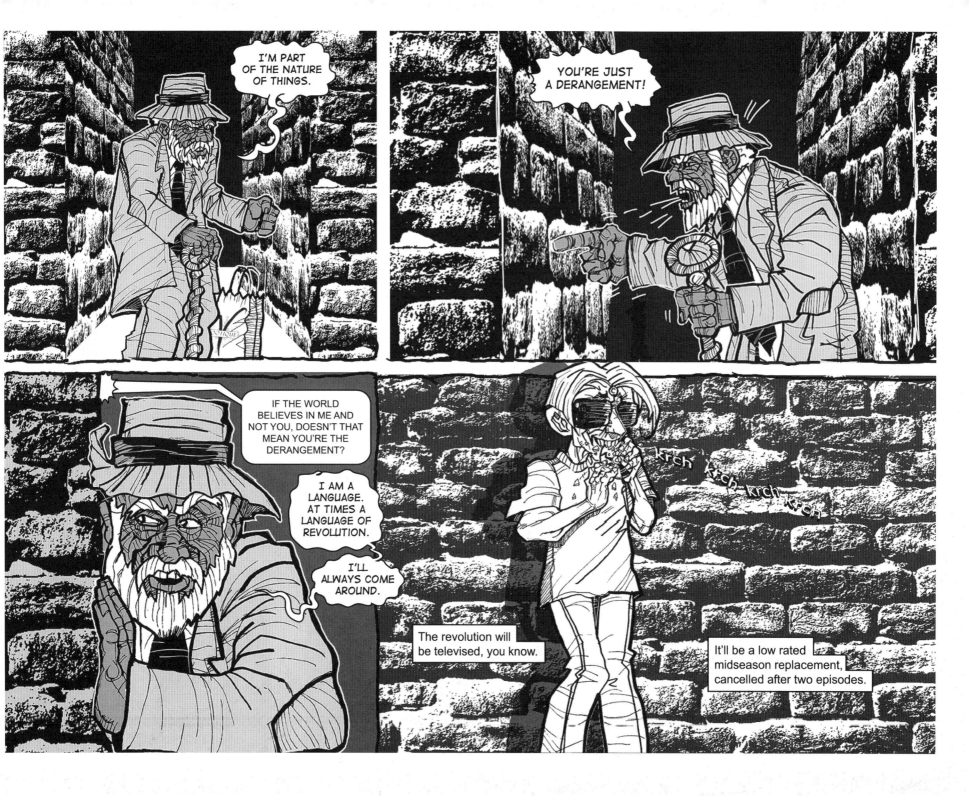

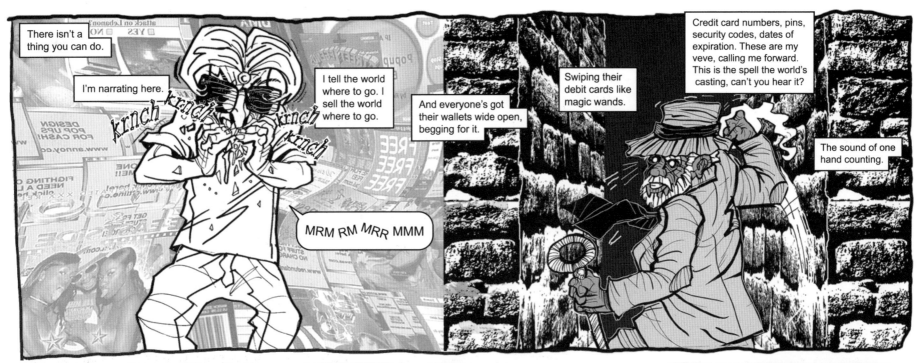

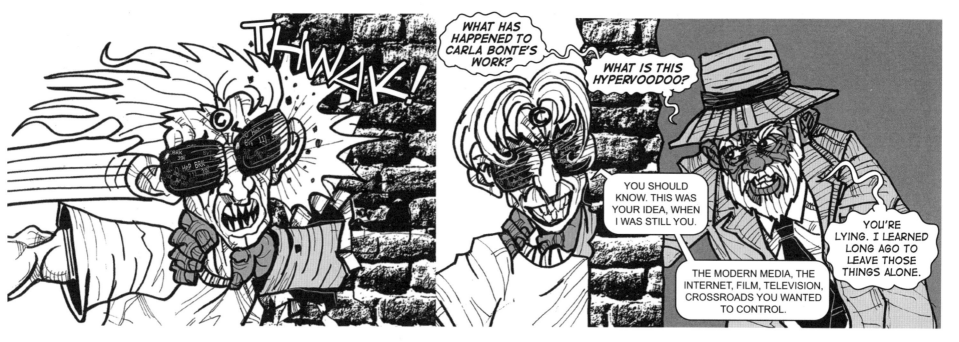

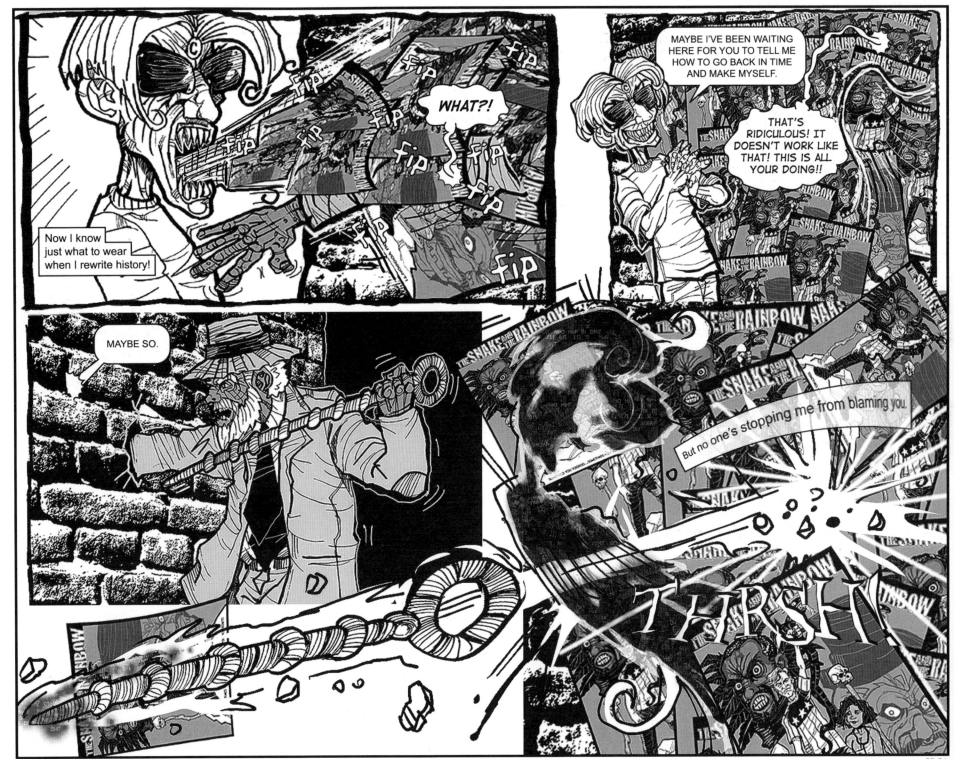

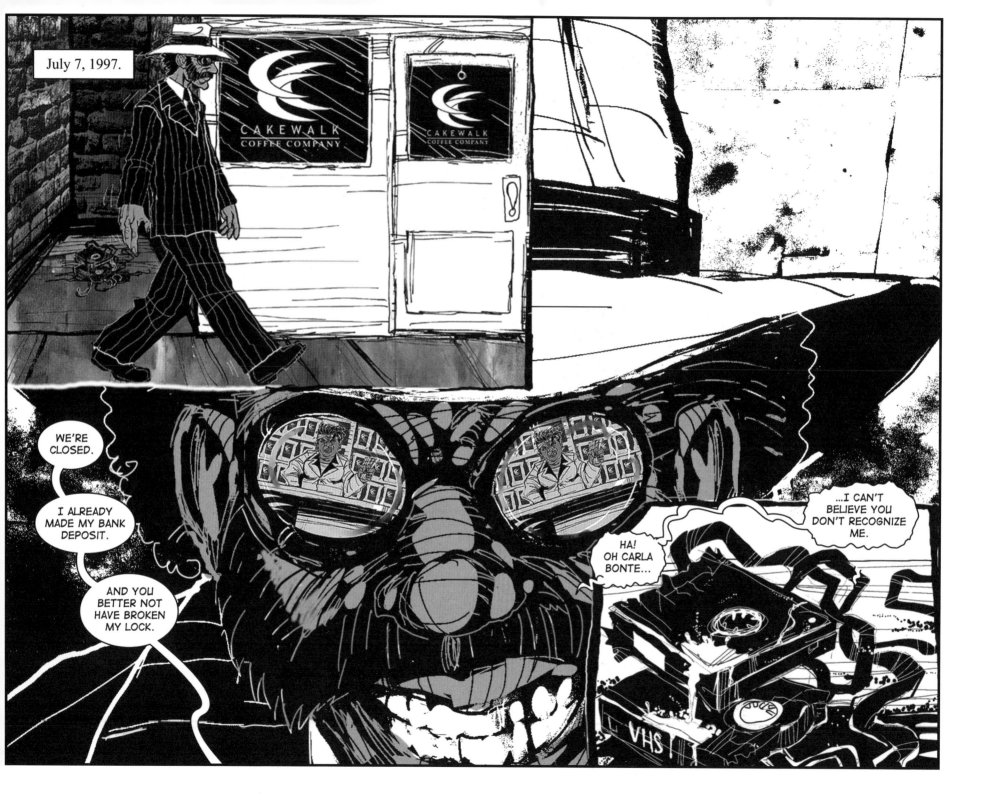

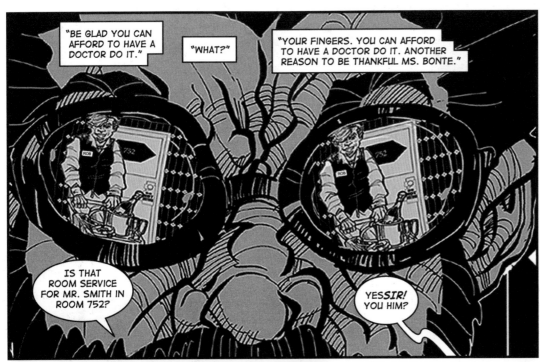

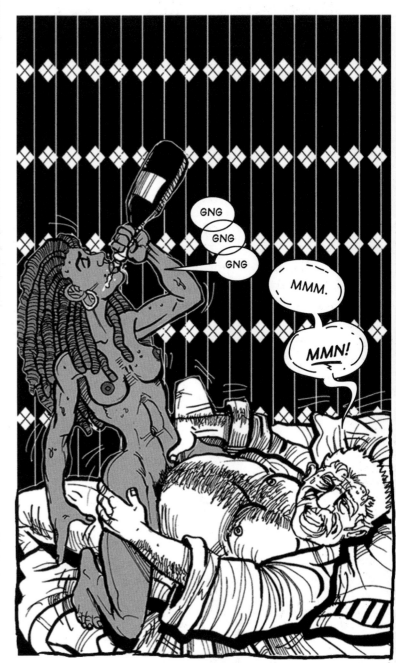

July 23, 1997.

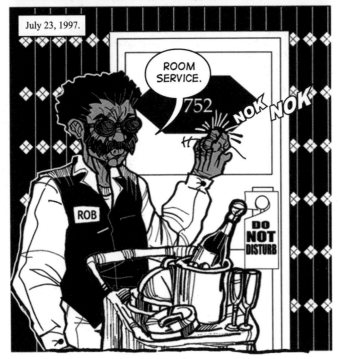

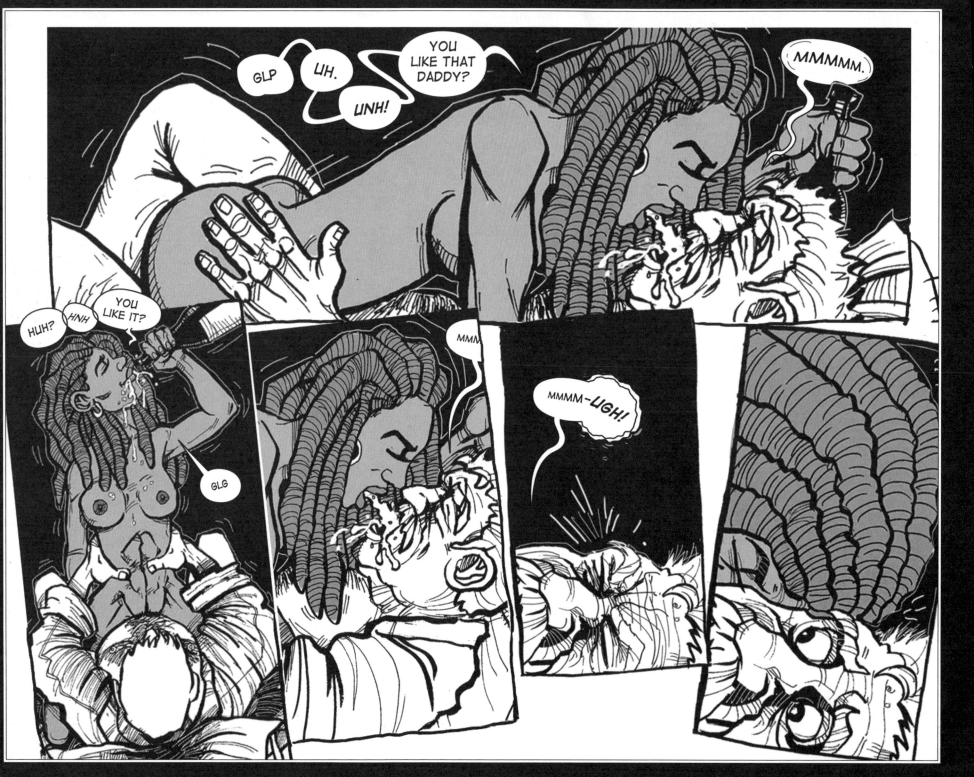

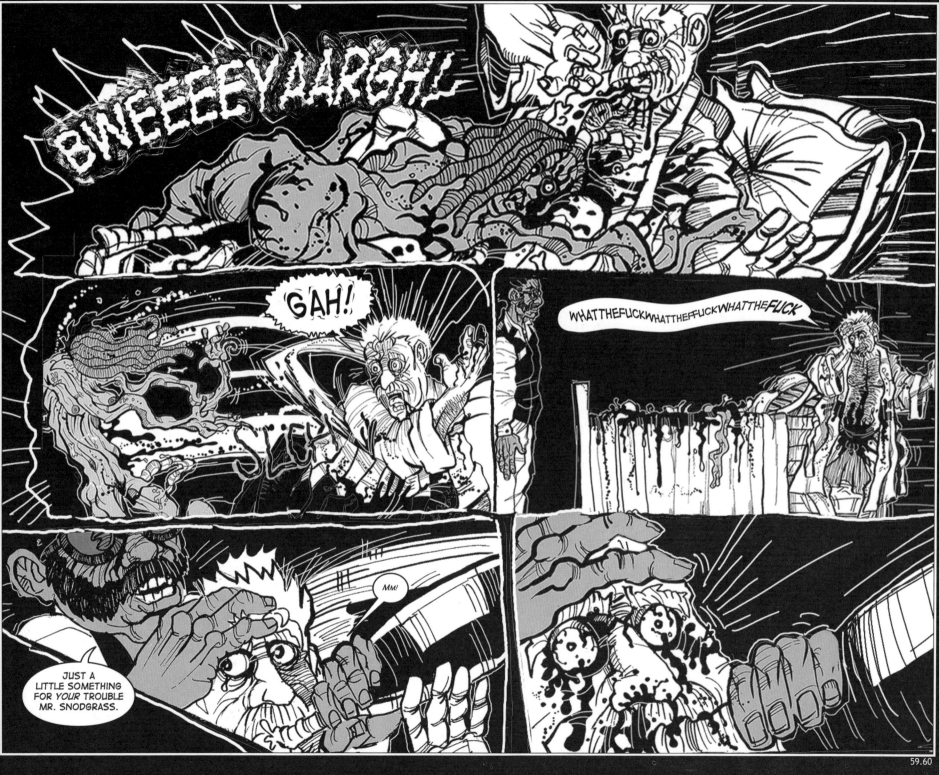

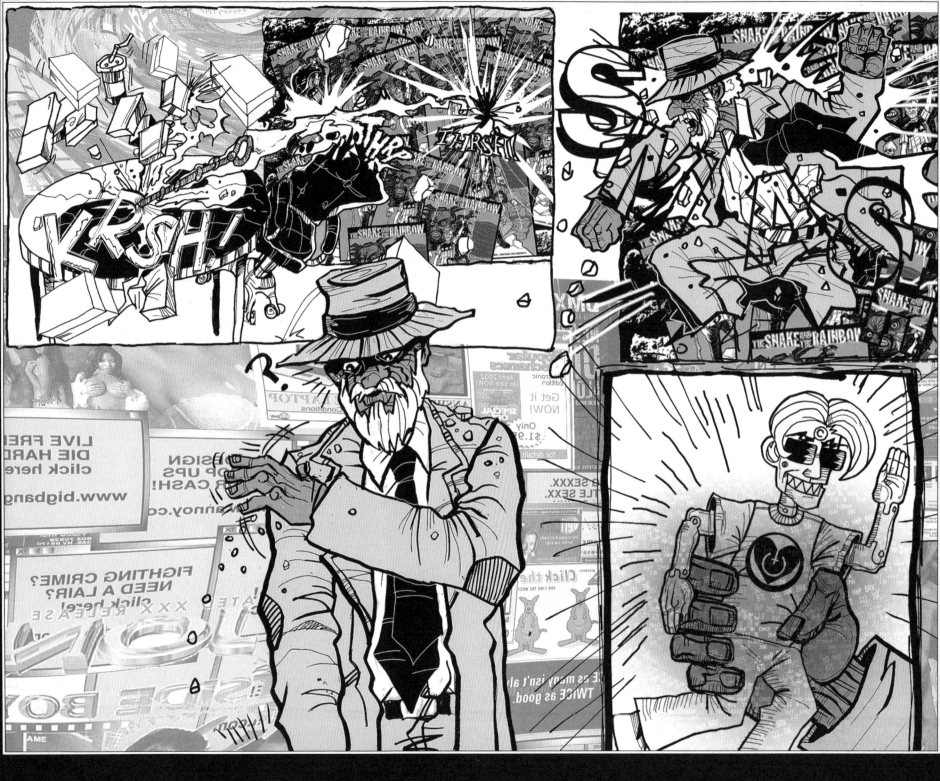

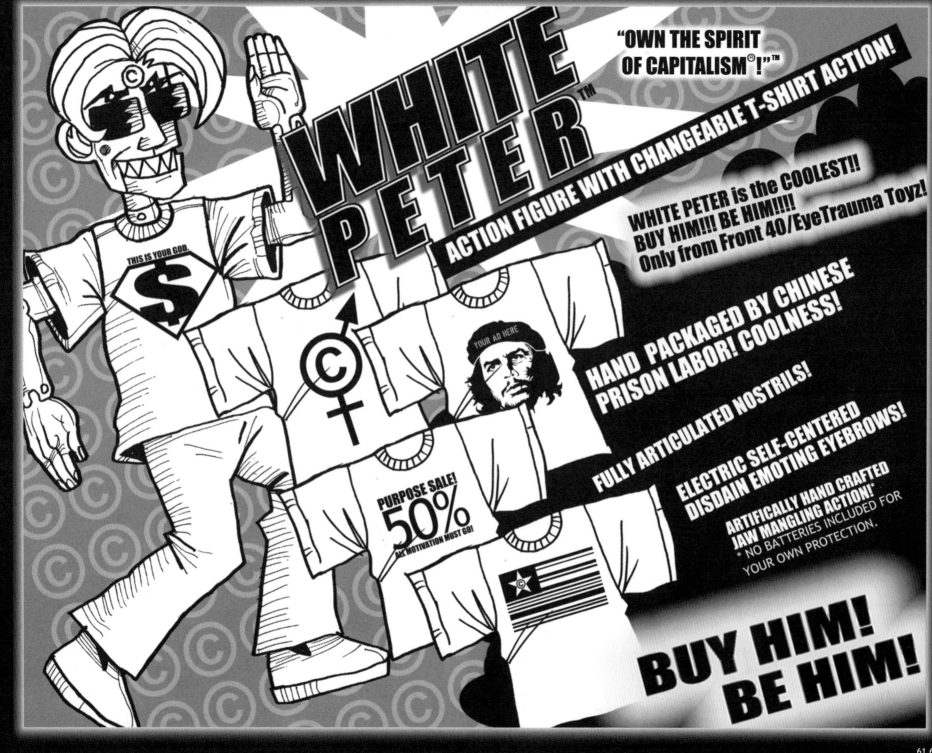

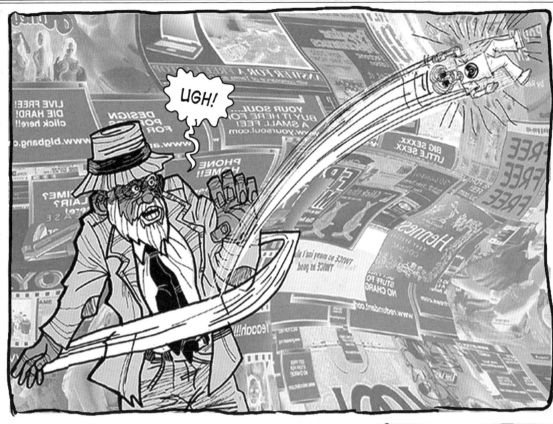

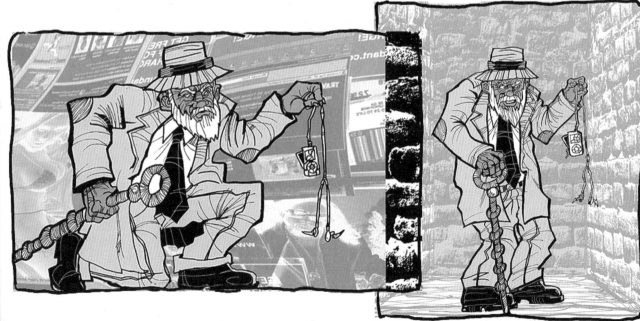

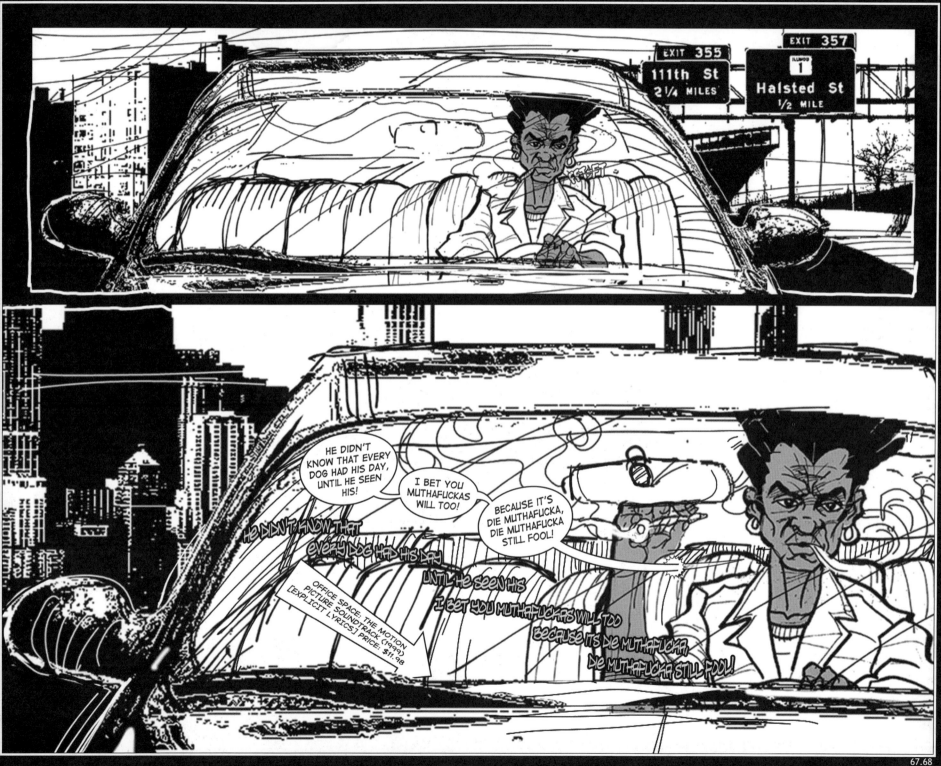

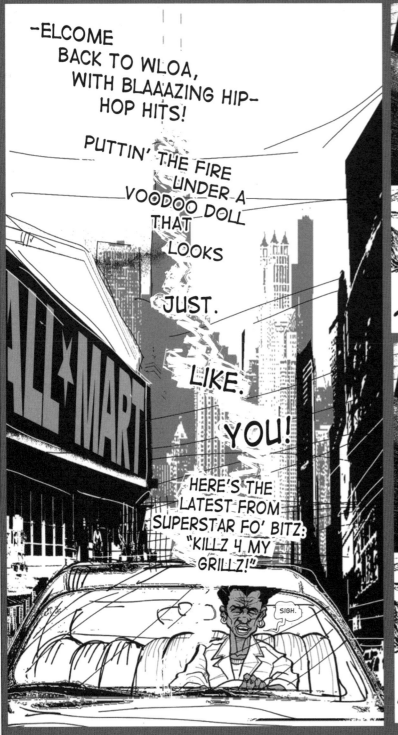

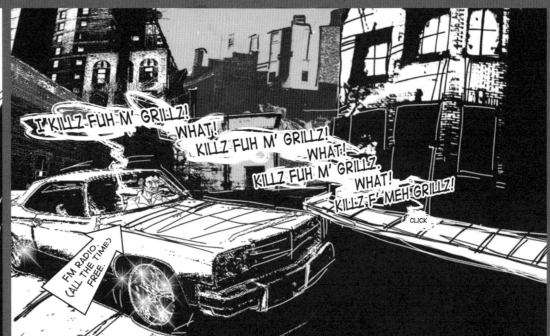

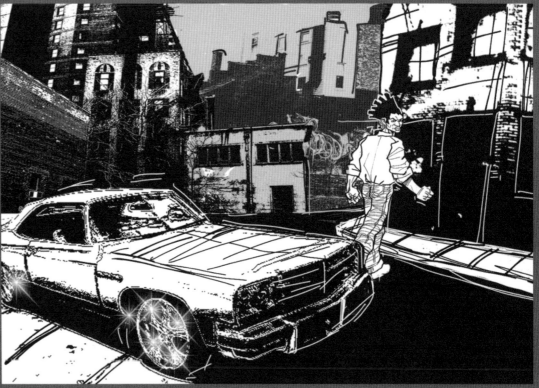

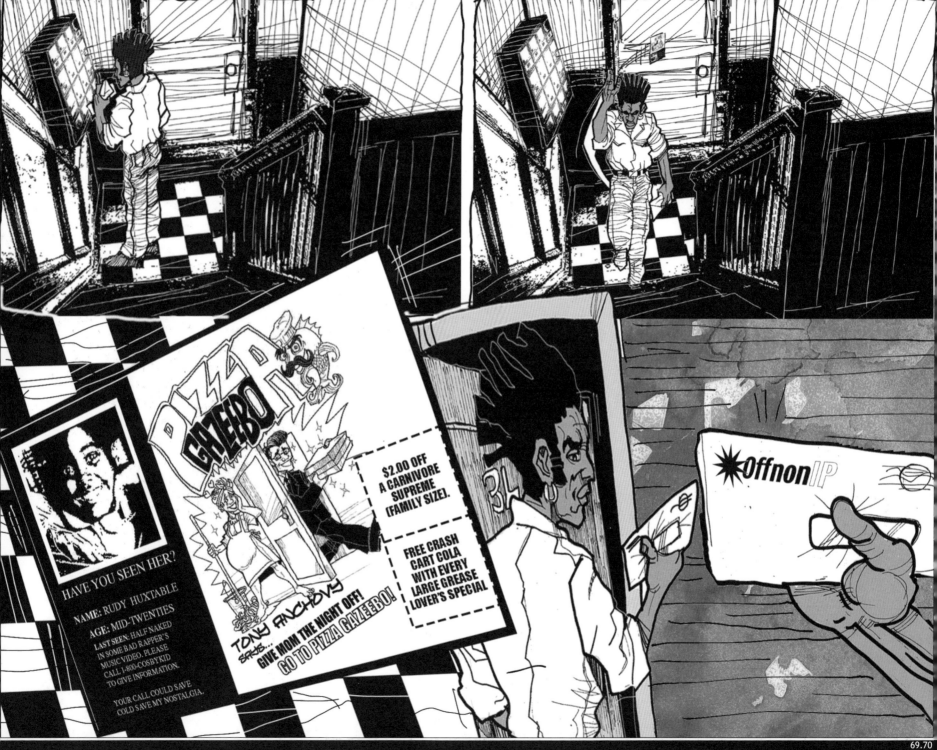

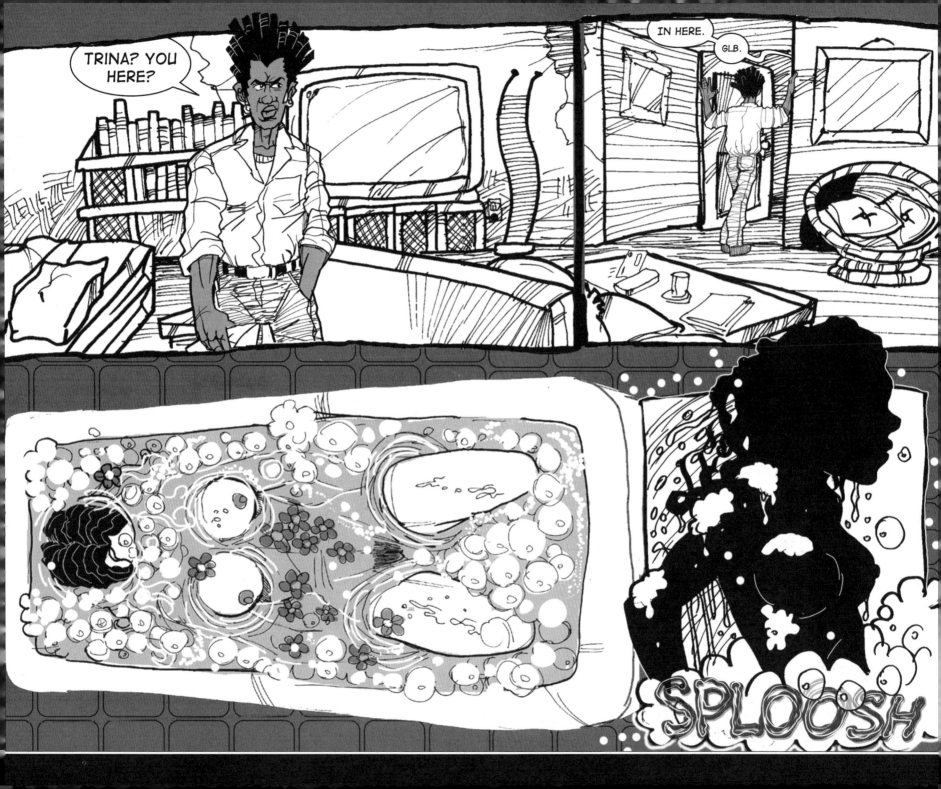

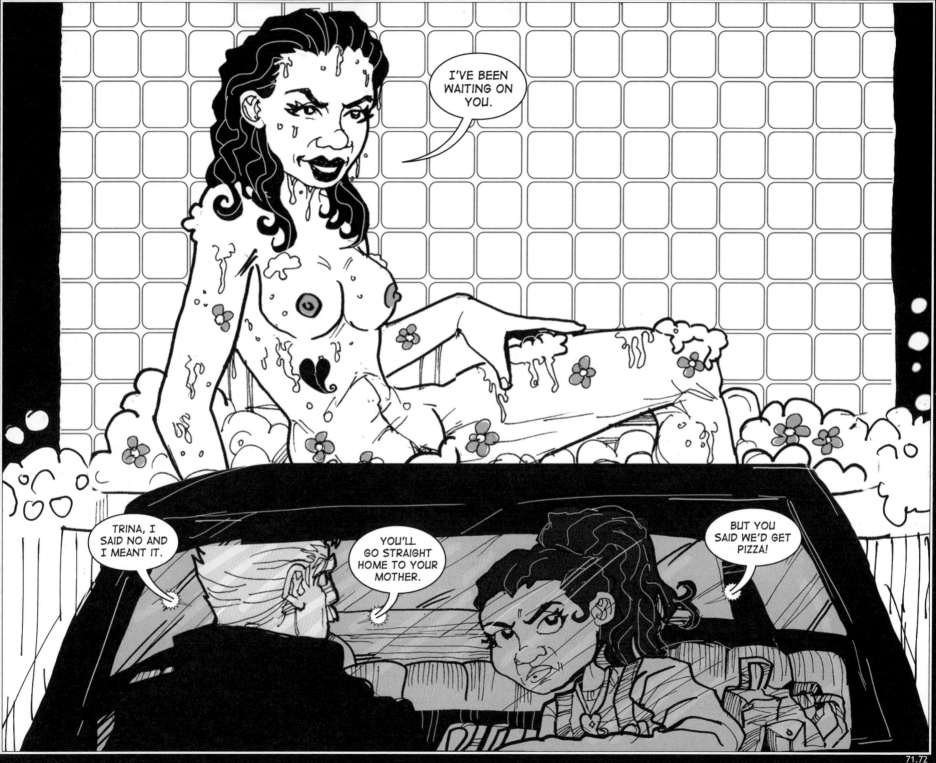

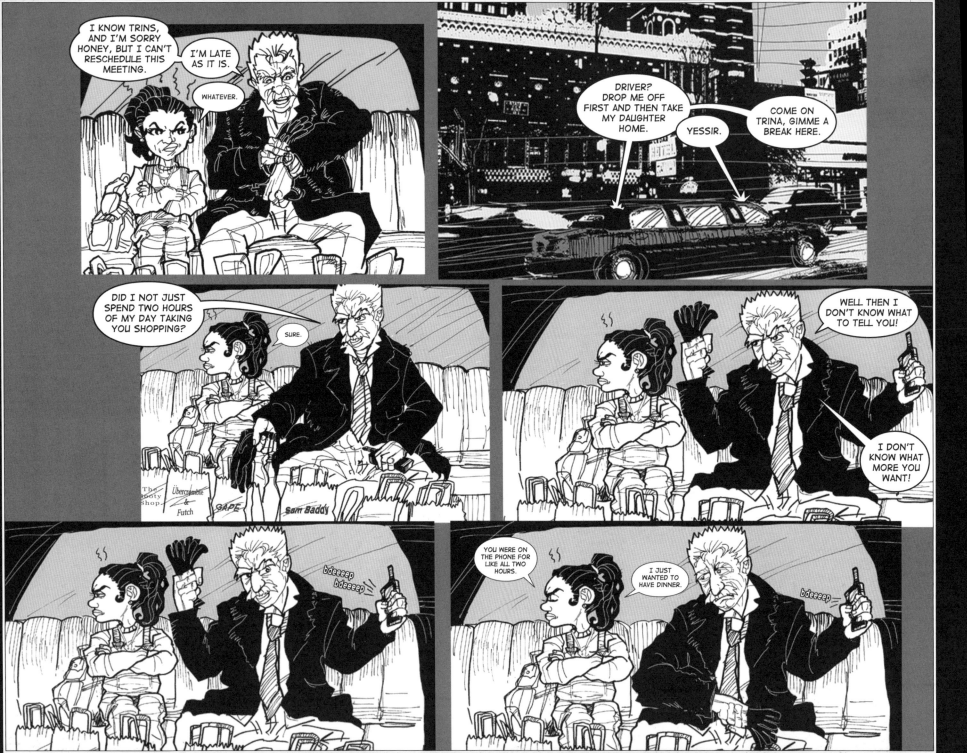

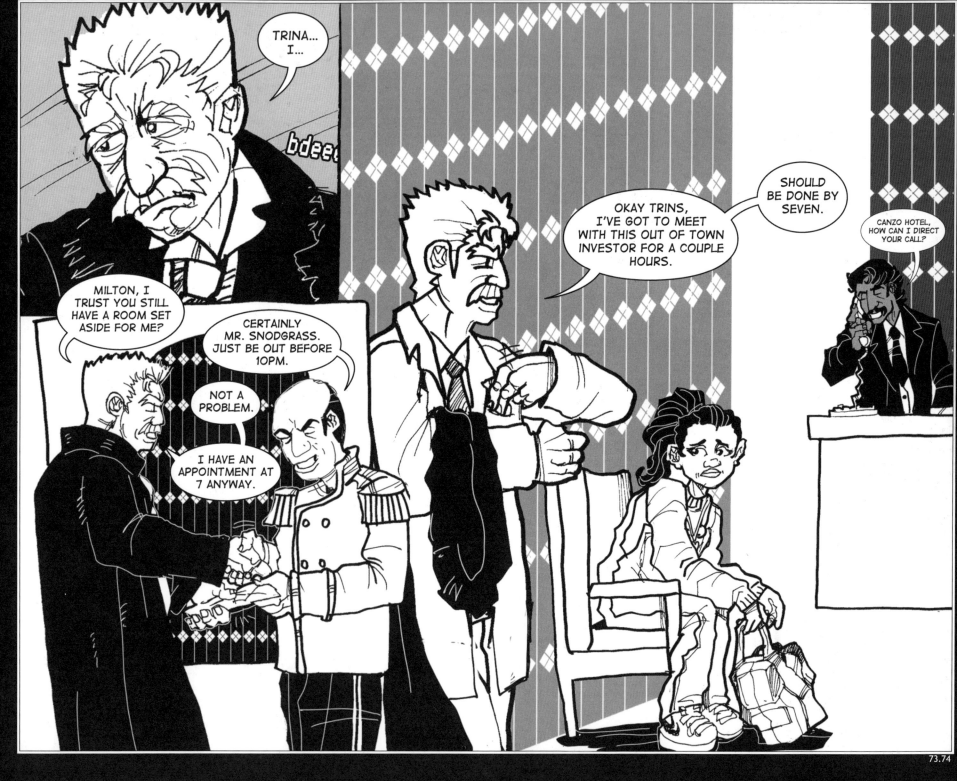

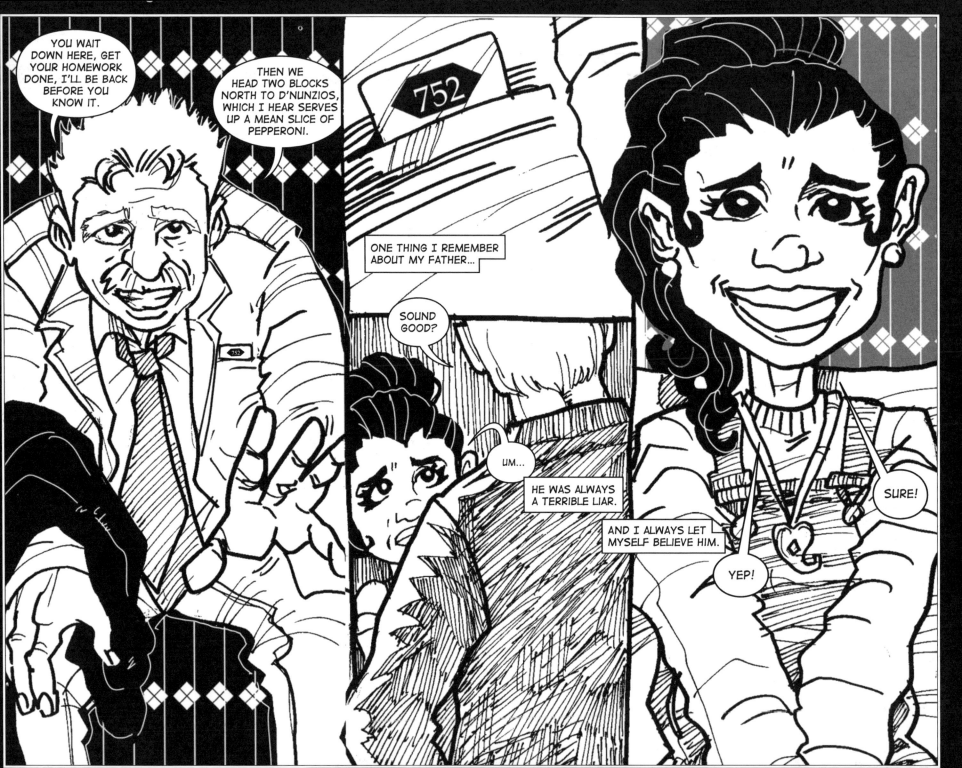

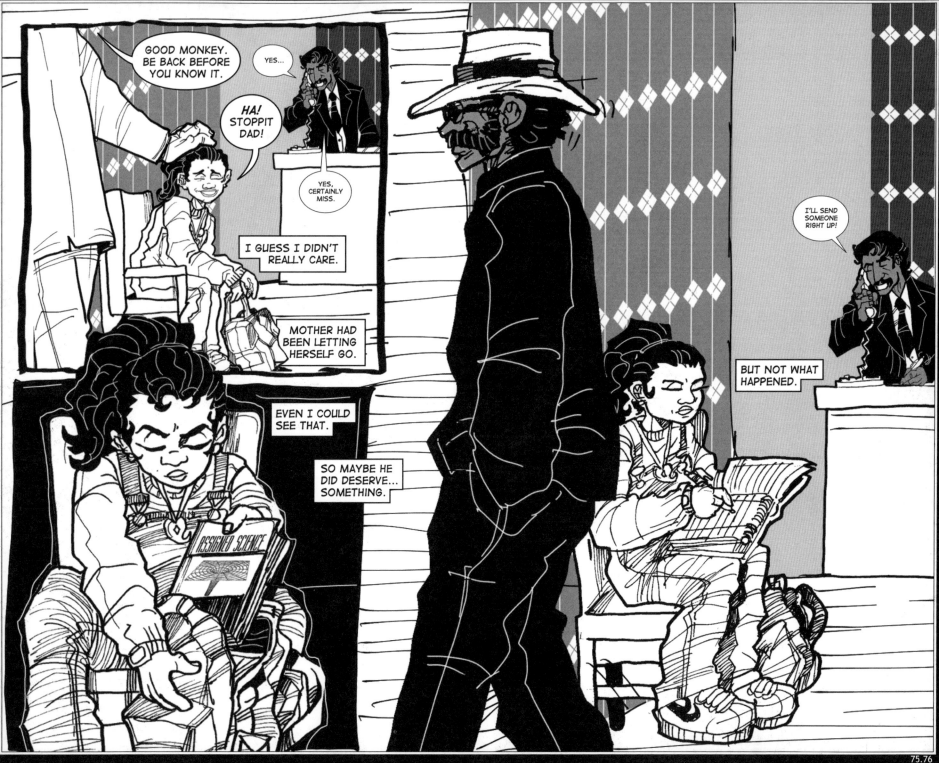

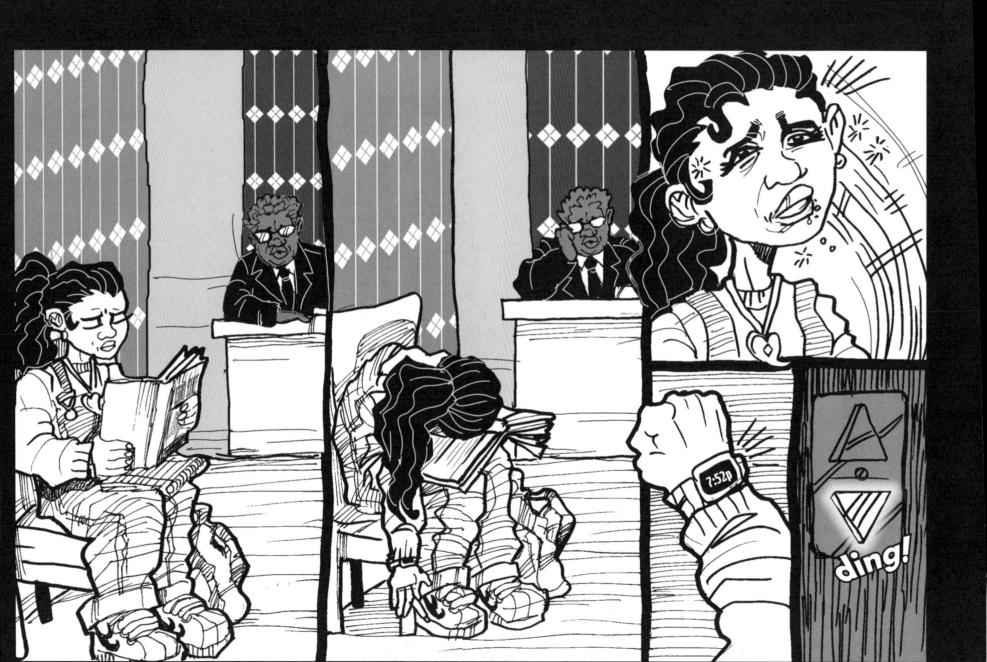

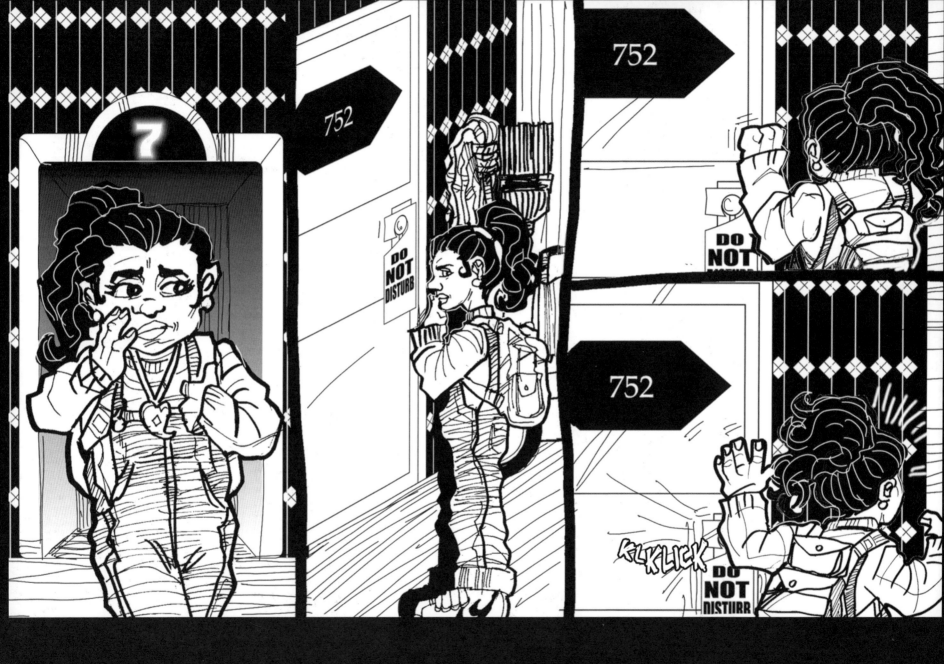

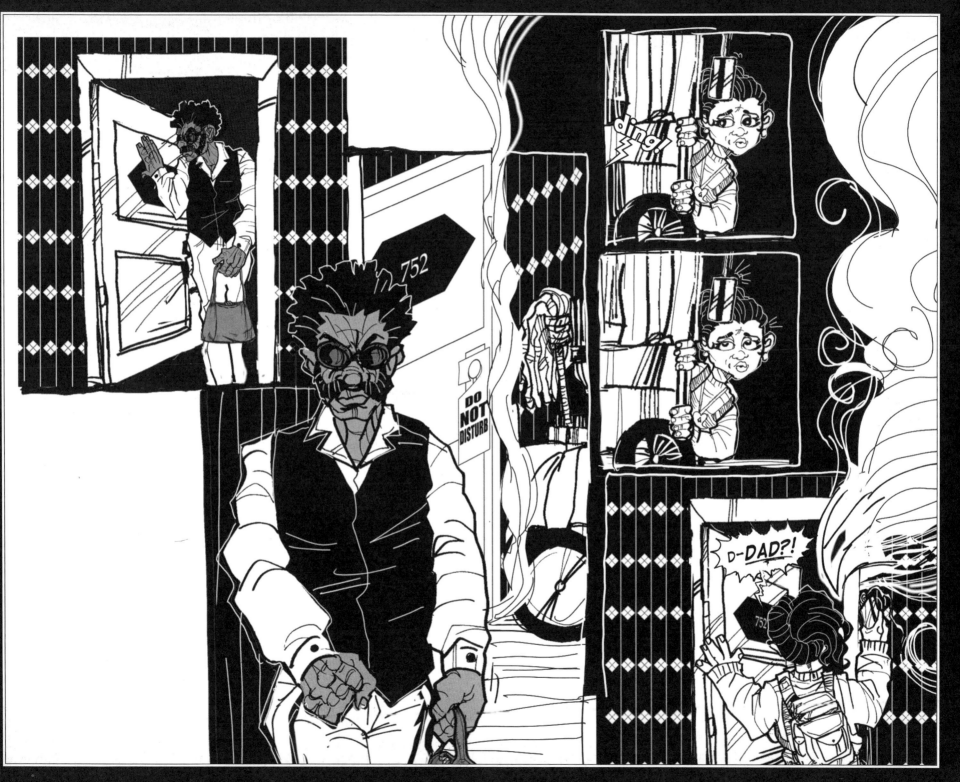

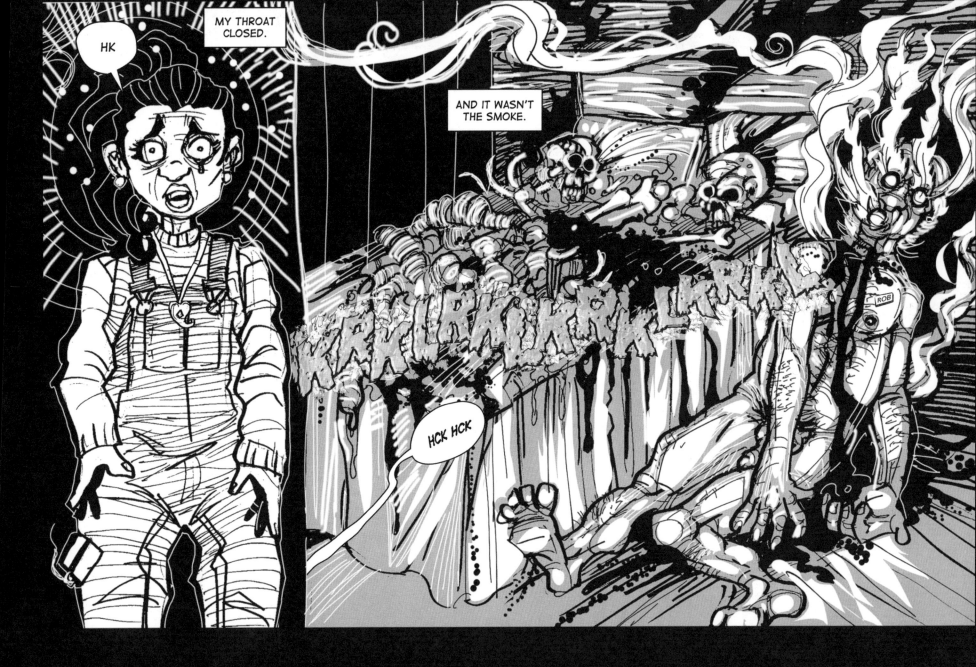

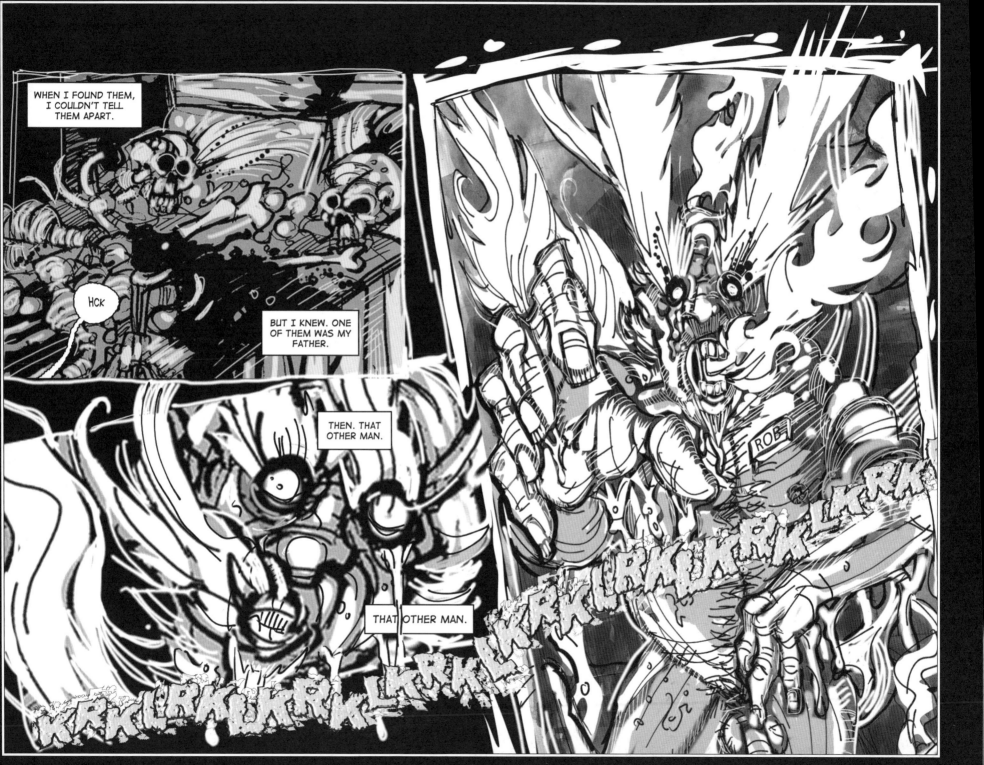

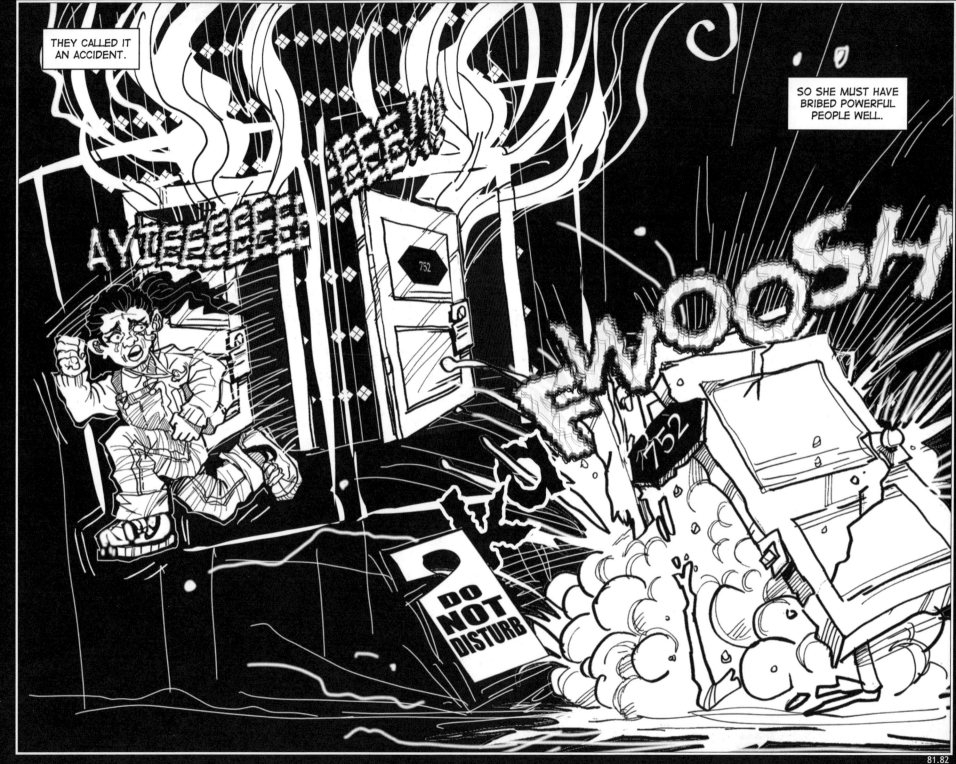

THE HOTEL WENT INTO
THE RED SOON AFTER.
CLOSED DOWN, REOPENED
UNDER A DIFFERENT NAME,
WENT BACK INTO THE BLACK.

I GUESS I RAN AWAY. THE
LAST THING I REMEMBER IN
THE HOTEL WAS THE FIRE
ALARM FINALLY GOING OFF.

IT ALL SHAKES LOOSE IN
MY HEAD AFTER THAT.

I WAS IN A PUBLIC BATHROOM, SCRUBBING THE SOOT OFF MY FACE BECAUSE SOME OF IT USED TO BE HIM.

SOMEHOW I PUT MYSELF ON A TRAIN THAT GOT ME CLOSE TO HOME.

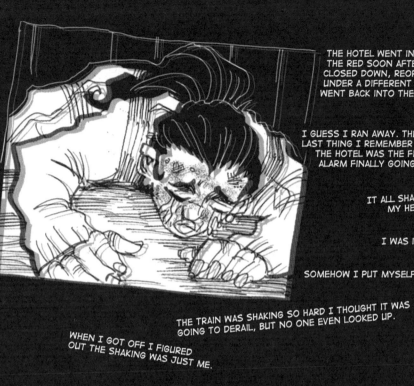

THE TRAIN WAS SHAKING SO HARD I THOUGHT IT WAS
GOING TO DERAIL, BUT NO ONE EVEN LOOKED UP.

WHEN I GOT OFF I FIGURED
OUT THE SHAKING WAS JUST ME.

I GOT HOME AND I MUST HAVE LOOKED
TERRIBLE BUT OUR MAID INEZ DIDN'T
EVEN NOTICE, SHE WAS SO WORRIED
ABOUT MY MOTHER.

MOTHER WAS IN THE HOSPITAL.
SOME ACCIDENT AT THE STORE.
BUT ALL I COULD THINK WAS
THAT HE'D GOTTEN HER TOO.
HE WAS KILLING MY FAMILY
AND I WAS NEXT.

I DIDN'T TELL INEZ ANYTHING.
MY THROAT WAS CLOSED AGAIN,
AND WHAT COULD I SAY THAT
ANYONE WOULD BELIEVE.

I MADE HER TAKE ME TO SEE MOTHER.
AND THERE HE WAS, JUST AS I FEARED.

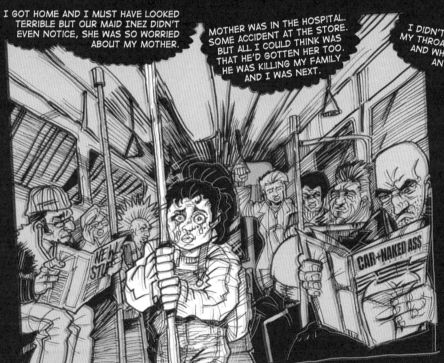

OH TRINA. IT
WAS THE STRANGEST
THING. THE DELIVERY
DOOR JUST FELL
DOWN AND...

WELL, DON'T
WORRY SWEET
DAUGHTER, I STILL
HAVE ONE GOOD HAND
TO HOLD YOU WITH.

GET
BETTA

WORSE THAN
I FEARED.

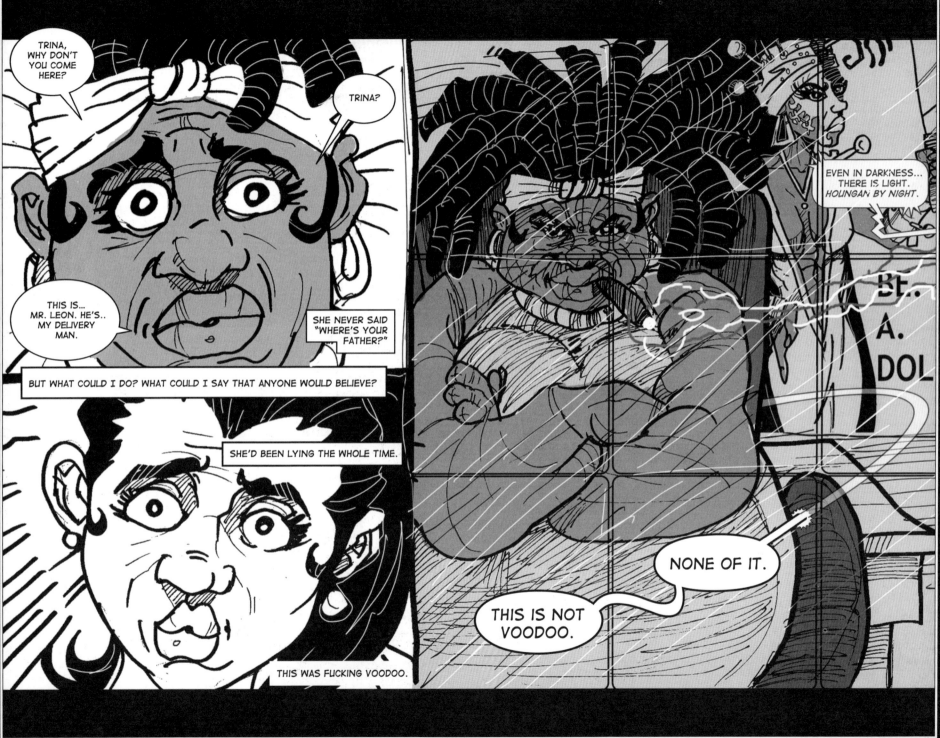

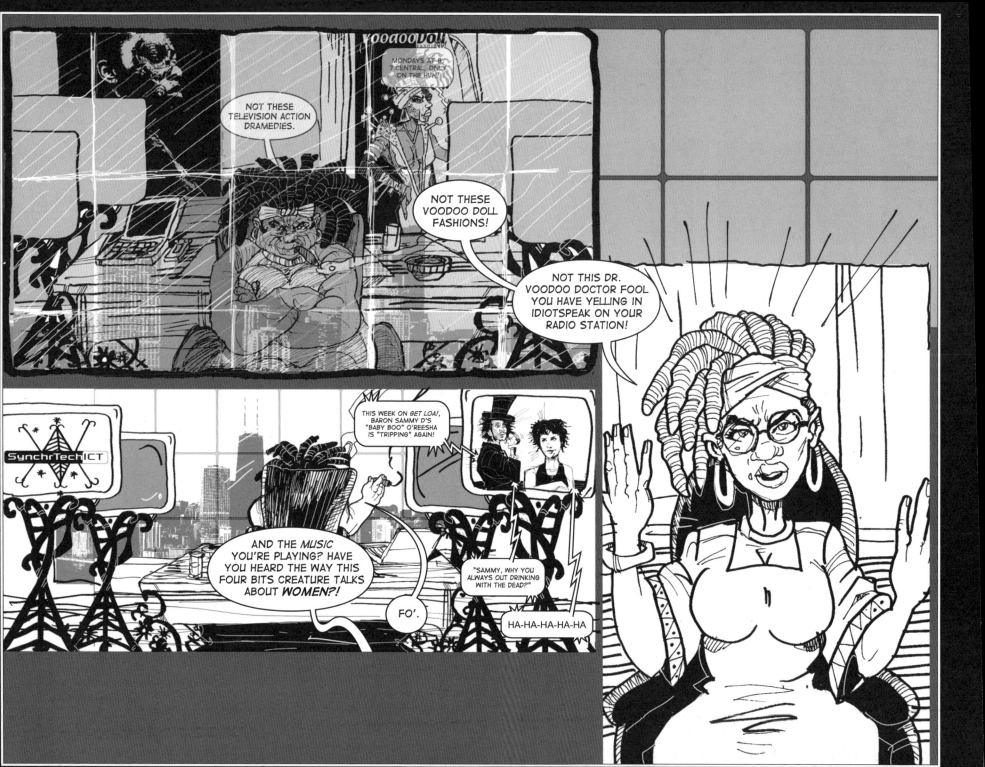

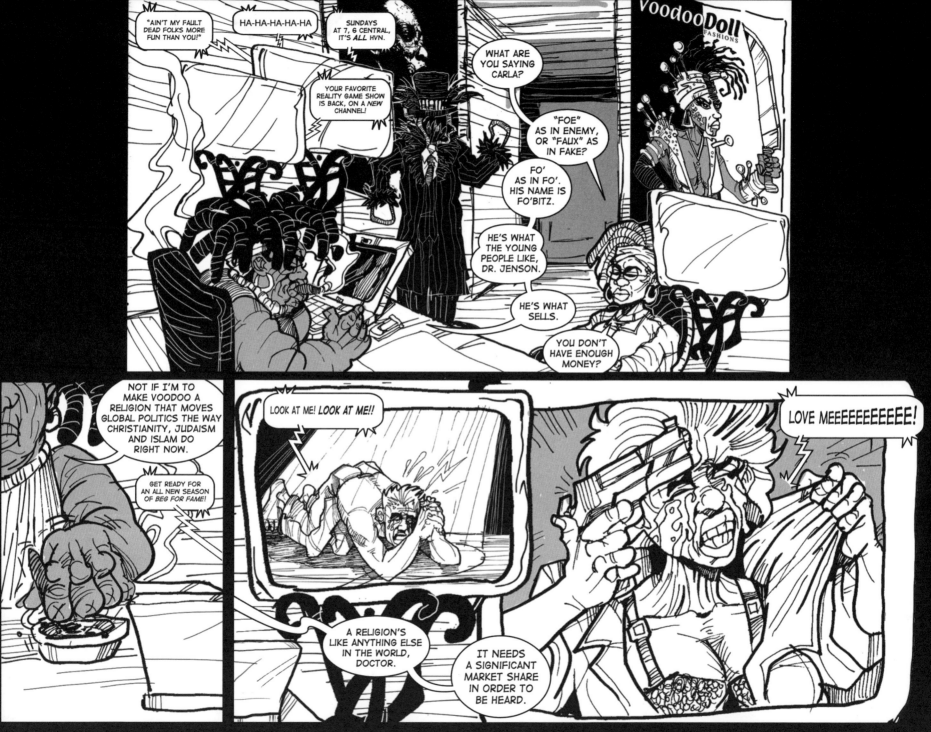

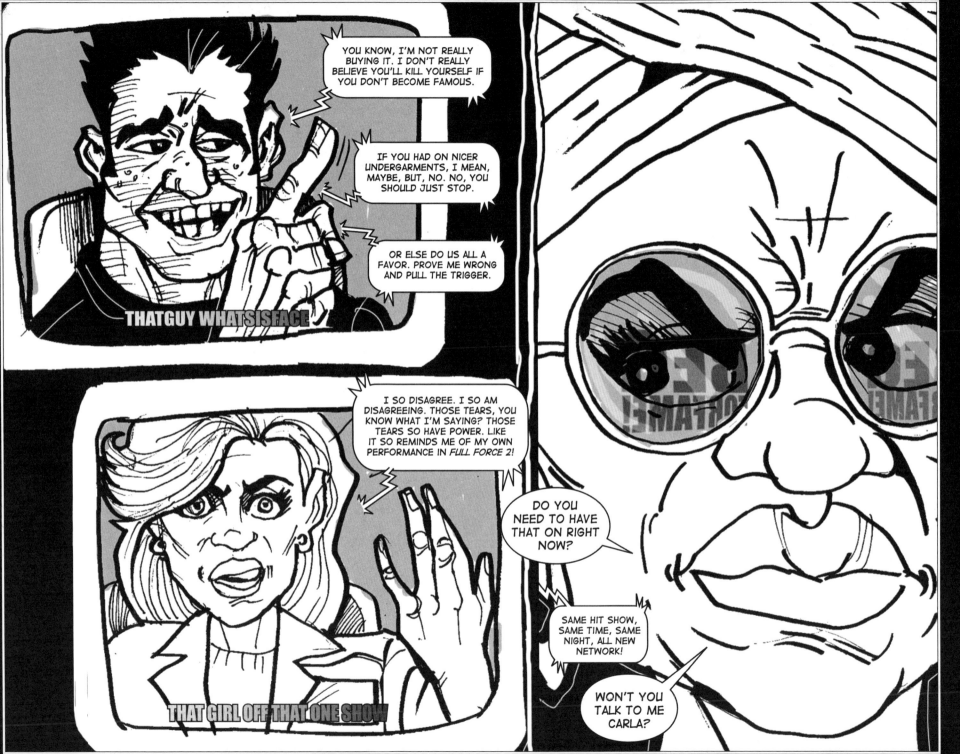

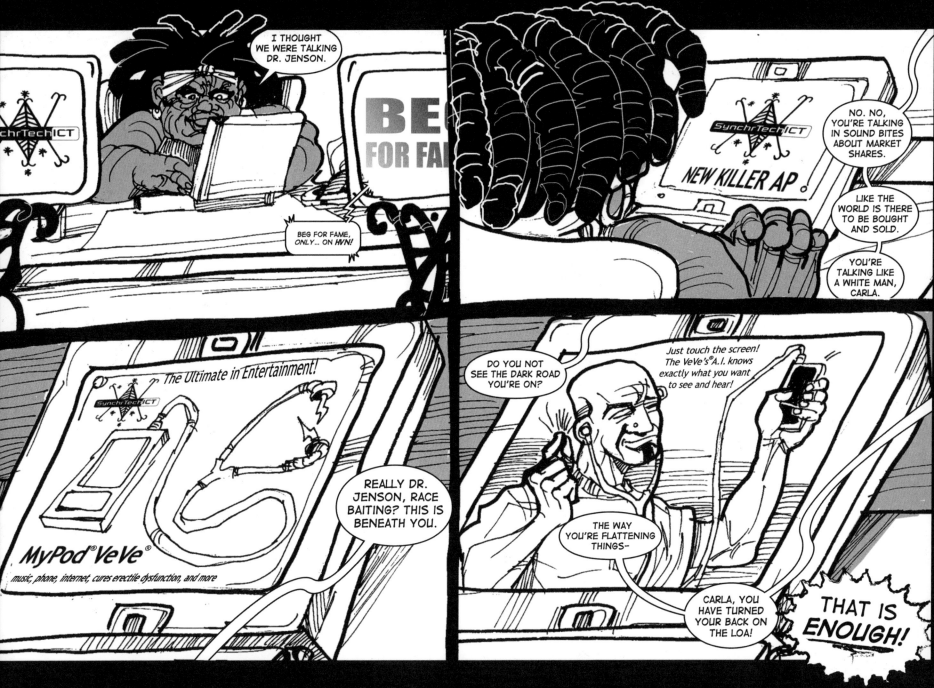

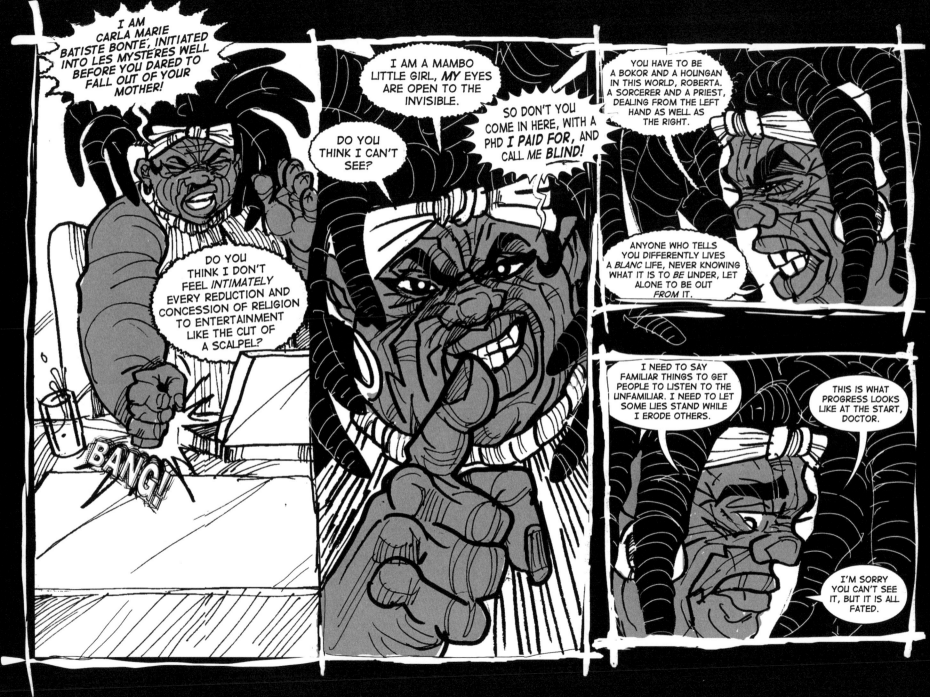

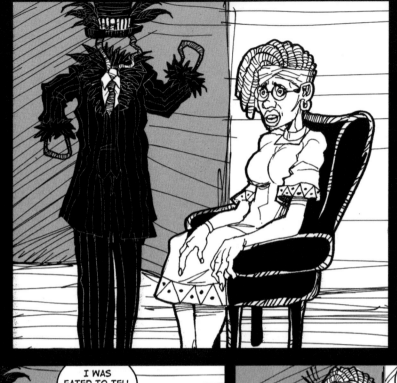

"FATED."

I WAS FATED TO TELL YOU THIS IS WRONG.

I PRAYED IT WAS YOUR DESTINY TO LISTEN.

BUT I SEE NOW. I SEE NOW.

YOU ARE COMPLETELY LOST.

SLAM!

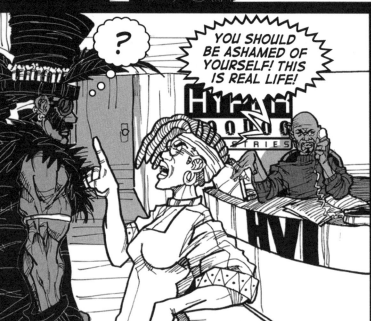
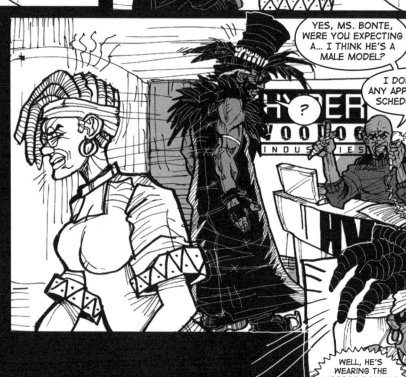

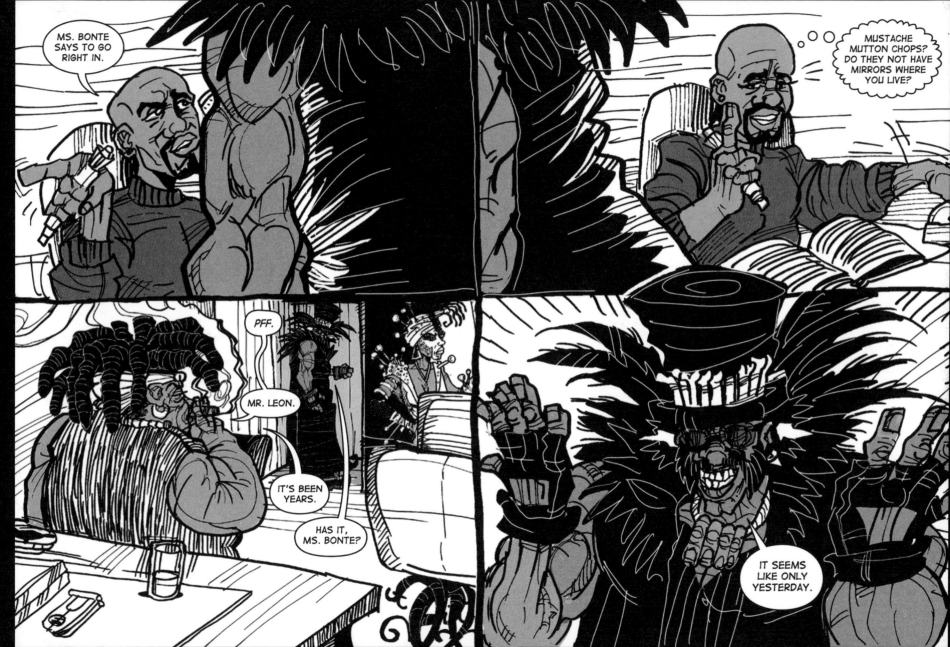

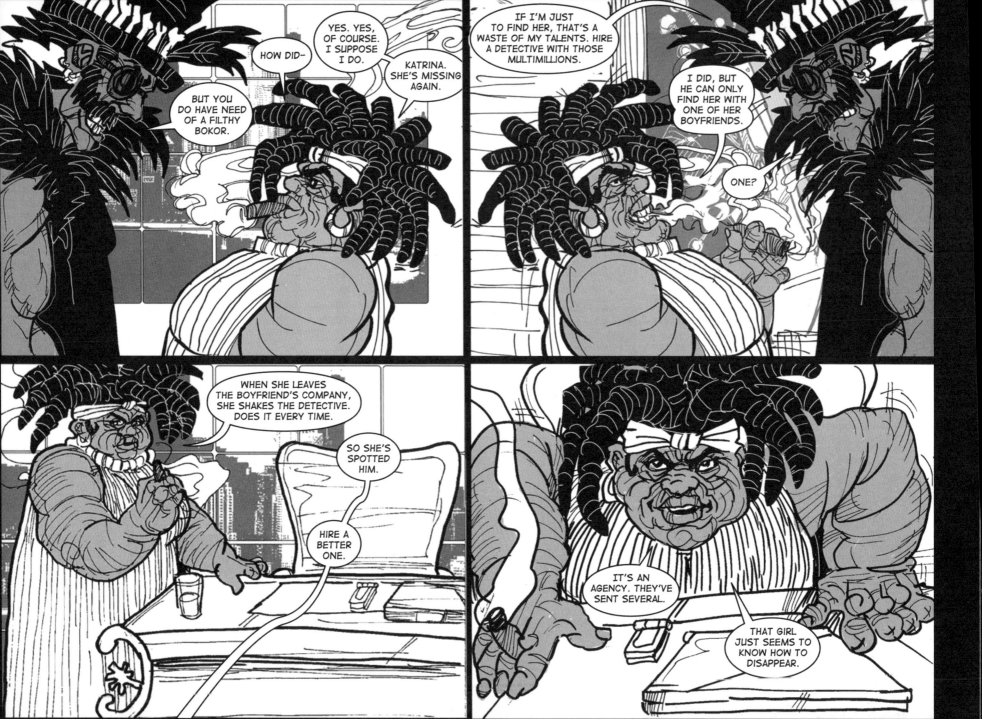

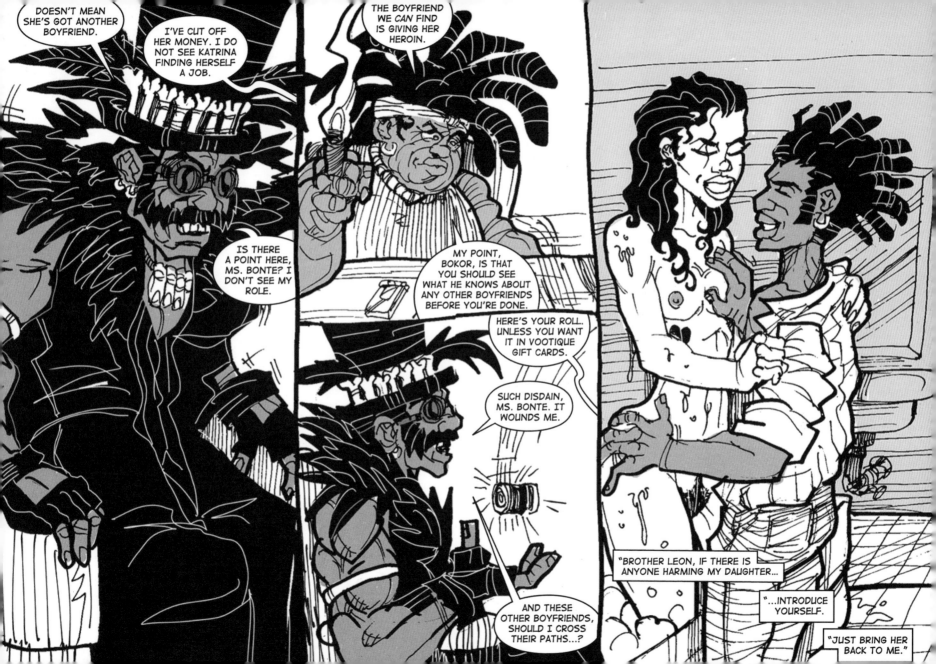

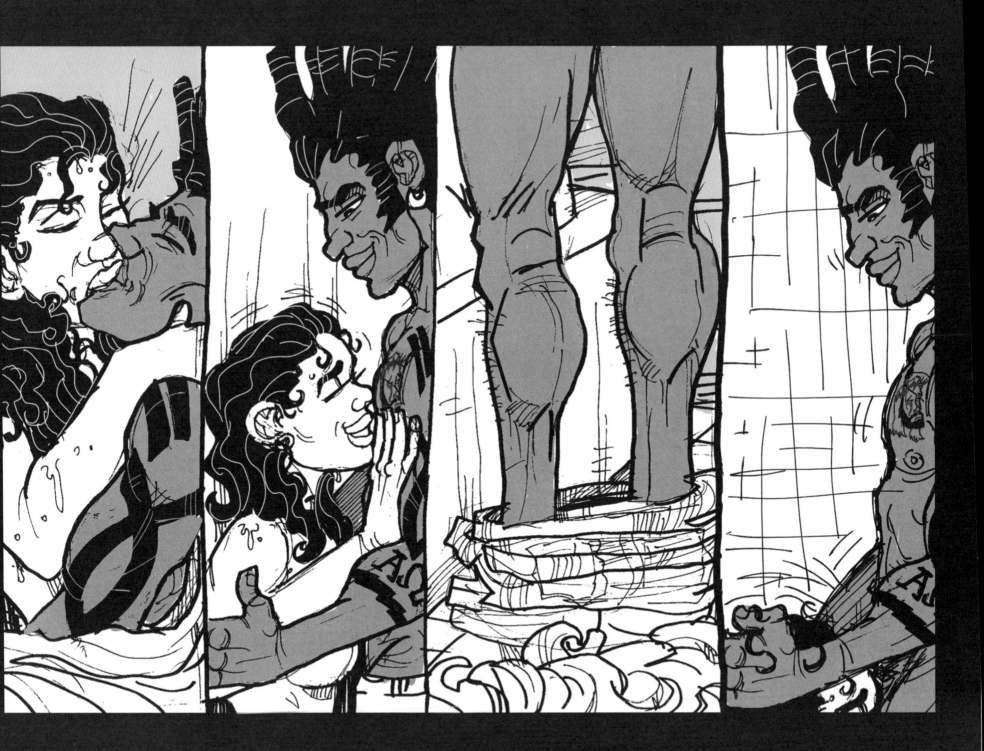

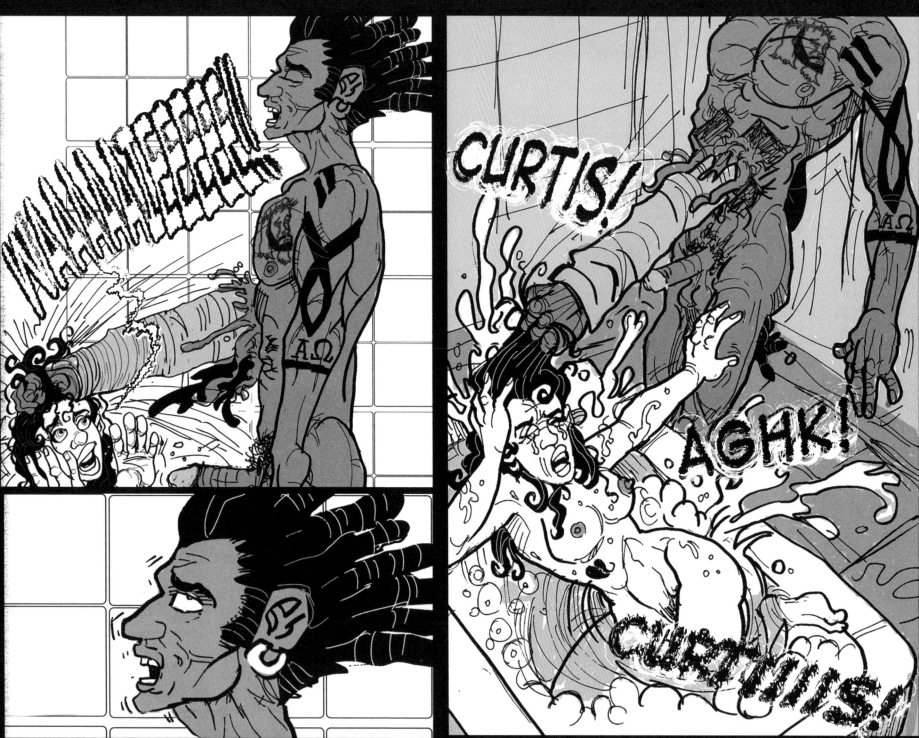

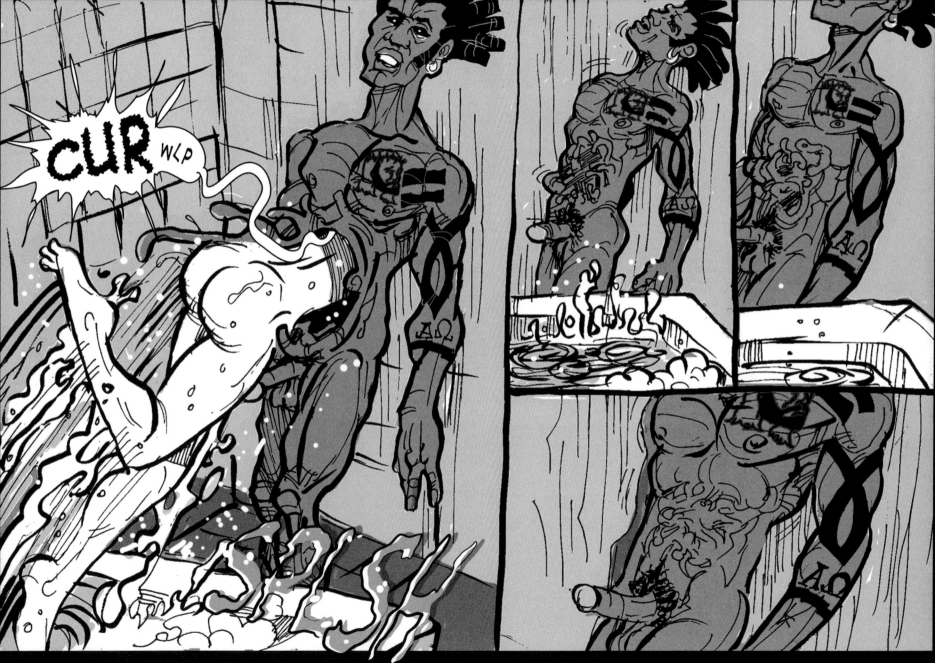

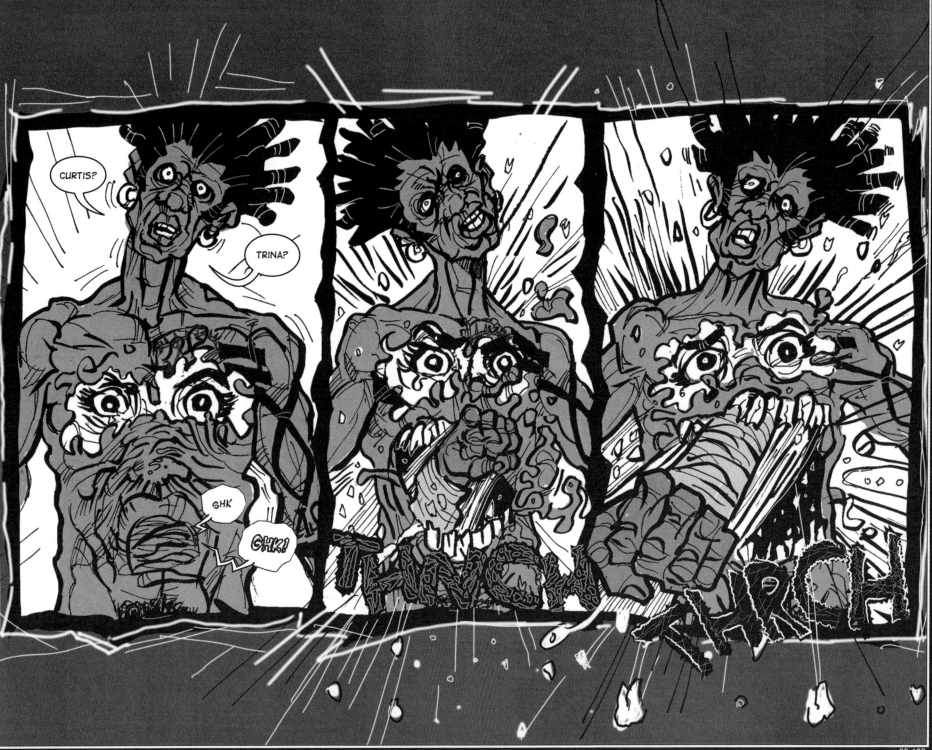

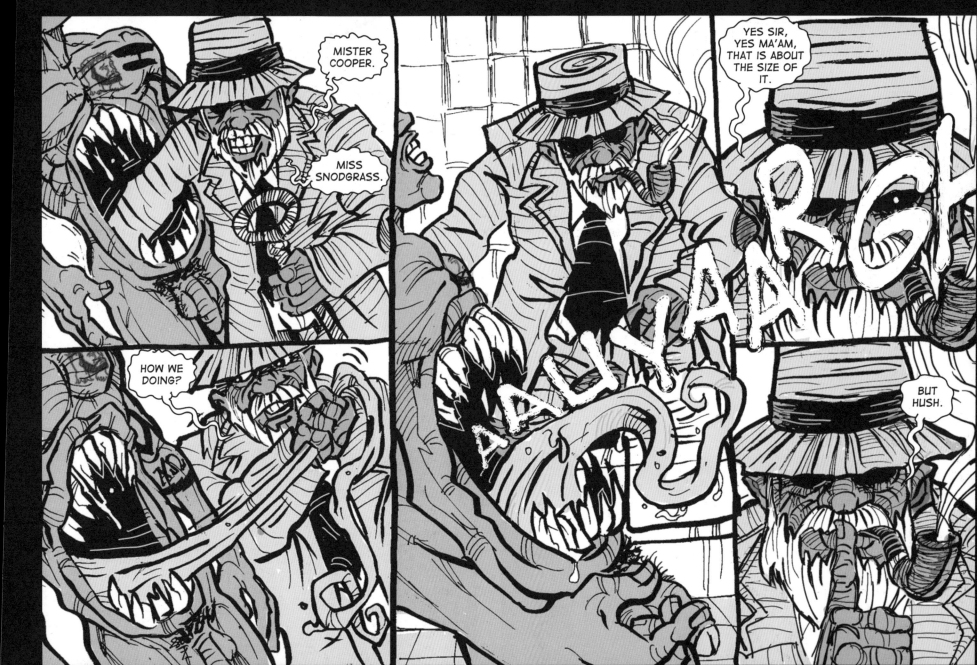

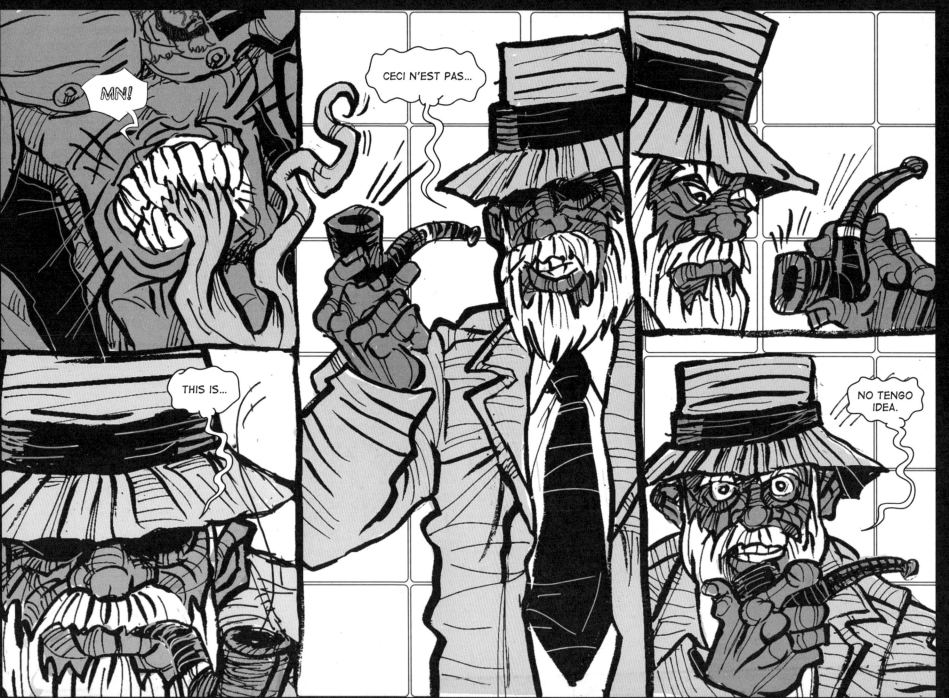

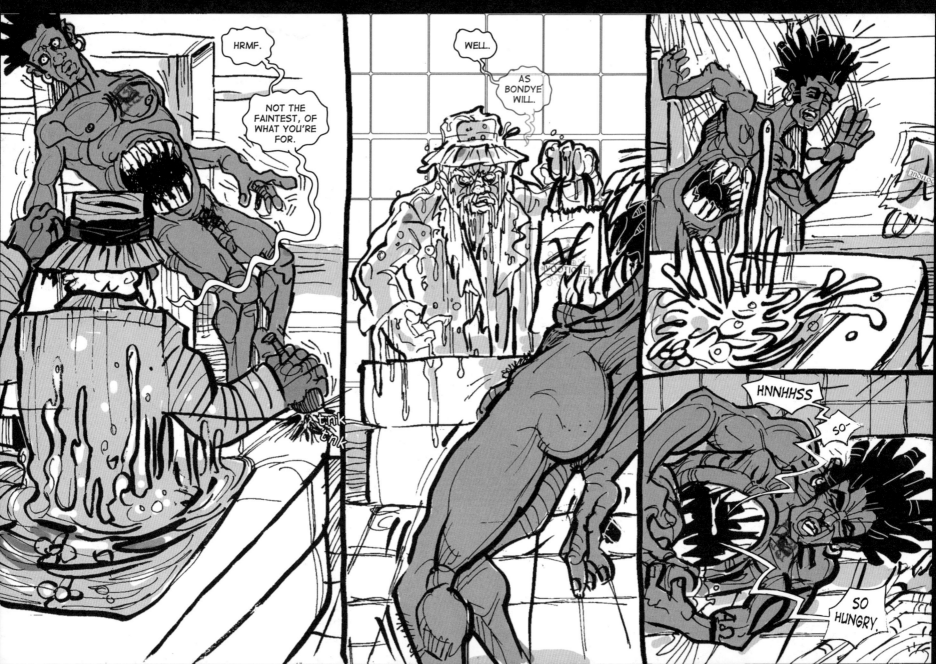

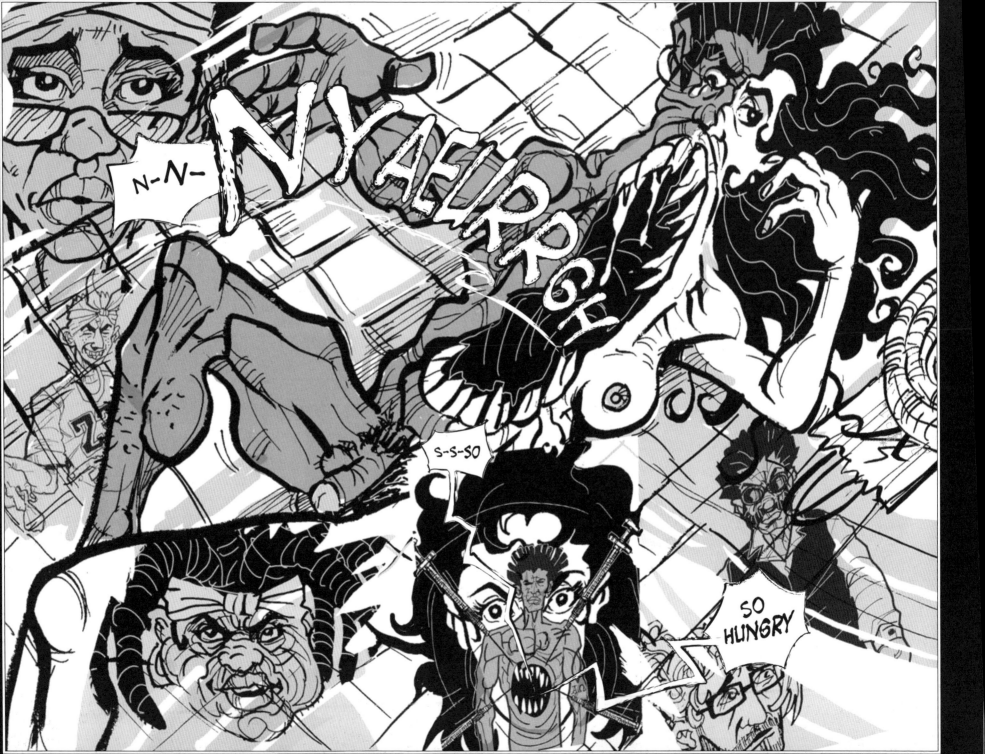

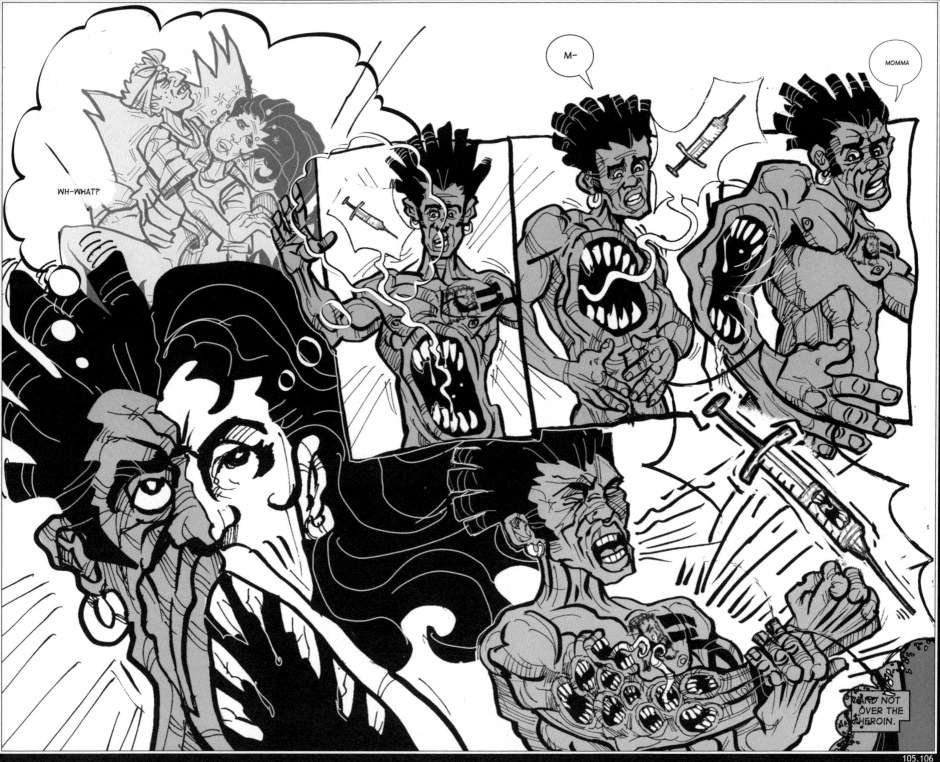

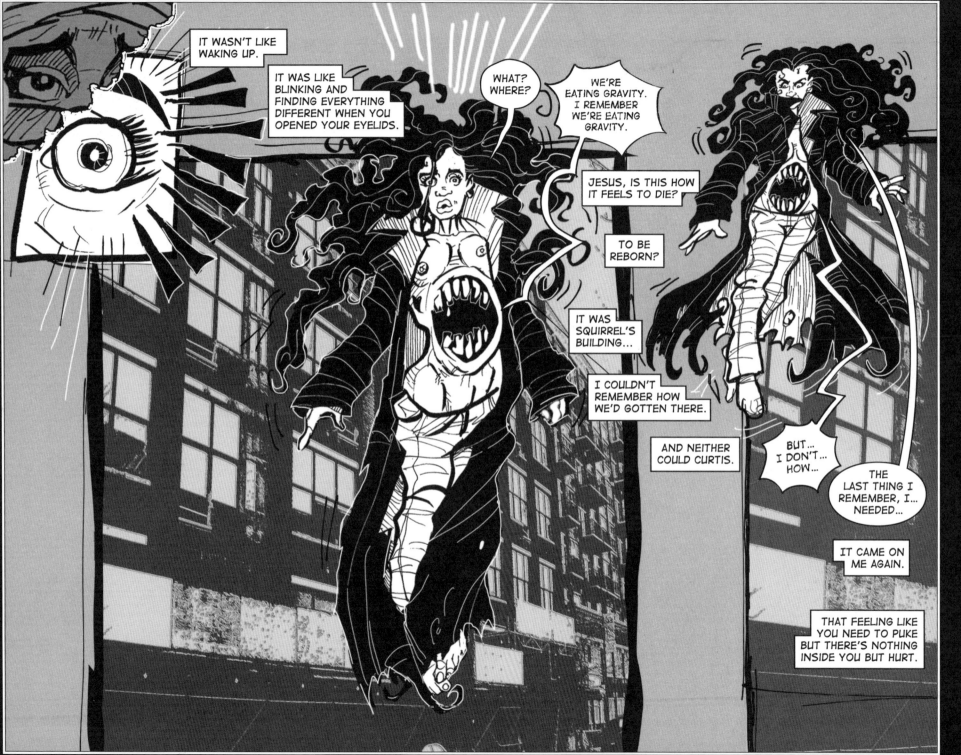

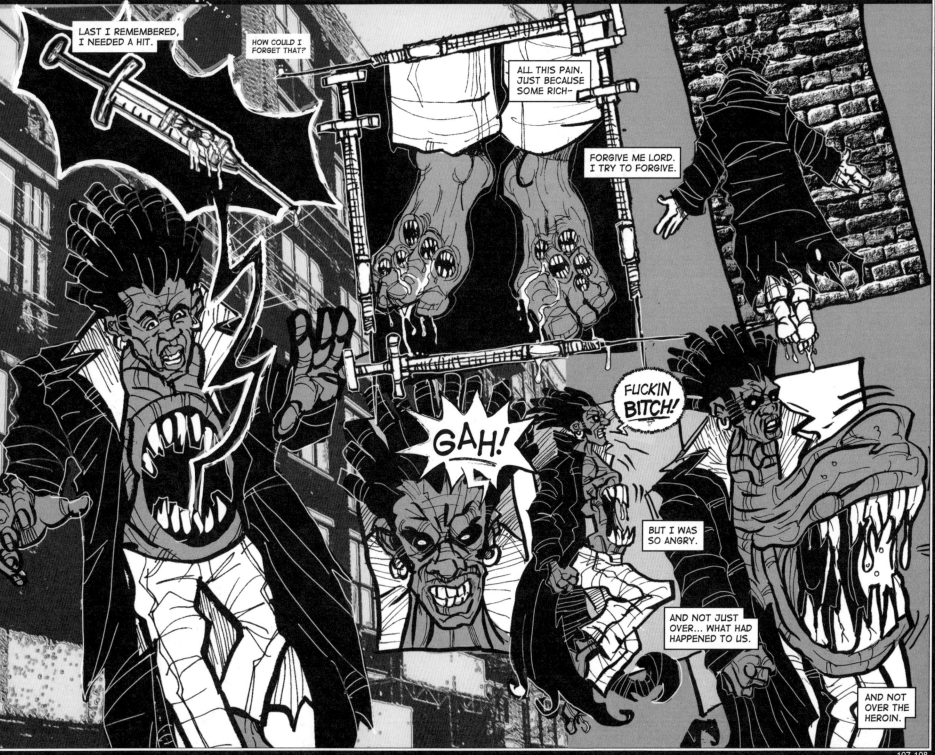

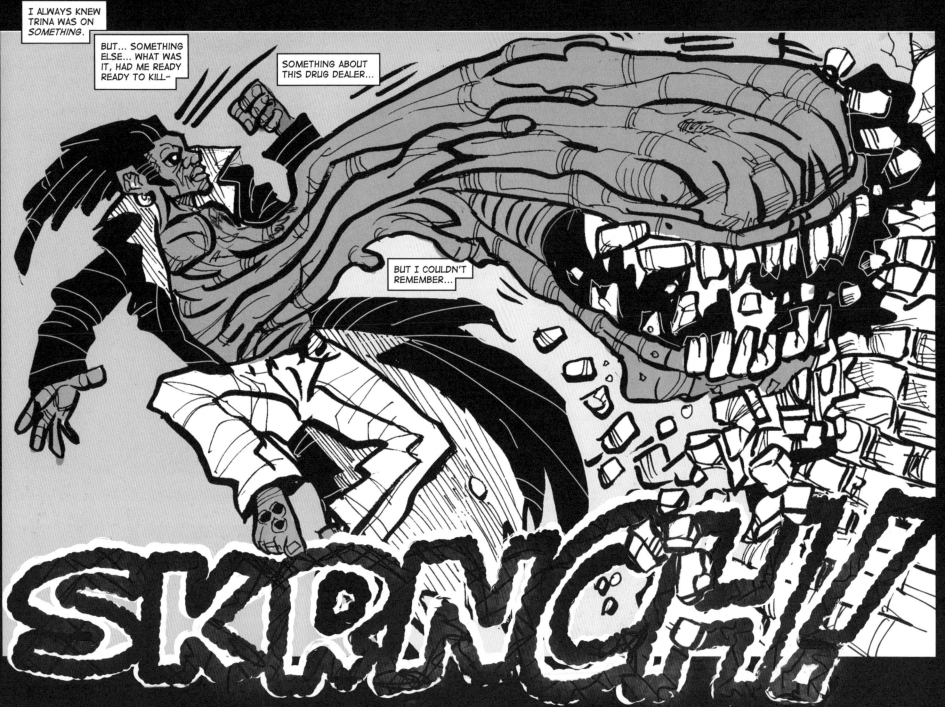

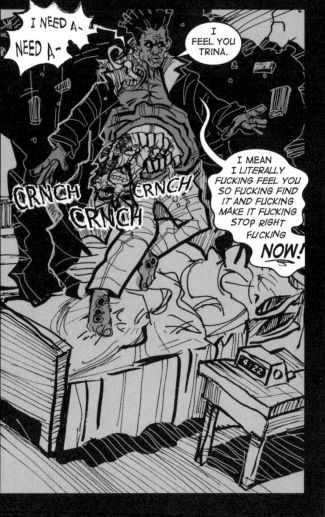

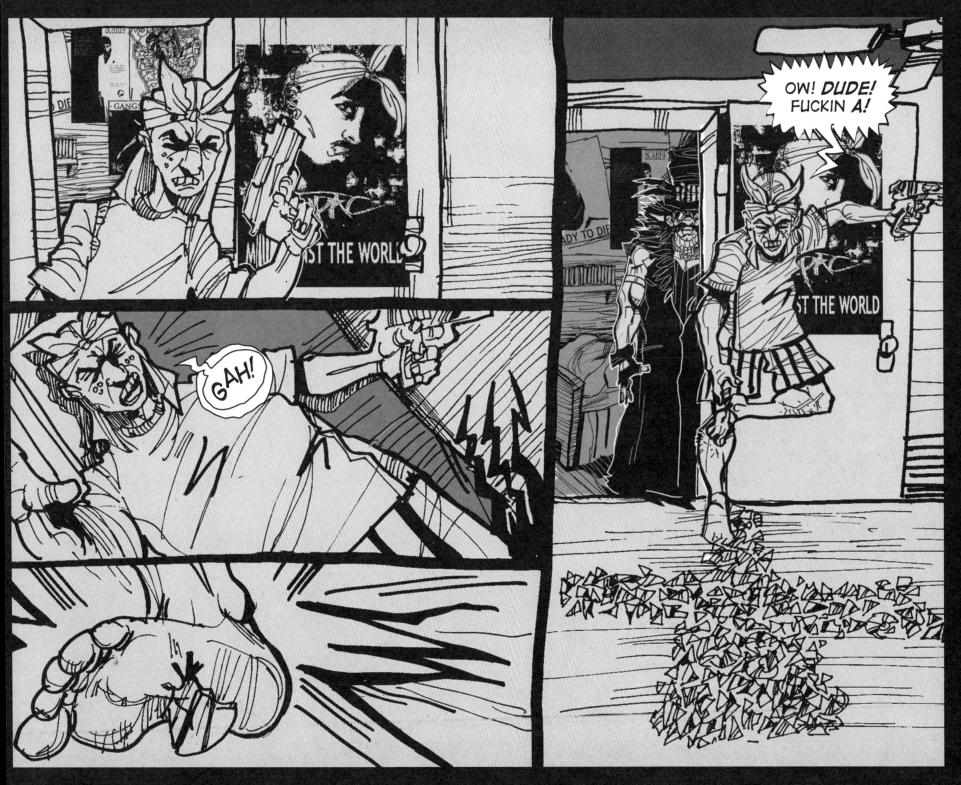

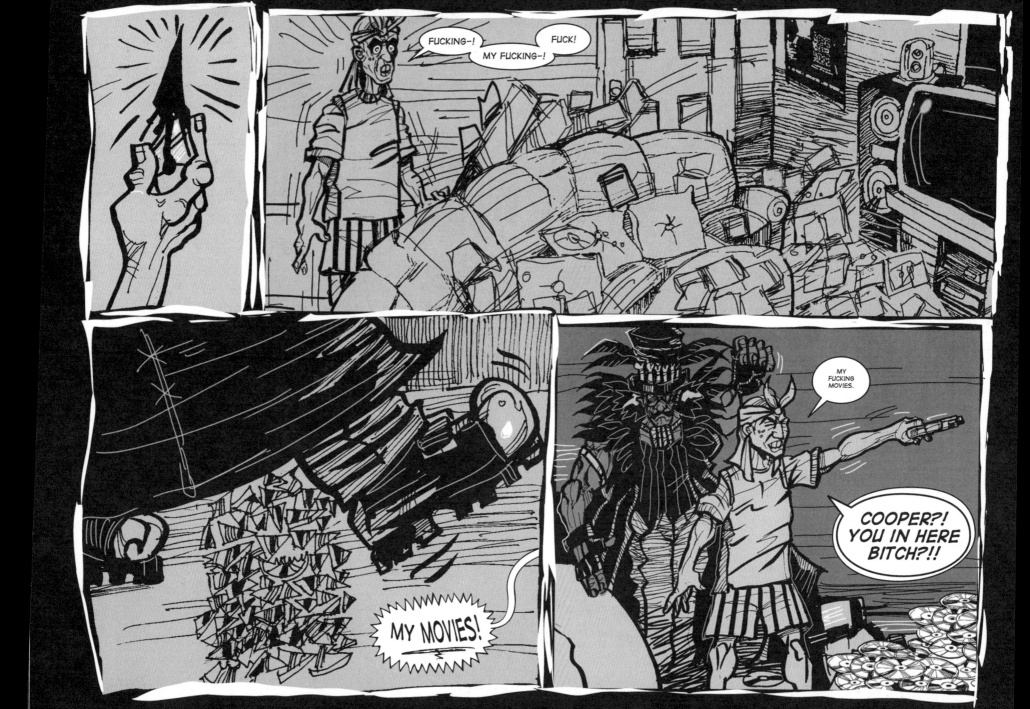

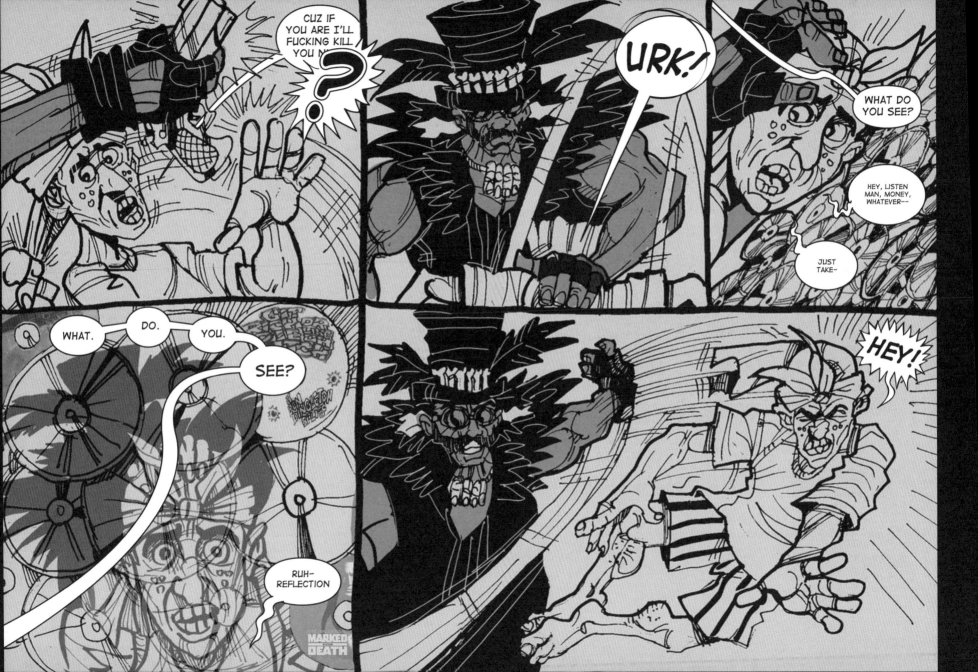

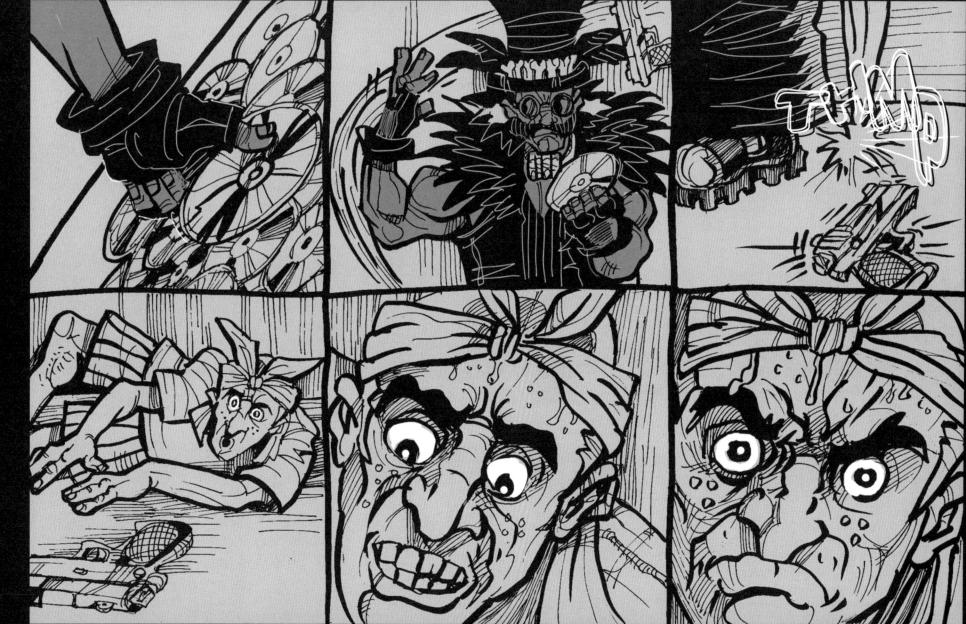

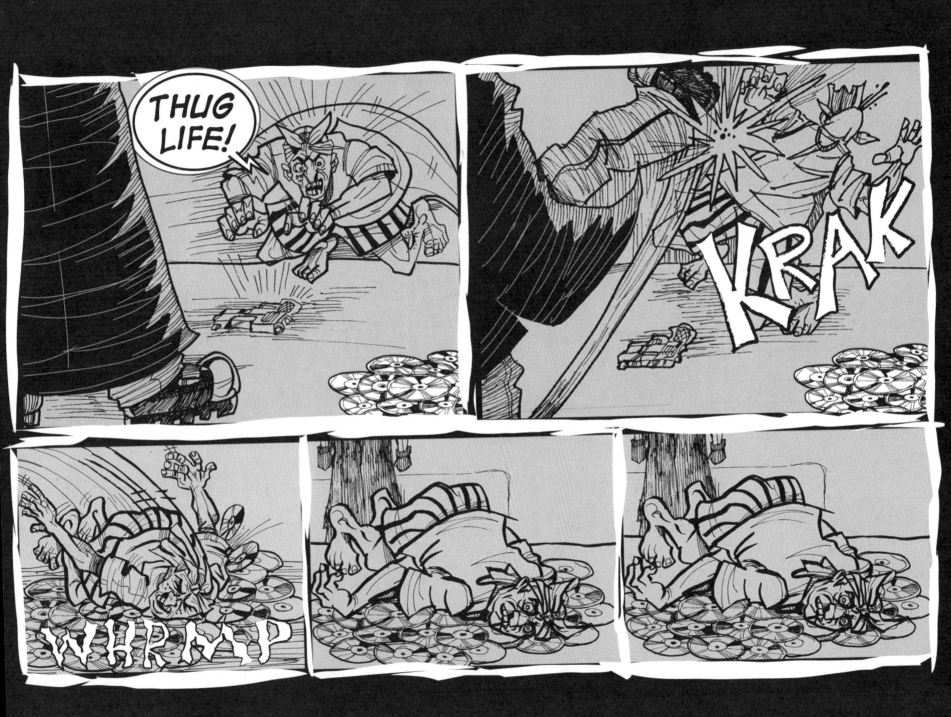

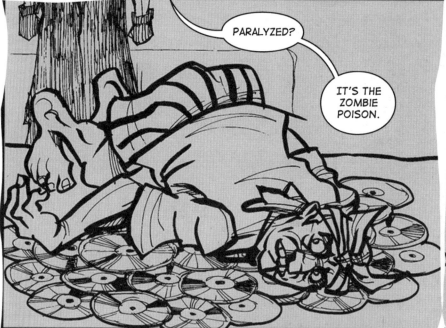

PARALYZED?

IT'S THE ZOMBIE POISON.

ITS SPELL WORKS QUICKLY...

ONCE YOU GET THE BLOOD PUMPING.

YOU CAN'T EVEN MOVE YOUR VOCAL CORDS.

BUT IT WILL WEAR OFF.

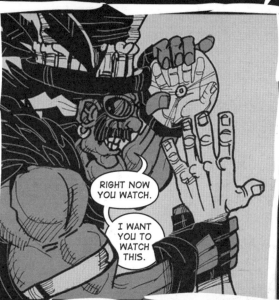

RIGHT NOW YOU WATCH.

I WANT YOU TO WATCH THIS.

115.116

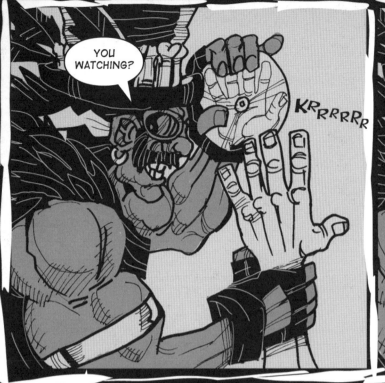
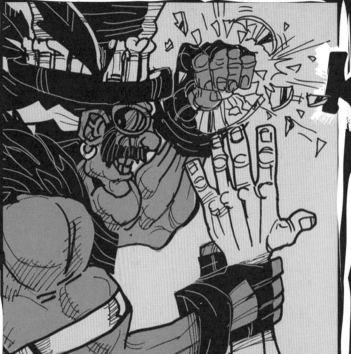

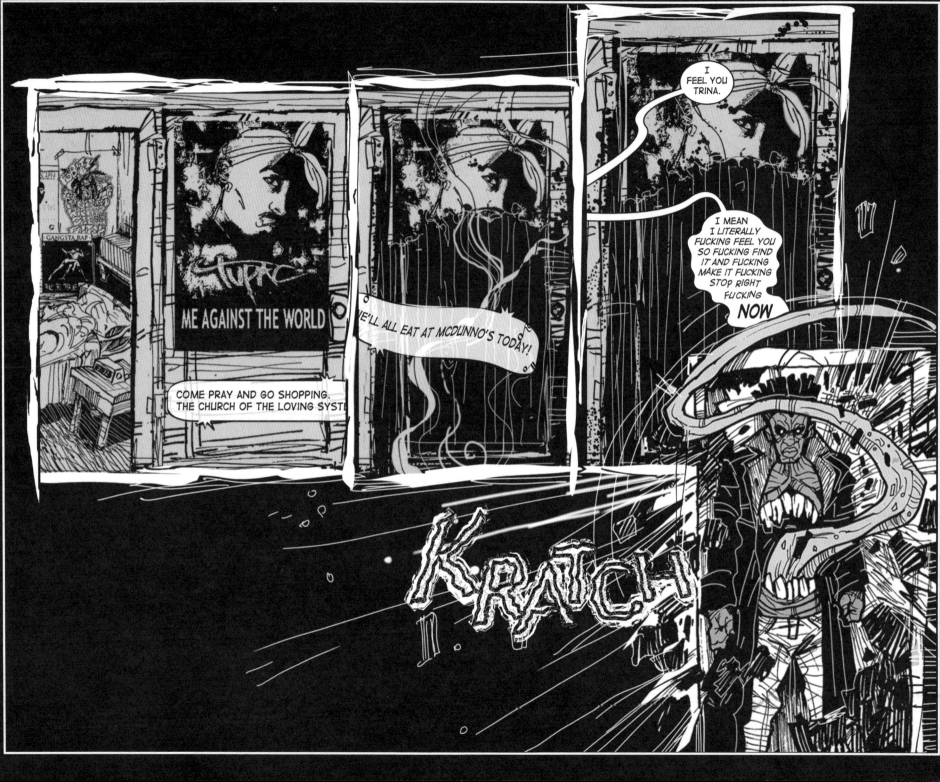

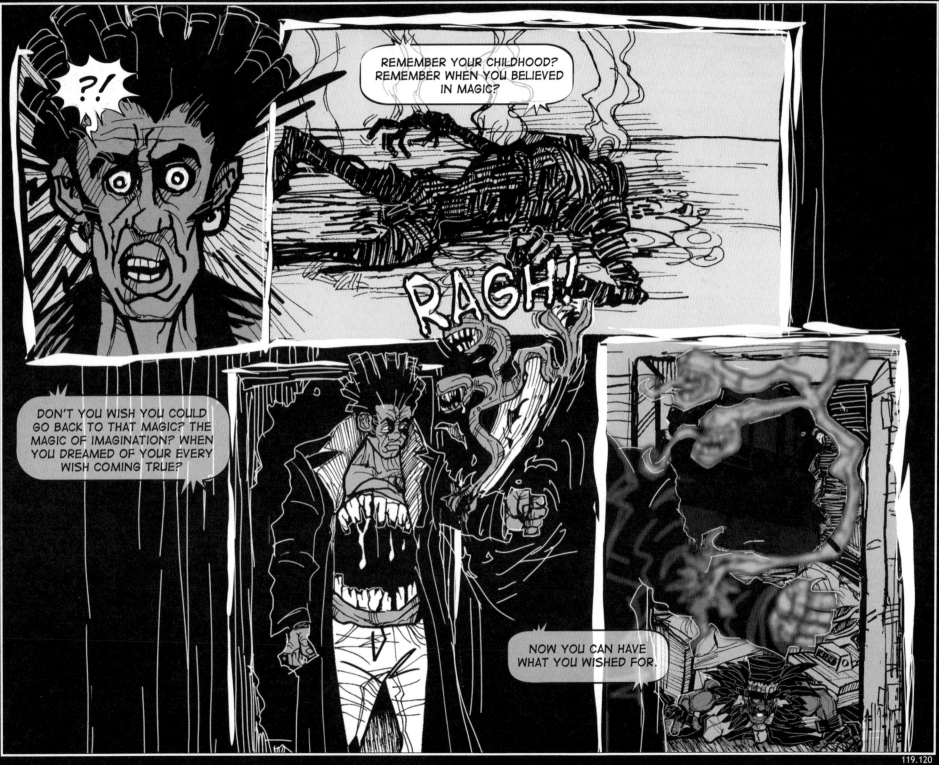

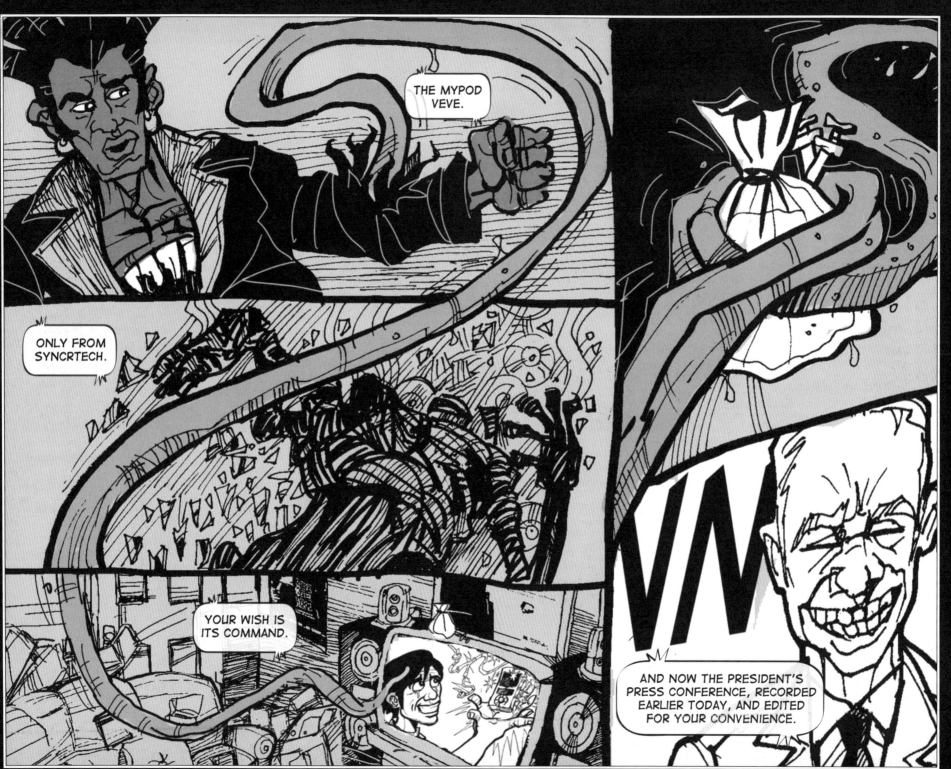

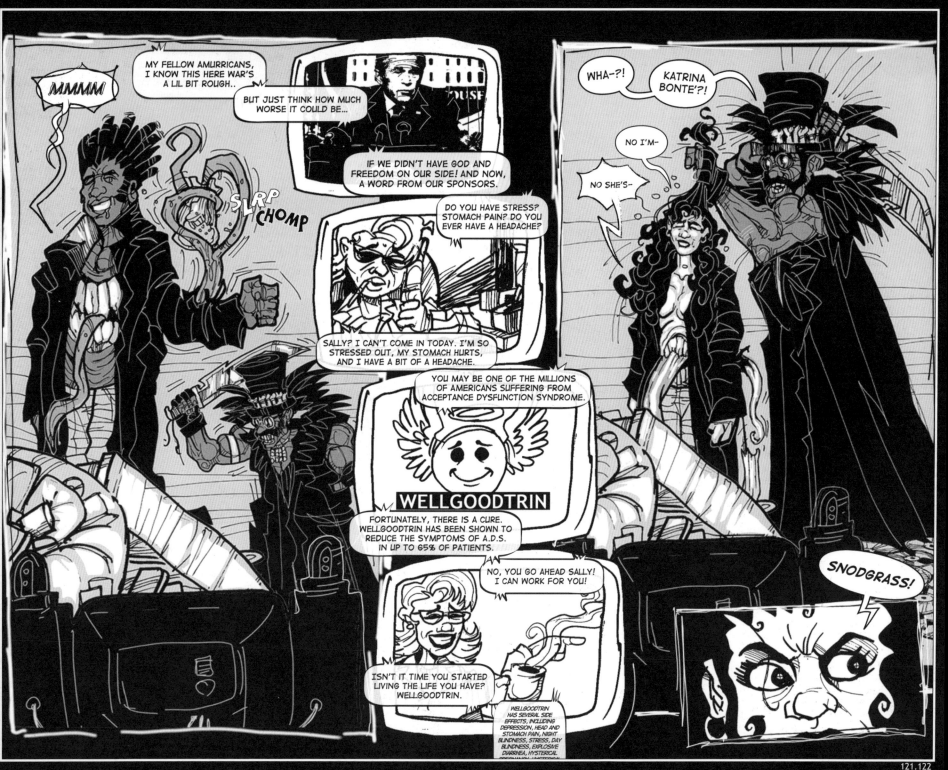

121.122

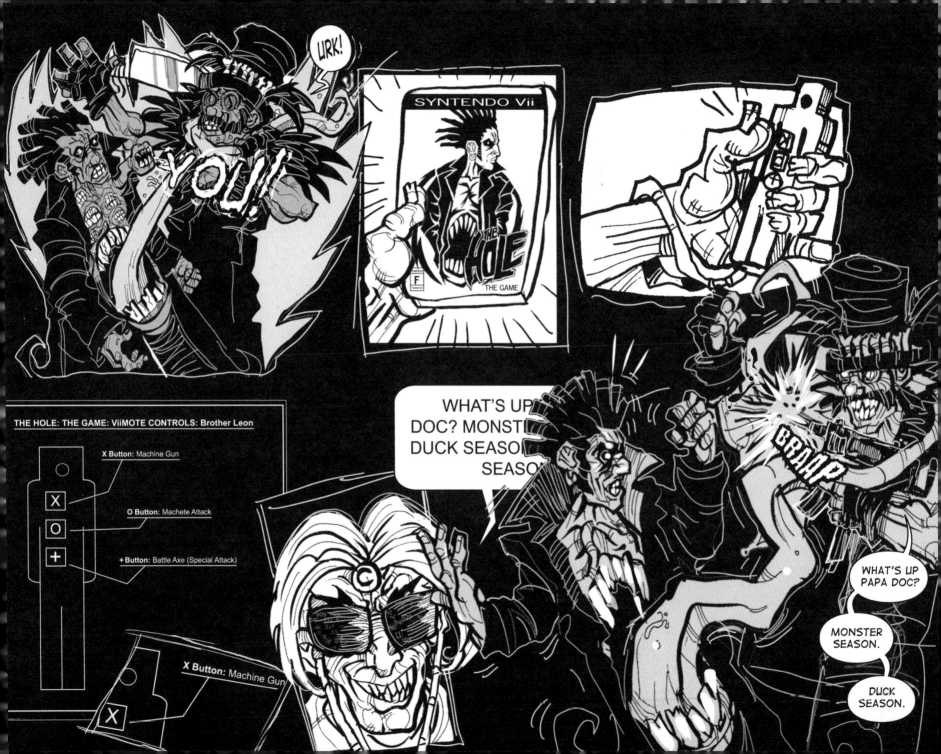

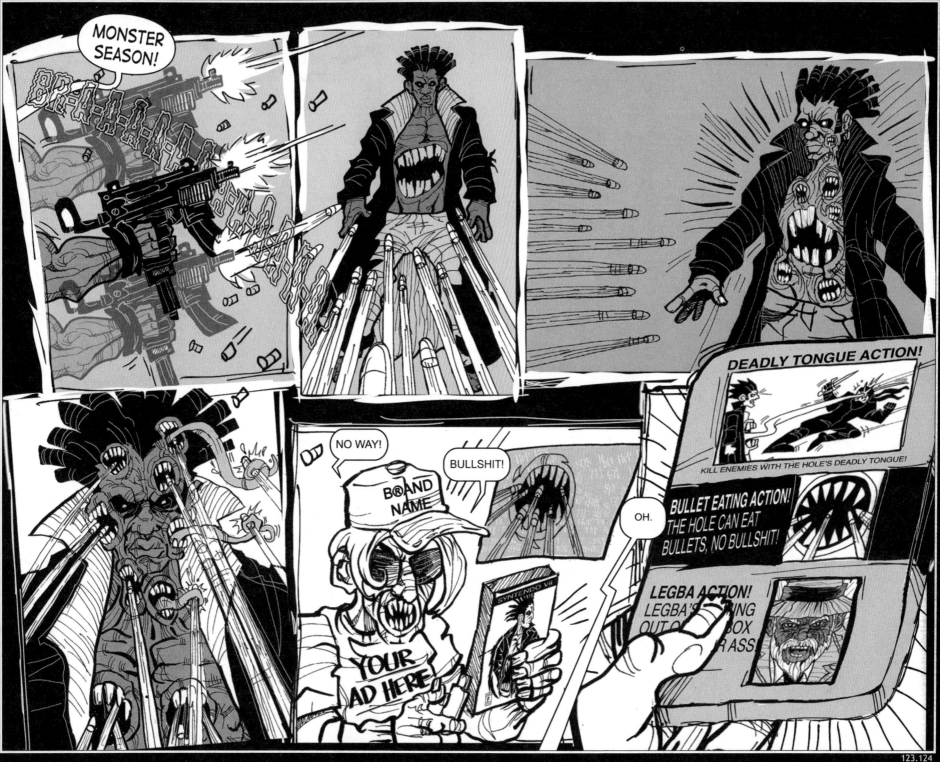

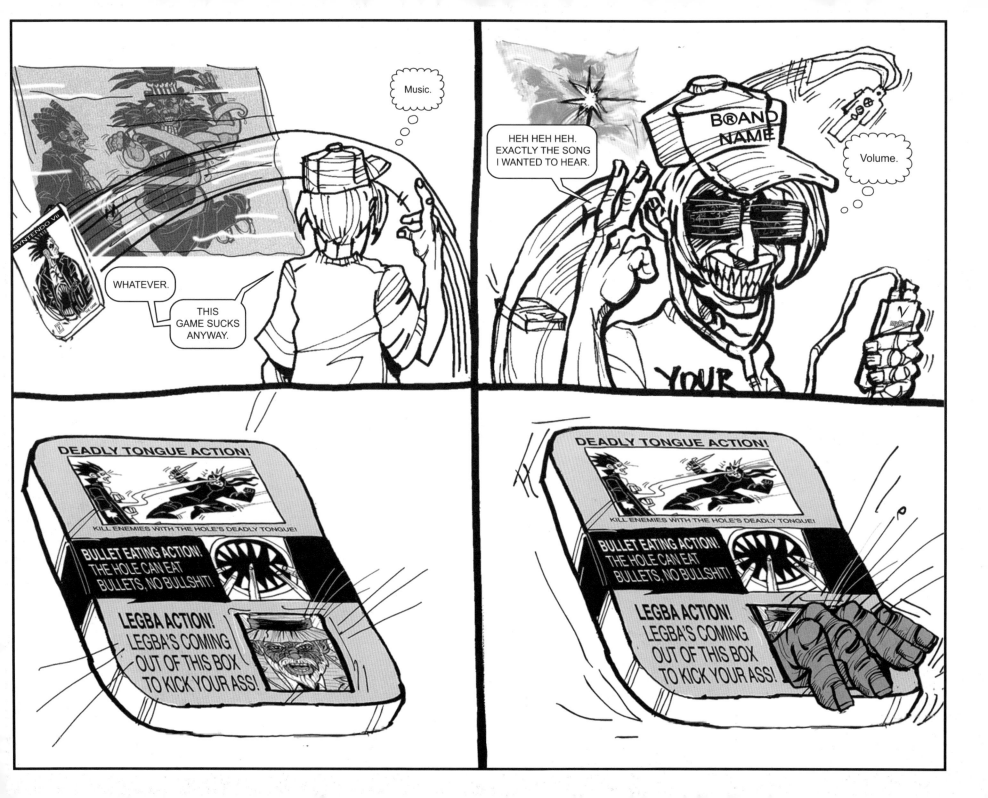

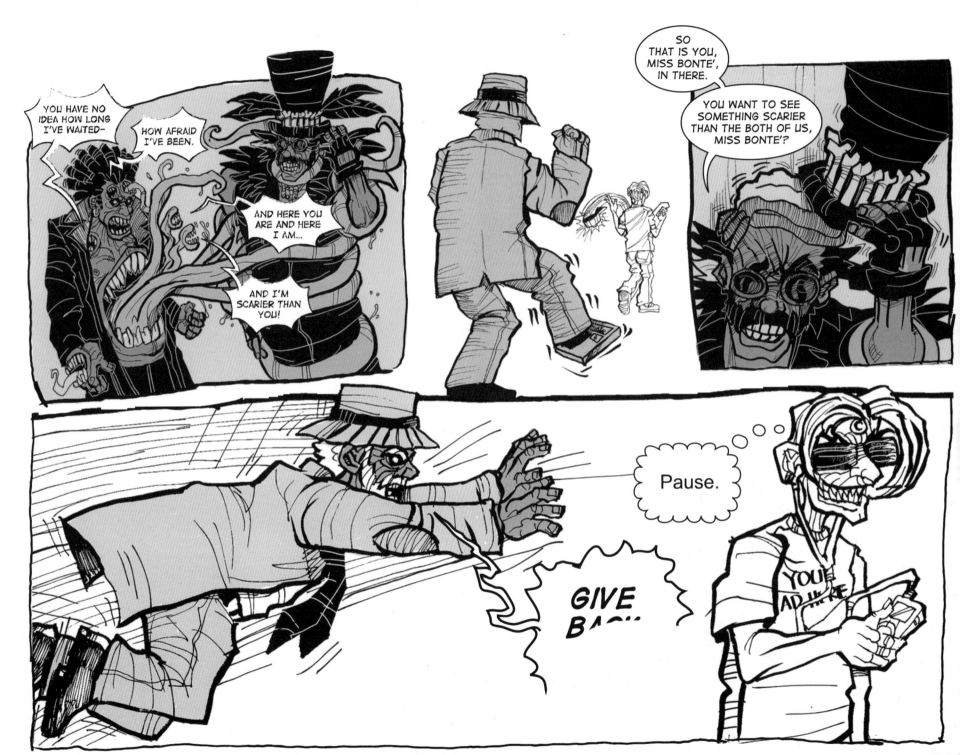

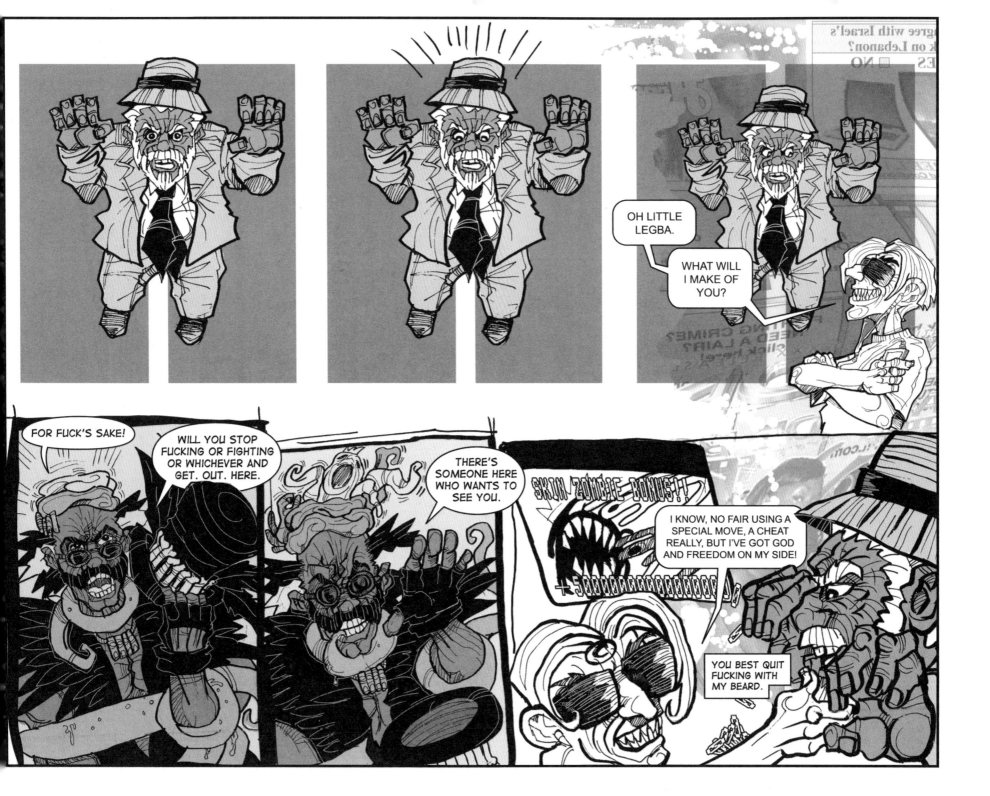

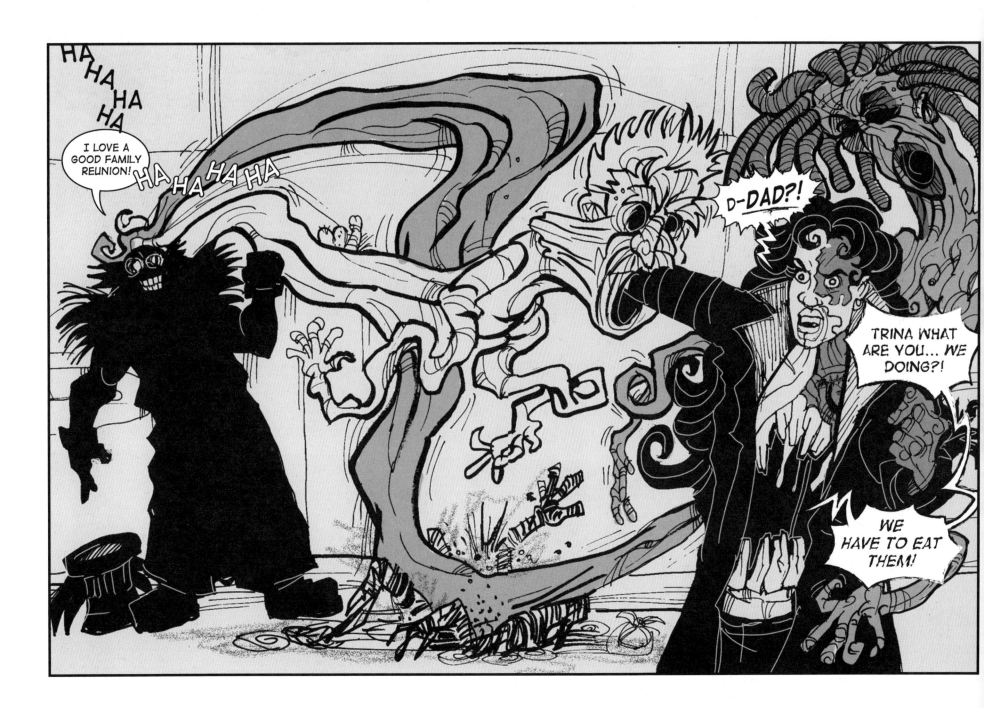

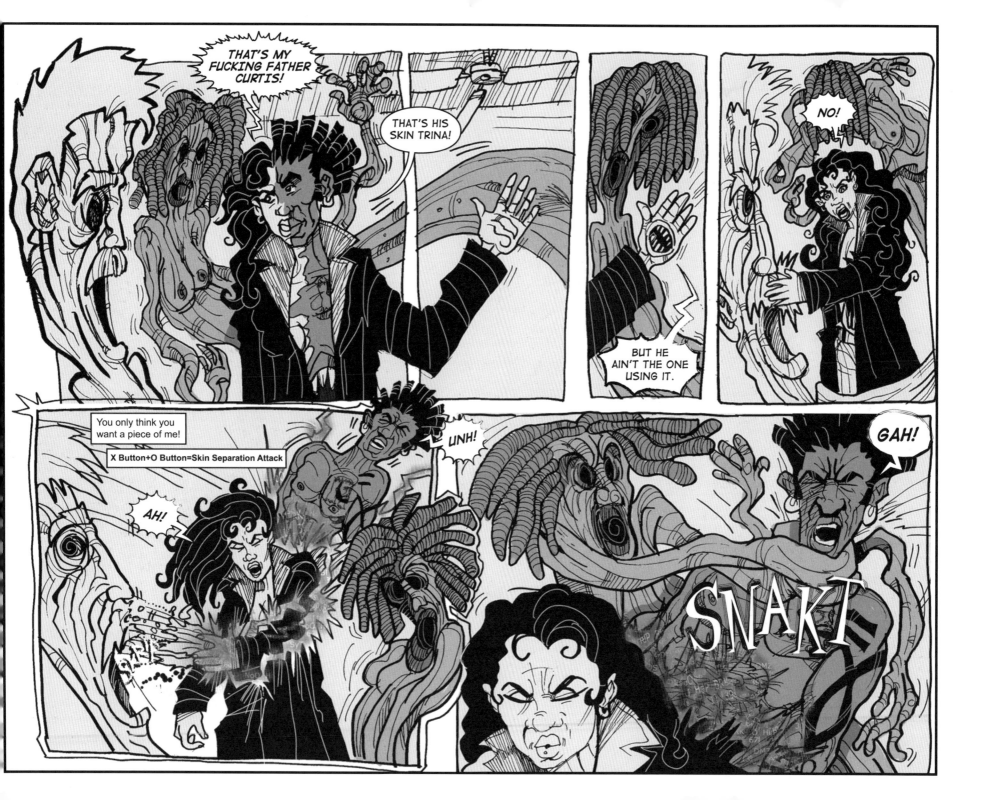

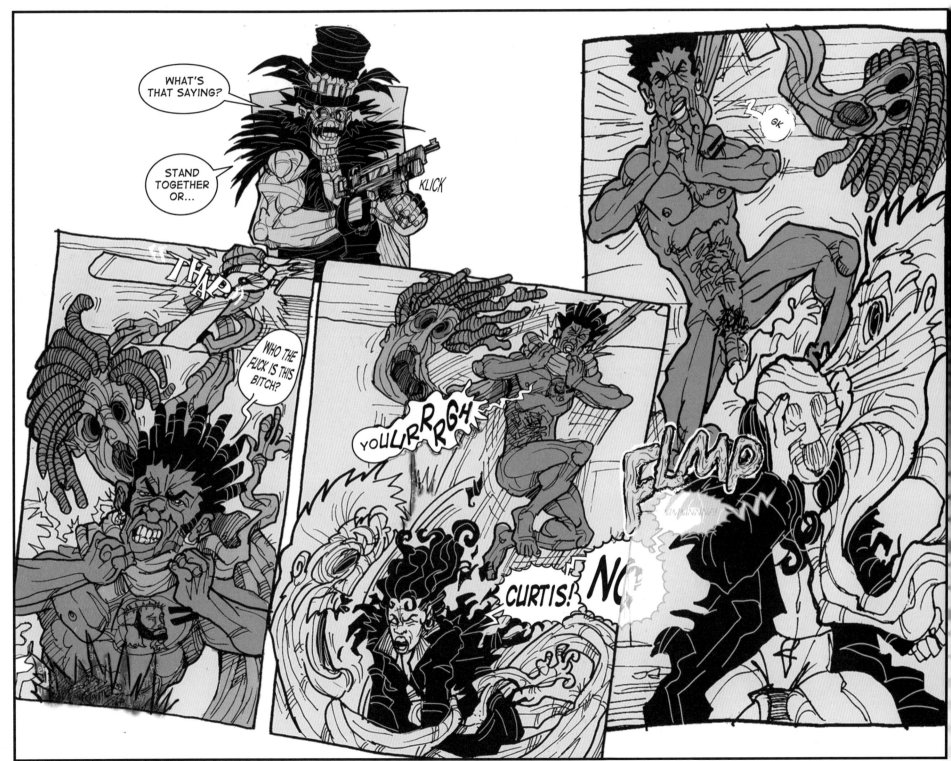

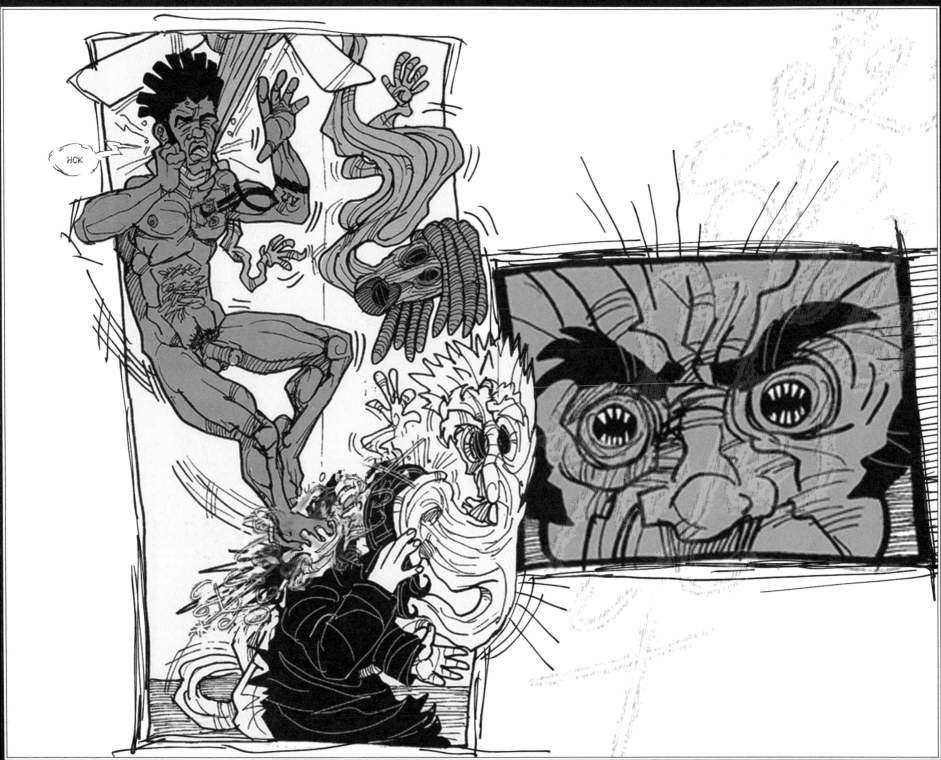

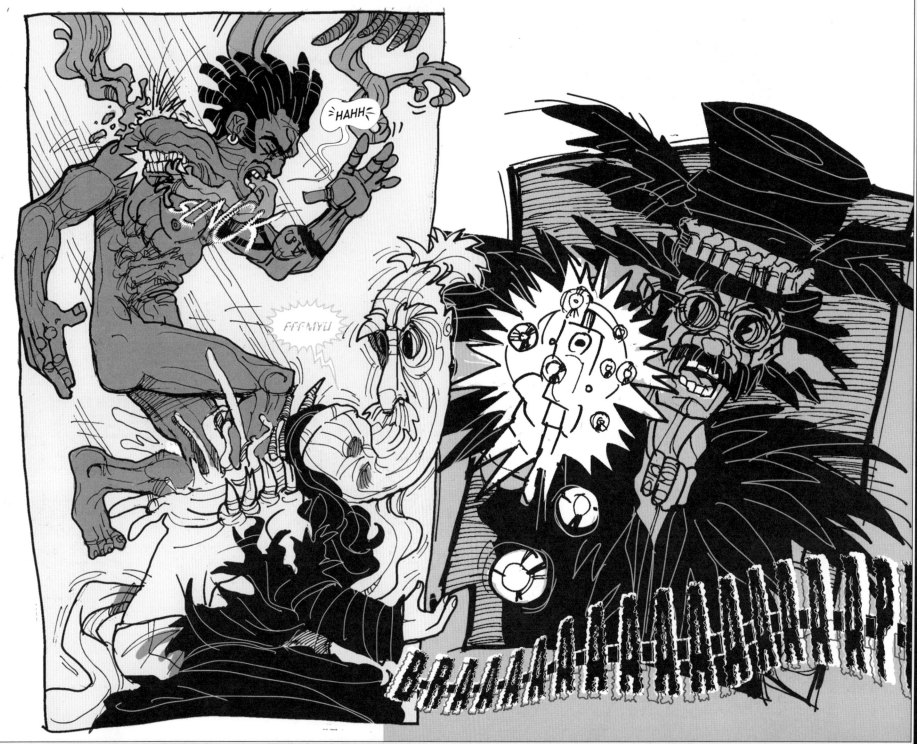

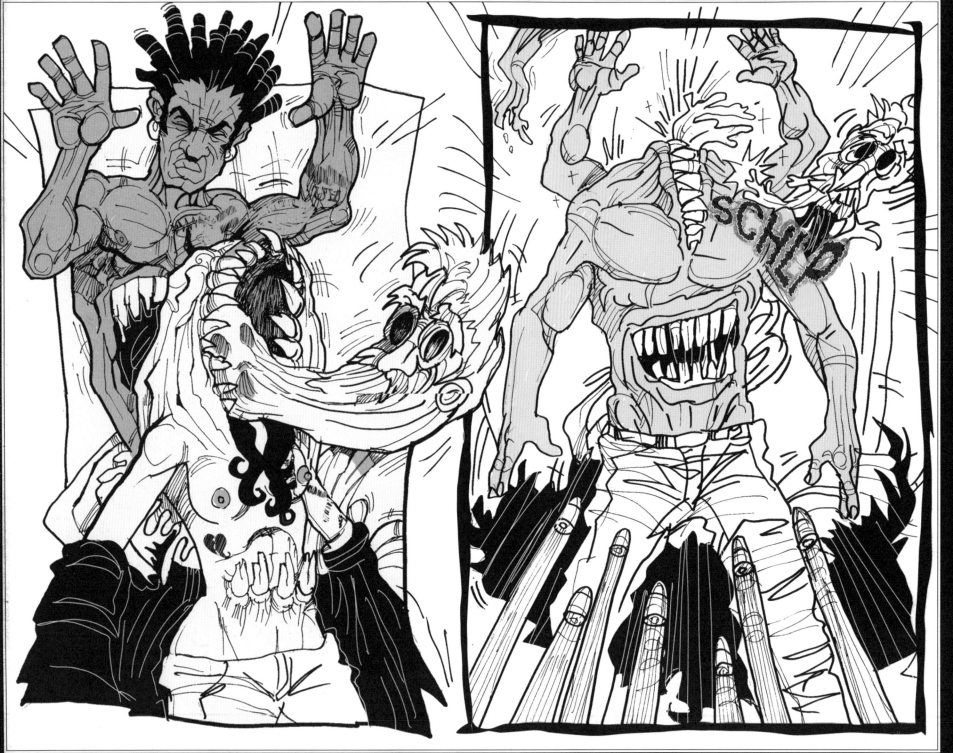

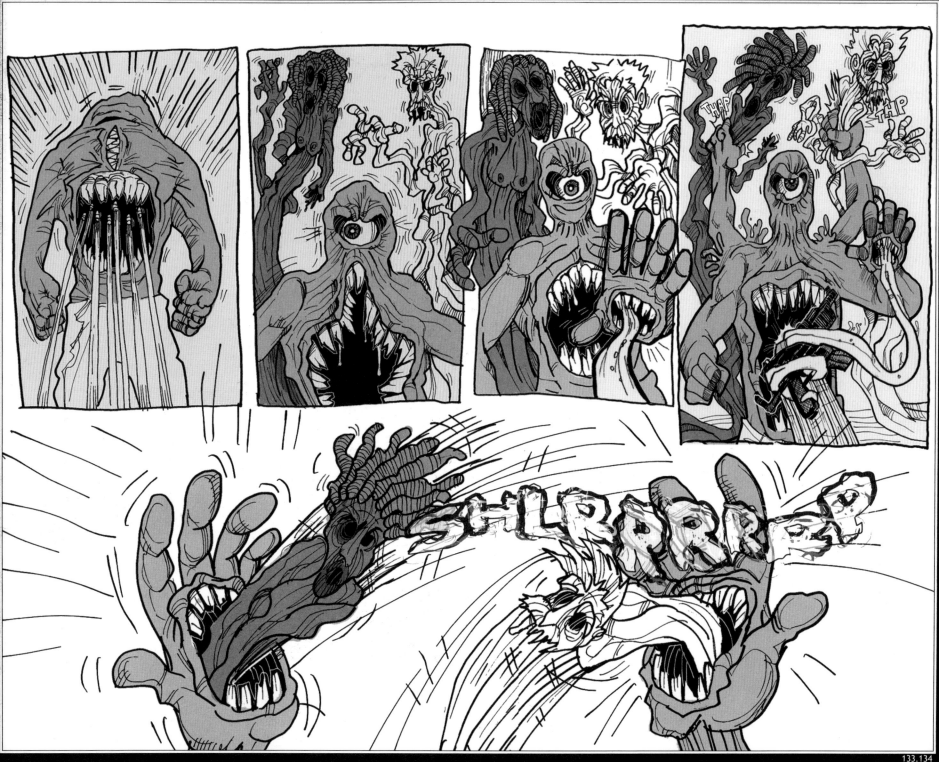

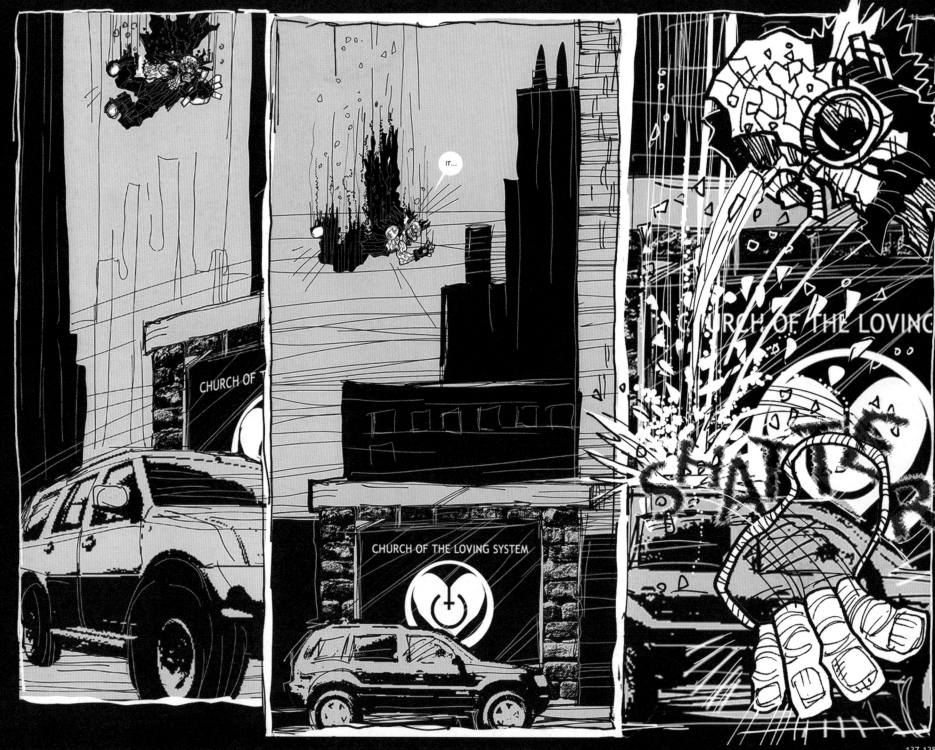

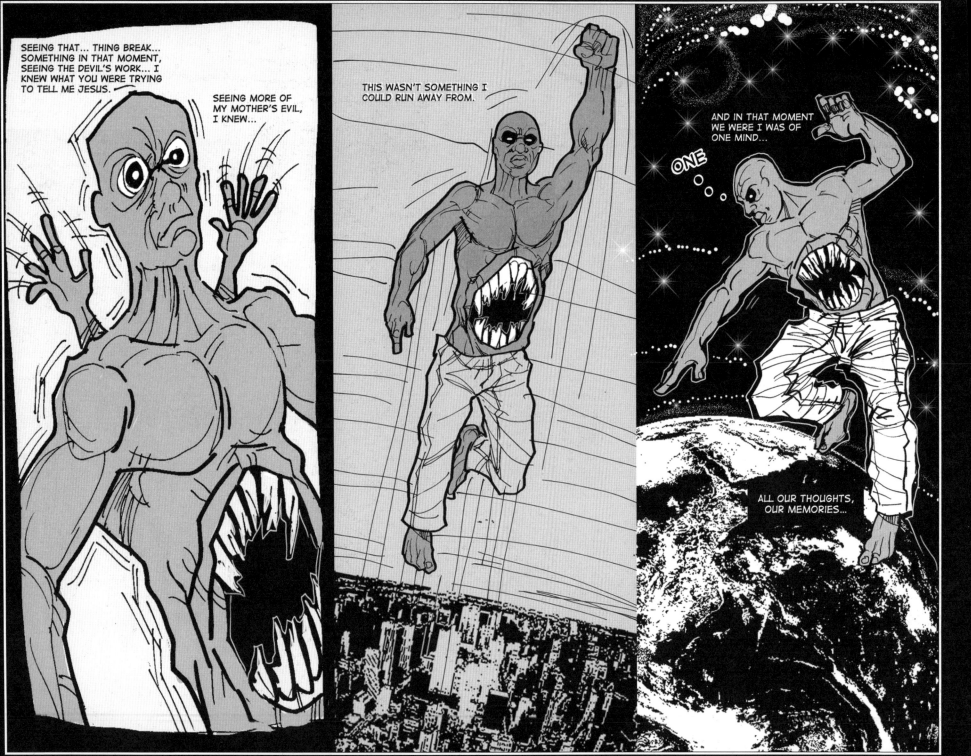

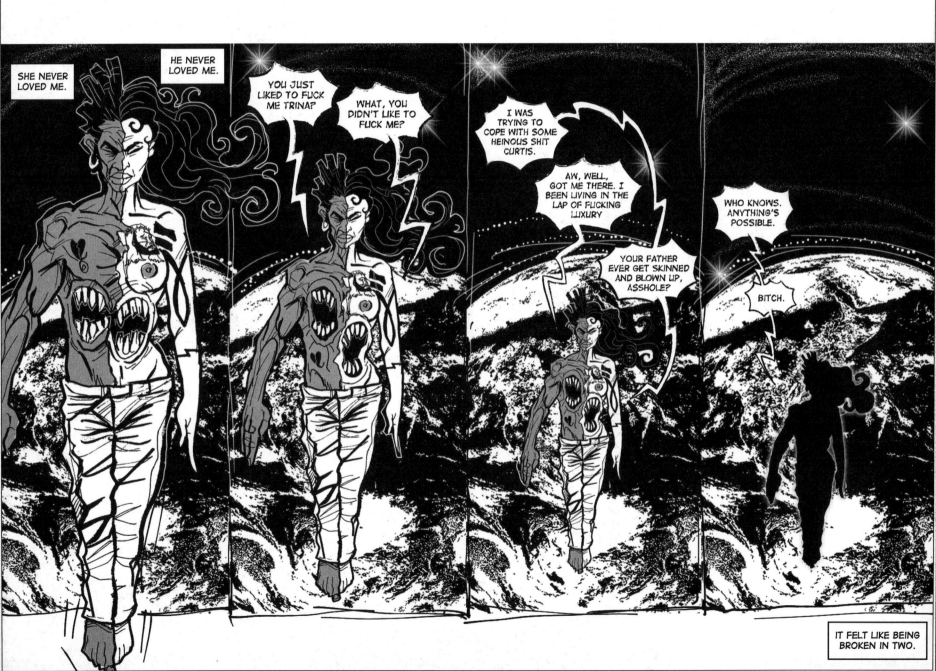

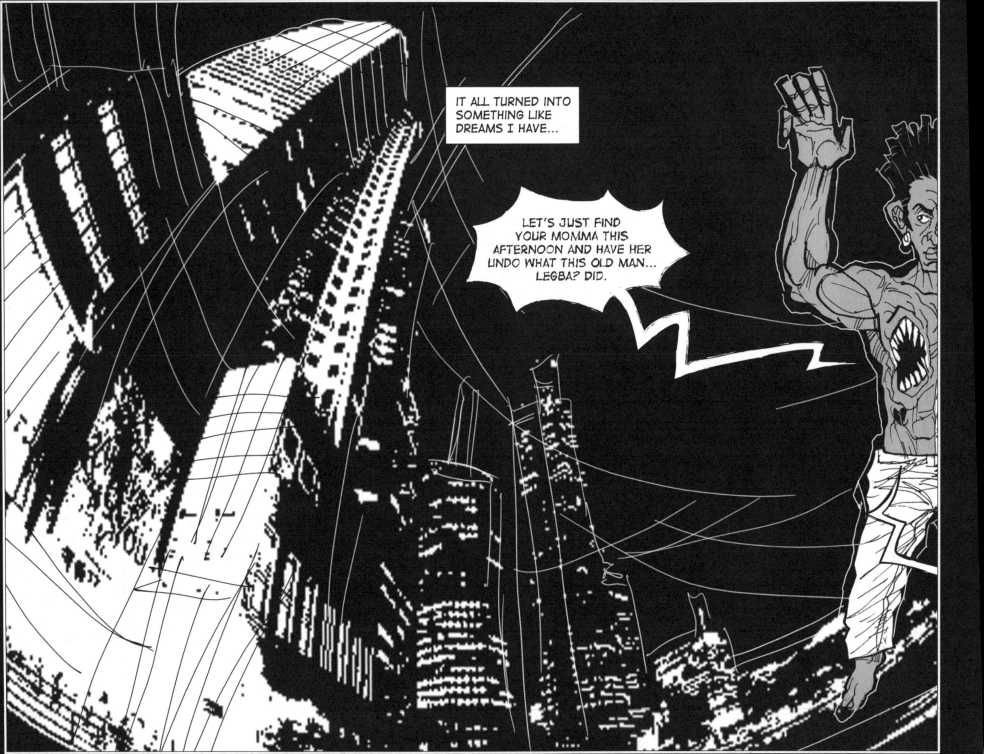

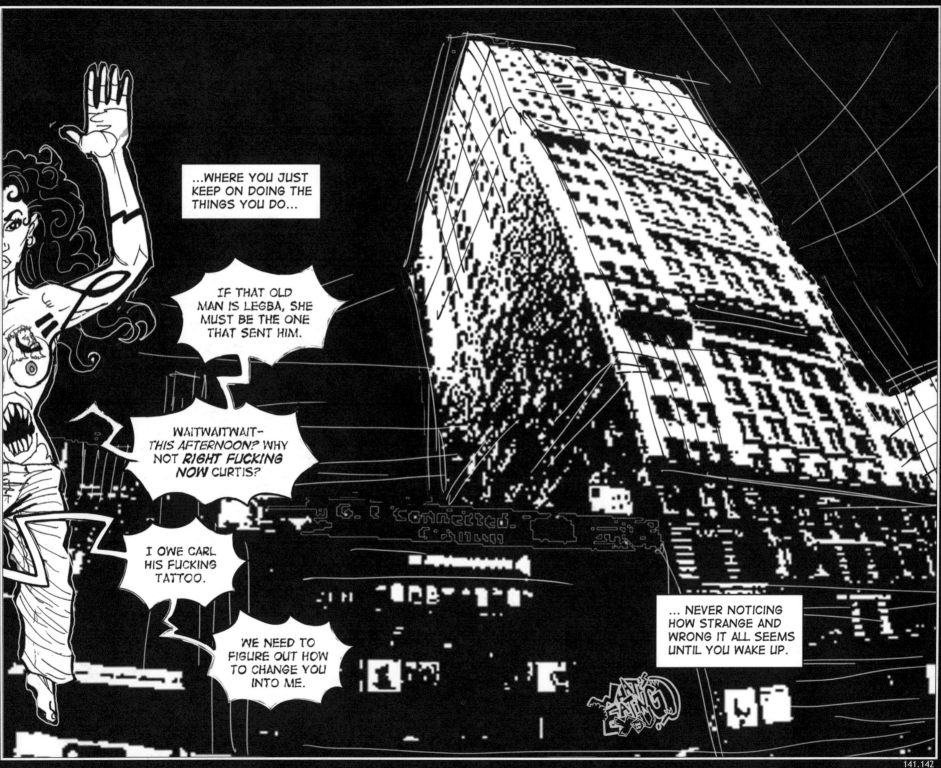

To tell you the truth...

I HATE COMICS.

I just buy up as many film rights as I can, so no one else gets them.

It just takes me a few years to find a bankable star with the perfect vision.

BUT FROM THE CROSSROADS OF TIME I SEE, MUCH TO MY SURPRISE, THE MOVIE DOES GET MADE.

THIS PREVIEW IS APPROVED FOR

RESTRICTED AUDIENCES ONLY
BY WHITE PETER

R **RESTRICTED**

UNDER 17 REQUIRES ACCOMPANYING CONSUMER WITH LEGAL TENDER. THIS AIN'T CHARITY Y'ALL

FOR LEWD HUMOR, SUPERNATURALNESS, ARCANE FLATULENCE, AND ETHNIC SENSUALITY

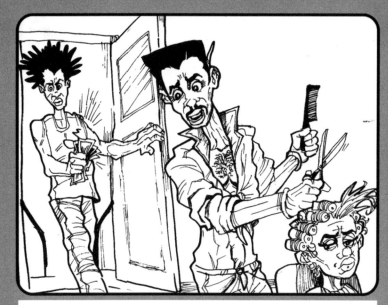

–GUESS WHO DONE ROBBED THE VOODOO SHOP!

–CURTITH, THAT ITH THUCH BAD JOO-JOO.

–AW, WHAT YO "FUDGEPACK SHAKUR" ASS KNOW ANYWAY!

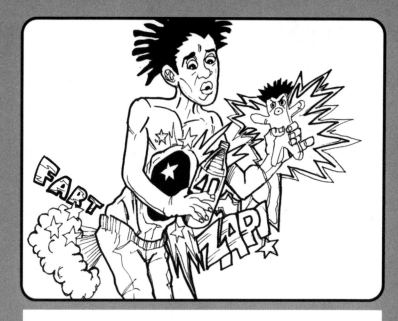

CURTIS COOPER WAS JUST YOUR AVERAGE "HOMIE" UNTIL HE TICKED OFF THE WRONG *VOODOO GODDESS!*

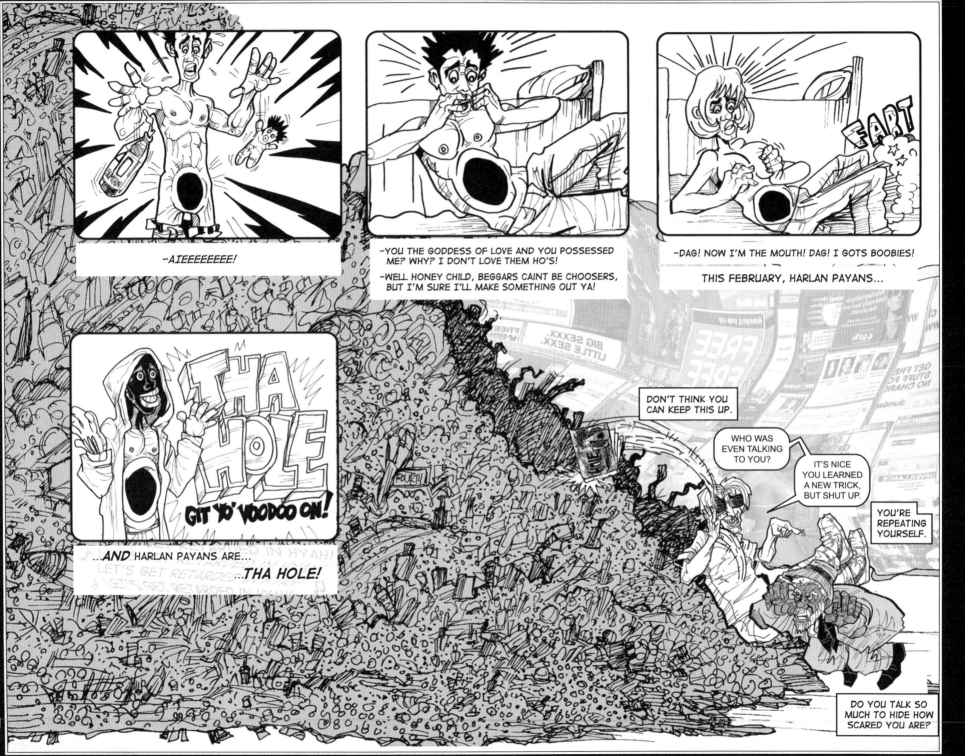

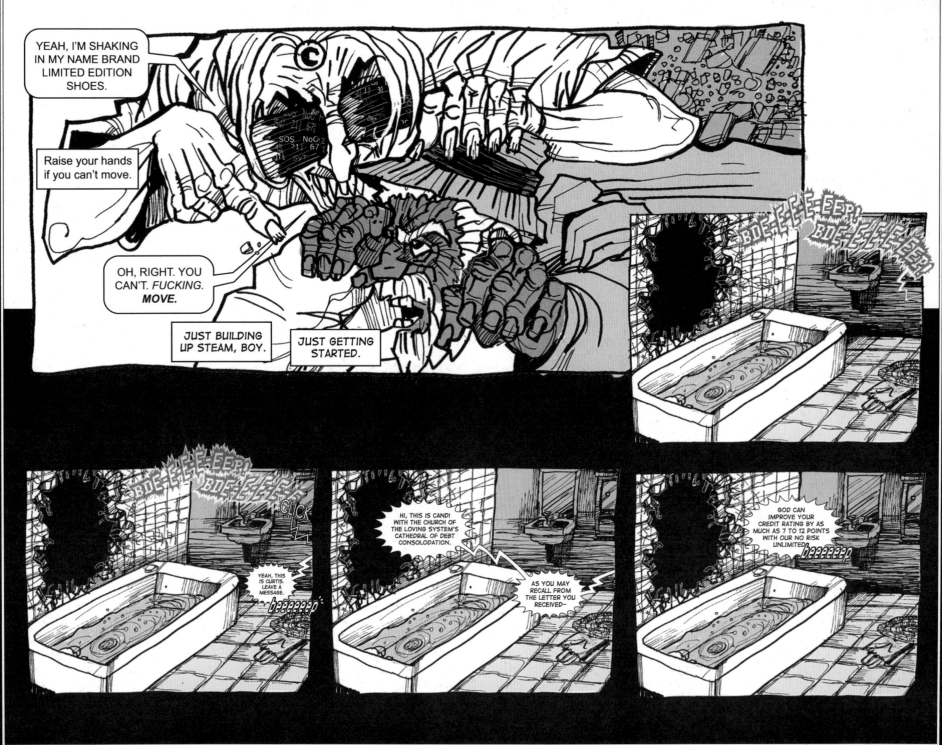

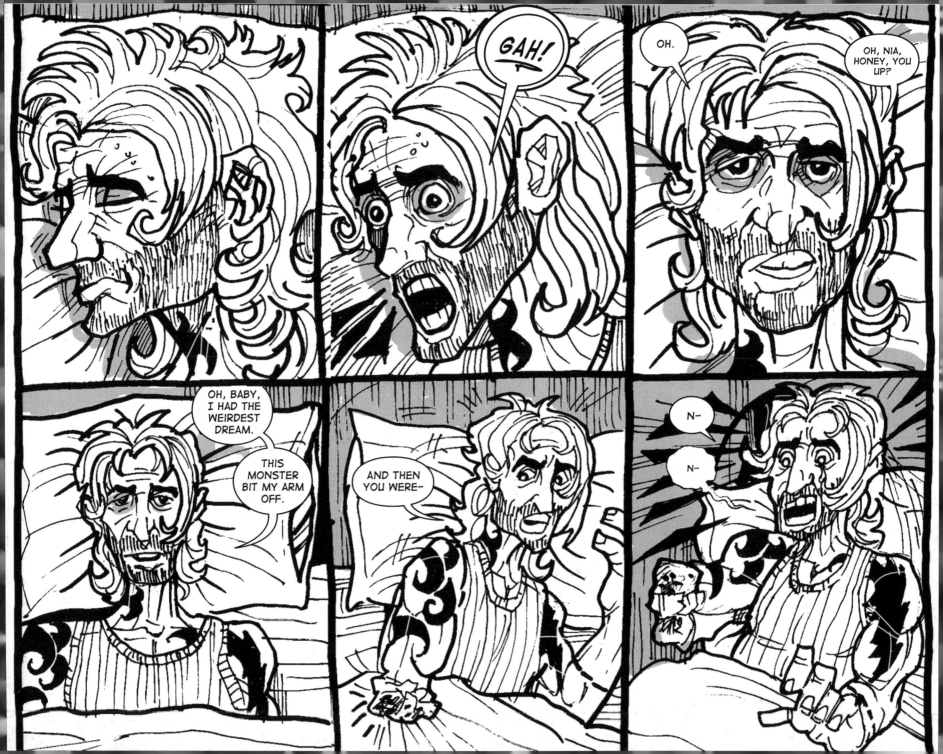

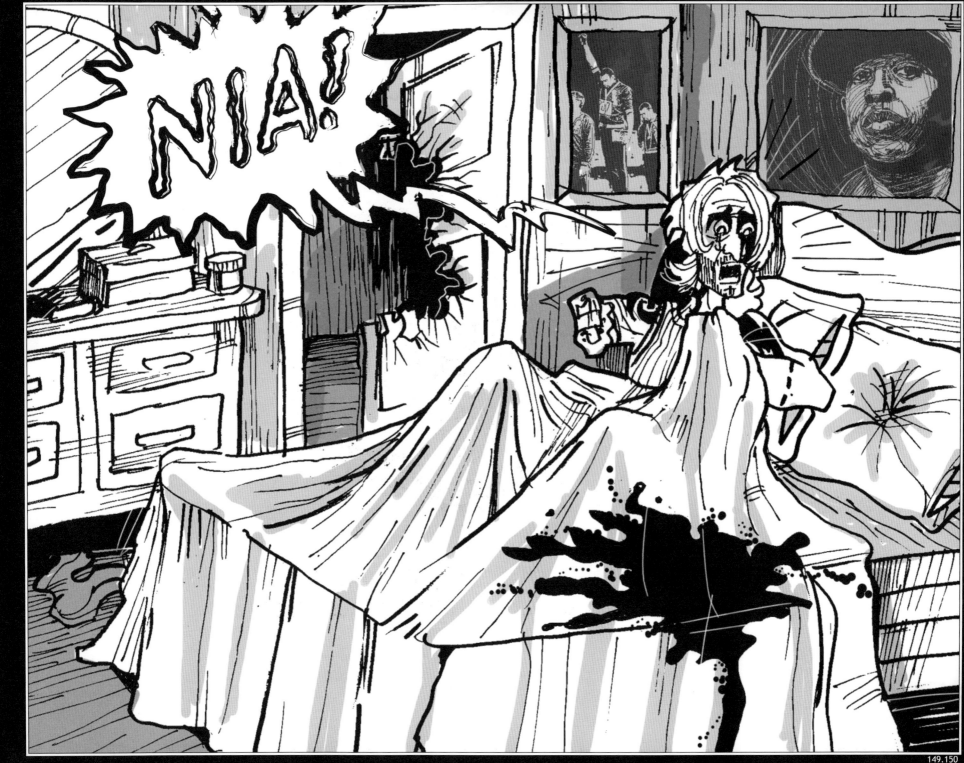

THE PRECEDING MESSAGE WAS SPONSORED BY

THE CHURCH OF THE LOVING SYSTEM
"ETERNAL SALVATION. AFFORDABLE PRICES."

PROCESS

by Damian Duffy

Pictured: John and Damian plotting the comic over dinner during their 10 months of story crafting and research.

Step 1. MADNESS AND TALKING: Soon after Hurricane Katrina, John has the insane idea of redoing The Hole, the title protagonist of his 'horror superhero' graphic novel.

(The original Hole, Eric Spade, appears in the foreground of page 21, panel 2 of the volume in your hands.)

Damian balks at retreading when they have, "like three other comics we're working on..." (2005).

However...

John's idea of a story about voodoo and race leads Damian to the idea of ultra-modern hypervoodoo, and the two begin bouncing ideas and research back and forth.

¹The term "superhero" is a registered trademark of Marvel and D.C. Comics and appears here only as a descriptor of genre. We have no money. Please don't sue us.

Step 2. WRITING: Unexpectedly, John and Damian find a publisher for the book, leading them to , you know, actually make it.

Damian writes, rewrites, and re-rewrites the script in an Alan Moore-inspired style, with an overabundance of language describing image.

...out the fate of the world?"

...a canvas s

cube ma...

...background. WP LEGBA is on the left, taking another drag off of his
the right of the panel, where LEGBA is just now landing on the horizo
foreground.

WP LEGBA: Ffft. So now it's... pre
LEGBA: It's unnatural!! Tha... woman's work... It's gone... wr
WP LEGBA: Sigh. Poor Esu...

Panel six
Two shot of WP LEGBA and LEGBA with WP LEGBA slightly in the
LEGBA looking directly at the spac...
box.

WP LEGBA: Always do...times
CAP: An antique too old to be of any u
brought on TV to see how much it's w

He writes the script on his Compaq laptop, using MS Word and sketches layout designs with Microsoft Paint (the generic paint program you get with Windows XP.)

Step 3: DRAWING:

Designing a logo using Freehand and Painter.

Hand inking on an oversized Bible Timeline book in lap

John begins the book pencilling backgrounds, props, and characters by hand, scanning them in, compositing them with reapproriated images in Adobe Photoshop, and inking them digitally with Painter. However, as deadlines approach, he finds it quicker with a more traditional process of pencilling and inking by hand entire pages (or, if very detailed, single panels). He still colors and composites scanned in images with Photoshop and Painter.

Step 4: LETTERING

Damian letters digitally, using Adobe Illustrator. Some word balloons are constructed using polygon drawing tools, some drawn with a Wacom tablet.

The main dialog font is Digital Strip, a Freeware font designed by Nate Piekos of Blambot Comic Fonts.

WILL YOU

Not pictured: Damian drawing edits on the art, John drawing a sound effect, John changing Damian's layouts, Damian changing John's layouts, Damian drawing this strip, Dana writing the intro, John designing and laying out the book, Doug, David, and Dan editing, and so forth, and so on...

MEANING

I can't tell you what this means.

JUST LE...ME
...TO MY HUSBAND,
...N I'LL PUT SOME
MUSIC ON

BECAUSE I'M AT WORK, FOR ONE!

NAW, I
S WATCHING THAT!

John can't either.

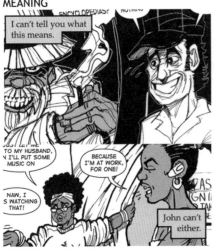

IT ACTUALLY WAS.

...HEY CAN'T OUTRUN

Not really.

We have ideas.

IN

...D NOW THE PRESIDENT'S
...SS CONFERENCE, RECORDED
...LIER TODAY, AND EDITED
...OR YOUR CONVENIENCE.

HA!
OH CARLA
BONTE...

We hope you do too.

SHSS

THIS IS
WHAT YOU
ASKED FOR.

STEREOTYPES

by Damian + John

Several of the main characters in The Hole are, in part, reified stereotypes; dehumanizing caricatures given human characteristics.

Carla, for example, is partially a reification of the Mammy stereotype. The Mammy is a generally sexless overweight slave woman who works as the head cook of the house and as a surrogate mother to the children of her white owner.

The Mammy is typically depicted in a headscarf or turban, her hair (often a symbol of power among African women) completely covered.

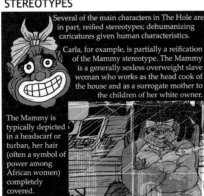

The characters in The Hole incorporate characteristics of these racist caricatures as a form of critique.

Curtis, in this sense, comments upon the Black Buck or Black Brute stereotype, the portrayal of the black man as anti-social, animalisitc, violent and obsessed with raping white women.

This stereotype appeared in the Reconstruction-era United States, replacing caricatures like the Mammy and Sambo who were happy as slaves. In other words the Buck acted as a straw man on which to pin the common white rationalization that with slavery came civilization, with emancipation, savagery.

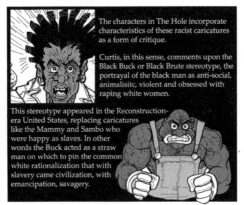

Trina has aspects of a reified Jezebel or "tragic mullato" caricature. (These two stereotypes are generally conflated, but sociologist Dr. David Pilgrim* argues that the Jezebel represents the sexual objectification of women of dark and light complexion.)

In either case, women of African descent are shown as inherently sexually licentious to the point of (again) animalistic abandon.

*Essays by Dr. Pilgrim on the historical context of stereotypes can be found on the website of the Ferris State University Jim Crow Museum of Racist Memorabilia at http://www.ferris.edu/htmls/news/jimcrow

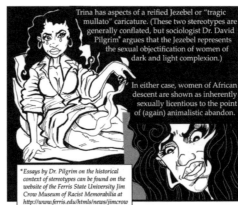

These stereotypes that wind their way through popular culture in consumer goods and mass media aren't real people.

They're embodiments of racism. Traces of hate based not on skin color, but on the meanings we attach to skin color.

Can we make new meanings out of the old? Or are they fated to haunt us, fearful social demons we cannot hope to exorcise?

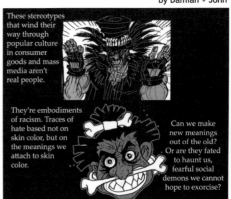

The Appetite for Hunger

DAMIAN DUFFY

"Everything is a hole. When you're born, two holes - there's a hole at the head of your penis, and you come out of a hole. So you come out, and everything is about holes. When you eat? Hole. When you breathe, it's a hole. When you see, it's a hole. When you hear, it's a hole. And when you die, where you goin'? Right back in the hole. If you get too much money you gonna be in a hole. If you don't get enough, you're definitely gonna be in a hole.

"So to me, the best thing to do is stop tryin' to stay outta the hole. Get in the hole and find out what's happenin' with the hole and try to control the hole. And then you can have the hole, because you understand the hole."

-Ike Turner

Esquire, Jan 02, 2002, p 101 [1]

What is the Hole? The Hole is everything. It is a floating signifier, that which has no stable meaning save what meaning is assigned to it. It stands at the crossroads of meaning, neither this nor that but both at the same time.

One meaning the authors of this graphic novel ascribe to is the idea of the Hole as an open wound, the wound of the middle passage, slavery and racism. This is a perpetual wound, the profound and continual schism of race relations that continues unabated in the 21st Century, a schism thrown into sharp relief by dramatic national events such as the virtual abandonment of the poor, primarily African American inhabitants of the Gulf Coast region during Hurricane Katrina in 2005 (the inspiration for what became this graphic novel), as well as the sadly commonplace economic and infrastructural disparities that continue to adhere so closely to racial divides.

Slave Narratives

Slavery works a lot like Hollywood Voodoo, making objects out of people. But the Africans put up on the auction block in the Americas of the 18th and 19th Centuries didn't have any vaudevillian witchdoctors holding dolls made in their image, just white men with guns and whips holding chains around their necks while they kept track of the going price of humanity.

Somewhat paradoxically, slavery gave birth to the unique Vodou of the Western Hemisphere[2], the very religion said to have helped fuel the successful slave revolt in Haiti. When Africans of diverse national and spiritual backgrounds were forced together by the colonial slave trade, cultural and religious practices began to interact and merge. Thus, Vodou[3] in Haiti and America went through a process of syncretism: a hybridization of faith, a religion built of multiple belief structures. African religions mixed with the religions of what remained of Haiti's indigenous people, the Arawakans, and with Christian doctrines forced upon slaves by their European owners. (e.g., Saint Peter stands at the gates of Heaven, Legba at the doorway between the mortal and spirit worlds, so Legba is identified with Saint Peter; Saint Patrick is pictured with snakes, and is thus associated in Vodou with the serpent loa Danbala.) Documentarian Richard Stanley (2002) has also put forth that European colonists in Haiti may have brought Masonic elements that were incorporated in ritualized handshakes and gestures of Haitian Vodou ceremonies. In any event, out of the confines of slavery Vodou coalesced into a singular (if highly variable) belief structure credited as instrumental in the slave revolt that lead to Haitian independence and the creation of the first black governed nation of the so-called New World.

However, the true extent of Vodou's role in the revolution may never be fully known. The meme of Vodou as an engine for the liberation of Haiti's slave population rests on the anecdotal canonization of two revolutionary figures. The first is a one-armed maroon (runaway slave) called François Makandal, said to have spearheaded a campaign of poisoning the white owners of sugar plantations in Saint Domingue in 1757-58, and believed by French colonial authorities to be an instigator of a new sort of revolutionary religious sect (Cosentino 136). Makandal was captured in 1758 and burned at the stake, although fear of his perceived supernatural powers lead some whites and most blacks in the nation to believe the revolutionary had escaped his death (Davis 243).

Makandal's poisoning campaign is widely considered a precursor to the Haitian slave revolt of 1791, whose beginning is often credited to a legendary Vodou ceremony held at a place called Bois Ca man in August of that year, some three days before slaves set the first sugar plantation ablaze. It was at this ceremony that the

second revolutionary legend, a slave and houngan called Boukman Dutty is said to have joined with an African-born priestess to sacrifice a pig and summon up Petro loa, fiery incarnations of the spirits that lead the Haitians to war and victory over the European slave owners. But, as Mintz and Trouillot note, the simplistic nature of this recounting suggests it to be apocryphal, and in the wake of the flames of the revolution there is little evidence as to the true nature of the Bois Caïman ceremony and its role in Haitian independence (Cosentino 138).

At any rate, it has been widely perceived both in and out of Haiti that there existed a strong connection between the slave revolt and Vodou. European and American belief in this connection helps to explain the mistreatment of the religion in mass media for over two centuries.

That Voodoo That You Do

Portrayals of Voodoo in literature, comics, radio, film and television are really a sort of specialized subset of racist stereotypical portrayals of blackness[4] in popular media. Be it the formalized caricatures of minstrelsy (the mammy, the Uncle Tom, the zip coon, the picaninny) or the more amorphous stereotypes like the black buck and the Jezebel (which later evolved into more contemporary generic stereotypes like the angry black man and the welfare queen), popular culture enacts the prejudices of the culture's dominant populace. As Joseph M. Murphey states, "These images reinforce social boundaries of otherness and displace impulses of lust, anger and violence away from their sources" (323).

Murphey's characterization of the inner workings of stereotypical imagery is applicable throughout popular culture, but specifically he was discussing the portrayals of Vodou ("Voodoo" as the term is used in this essay) in American popular film of the 20th Century. [see Fig. 1 for examples]

Elizabeth McAlister (1999) aptly terms the modes of representation in such films "Hollywood bullshit," a process of representing Vodou whereby, "diverse diasporic religions are mixed and matched, interspersed with accurate details and sprinkled liberally with fantastic nonsense." Murphey sees this bullshit Voodoo as suggestive of projected sublimated white guilt over racism stating:

Examples of Voodoo in American Film

title	year	depiction of voodoo		
Live and Let Die	1973	BLACK MAGIC	DRUG RUNNING	RITUAL MURDER
Angel Heart	1987	BLACK MAGIC	SATAN WORSHIP	RITUAL MURDER
The Believers	1987	BLACK MAGIC	KIDNAPPING	RITUAL MURDER
The Serpent and the Rainbow	1988	BLACK MAGIC	SOCIAL OPPRESSION	RITUAL MURDER
Marked for Death	1990		DRUG RUNNING	RITUAL MURDER
Predator 2	1990		DRUG RUNNING	RITUAL MURDER

Fig. 1

"Images of `black magic' disguise the flow of seduction and violence in our society by reversing it. Instead of blacks being the victims of white seduction and violence, whites are victimized by blacks. This reversal allows whites to recognize the consequences of racism and at the same time absolve themselves of responsibility for it" (333).

As is widely noted [see, e.g. Murphey (1990), McAllister (1999), Davis (1998)], the representation of Voodoo in Hollywood film grows out of a tradition of enormously socio-politically biased lit-

erary antecedents. The earliest outsider account of Haitian Vodou comes from French colonial Moreau de St Mery. Written in 1797 during the Haitian revolution, his recounting of the mad uncivilized hedonistic Voodoo was written primarily as a justification for re-enslaving the island. Similar portrayals of the religion as savage, paganistic and sexually licentious in 19th Century American literature were written at a time when American slave holders obviously had a strong vested interest in casting a nation that gained its independence through a successful slave revolt as a dangerous and demonic aberration. By the time we reach the horror and action films of the 20th Century, the common tropes of white depictions of Voodoo rituals as wild sexual orgies in the woods complete with human sacrifice and Satanism[5] had become deeply ingrained in the American popular consciousness.

Voodoo Economics

Objectification has always been bound up in economics. Just as it is easier to sell a person if you make them an object, it is easier to sell to a person if you make them an object. Blanket racial and gender boundaries exist to transform diverse and complex physical and social characteristics into flat economic quantities, both as commodities to be packaged and demographics to be sold to. Corporations and politicians alike are able to market themselves to demographics, not individuals. The demarcations between "them" and "us" are a useful control mechanism. Divisions maintain a discernable order and thus a powerful means of control for those in power.

Perhaps voodoo has been such a touchstone of racial fear and demonization precisely because it lacks the definitive boundaries and hard binaries of Western Judeo-Christian patriarchal white supremacist thought. There is no Devil figure, no defined demarcation between good and evil in Vodou, only the psychological complexity of humanity itself.

In Ishmael Reed's novel Mumbo Jumbo, the character Hinkle von Hampton, a representative of white hegemonic social repression, considers voodoo a religion of individuality. On the subject of individuality, he concludes: "It couldn't be herded, rounded up; it was like crystals from winter, each different from one another but in a storm going down together" (Reed 140). As Reed scholar Patrick

McGee says, von Hampton "fears individuality because he can't control it" (95).

And so the minstrel show of Vodou played over and over in popular culture is, in one sense, an attack on individuality. Stereotypes are played to and thus maintained, with little question as to the racist histories and convenient subjugations from which these modes of representation originate.

It is through such social systems of meaning making that people are made into things, pigmentation into race, physicality into gender. Social complexity is crushed under the wheels of economic simplicity. We buy the idea that we are good, they are evil, we are right, they are wrong. We ignore the hazy definitions and fuzzy logic that so poorly defines who "we" are in relation to "them" in the first place. We dig deeper the Hole in ourselves, never trying to understand the Hole we're in.

[1]For thematic resonance and my own bizarre amusement this essay uses a syncretic citation style, part MLA, part ALA, part Chicago.

[2]That is, Vodou in the Carribean and American South, a religion unique from the West African traditions from which the religion is in part derived. According to Blier, the cultural traditions of West Africa from which American/Carribean Vodou are derived are generally placed in countries of Benin (formerly Dahomey) and Togo (Cosentino 1995).

[3]The name for and terms of the predominate Haitian religion resist single proper spellings, a point of consternation for a number of writers on the subject (see e.g., Davis 1985, Cosentino 1995). This essay uses "Vodou" to describe the real world religion, and "Voodoo" to describe its fictional counterpart. Within the graphic novel proper, however, various spellings are used in service of the shifting meanings that underlie the narrative.

[4]And these stereotypes are themselves a subset of the larger process of describing Otherness (as the term is assigned by the systemic power structures of white patriarchal) through demeaning and dehumanizing portrayals. That is to say, women, minorities, gay and lesbian people, all are given their own particular version of popular culture's rough trade.

[5]In his study of mid-19th Century newspaper accounts of New Orleans Voodoo ceremonies, Rod Davis (1998) further underlines the biases of white writers about Vodou, pointing out that the language used in these accounts seems closer to historical descriptions of Western European paganism than the actual practices of Vodou.

Glossary

agency: The power to act or make meaning. In some contexts, certain groups have no agency because they lack the power to make meaning.

appropriation: The act of borrowing, stealing, or taking over others' meanings for one's own ends.

bokor: In the religion of Vodou, bokor are sorcerers, houngan (priests) for hire said to 'serve the loa with both hands', that is, they can practice both dark magic and benevolent magic.

bricolage: The practice of working with whatever materials are at hand in the creation of a work. In one sense this is accomplished by appropriation of consumer goods and using them to create one's own meanings.

capitalism: An economic system in which investment in and ownership of the means of production, distribution, and exchange of wealth are held primarily by individuals and corporations, as opposed to cooperative or state-owned means of wealth.

code: The implicit rules by which meanings are put into social practice and thus can be read by their users. Codes involve a systematic organization of signs.

commodity fetishism: The process through which commodities are emptied of the utilitarian meaning of their production and filled instead with an abstract meaning. (ex. cigarettes make you cool)

commodity self: A term, coined by Stuart Ewen, that refers to how we construct part of our identities through the consumer products that inhabit our lives.

commodity sign: A term that refers to the semiotic meaning of a commodity that is constructed in an advertisement.

connotative meaning: In semiotics, all the social, cultural, and historical meanings that are added to a sign's literal meaning. (ex. "blue" means "boys," "pink" means "girls")

counter-bricolage: The practice used by advertisers and marketers of manufacturing and selling as commodities aspects of bricolage style.

denotative meaning: In semiotics, the literal, face-value meaning of a sign.

diaspora: The existence of various communities, usually of a particular ethnicity, culture, or nation, scattered across places outside of their country of origin.

discontinuity: In postmodern style, the strategy of breaking a continuous narrative and audience identification with it in order to defy viewer expectations.

exchange value: The monetary value that gets assigned to a commodity in a consumer culture.

fetish: In anthropology, an object that is endowed with magical powers and ritualistic meaning, (ex. water from a sacred pool)

floating signifier: Signifiers without referents, whose meaning is not intrinsic but determined solely through relational contexts, (ex. words like "valor" that don't point to an actual object)

gaze: In visual art theory, the gaze is a term used to describe the complex relations of power derived from the power of the observer over the observed person or object.

gender-bending: Practices that call into question the traditional gender categories of male and female and the sexual norms associated with them.

genre: A loose set of criteria used to categorize a composition in literature, speech or art. In popular culture the term is usually associated with works that fit easily within defined boundaries, particularly science fiction and fantasy. Superhero fiction is a genre, comics is a medium.

hegemony: Predominant influence of one culture, philosophy, society or nation over all others.

high/low culture: Terms that make qualitative distinctions between different forms of culture wherein high culture is elite, specialized, sophisticated and contemplative and low culture is populist, widespread, simplistic and communicative. (ex. oil paintings in museums are high culture, illustrations in magazines are low culture)

horse: In Haitian Vodou, the "horse" is a worshipper that becomes the carrier of a spirit (the lwa) during Vodou religious ceremonies. The term is derived from the expression "ridden by the gods"; basically, the worshipper becomes a medium of expression for the law.

houngan: the term for a male High Priest in the Vodou religion.

hyperreal: A term coined by French theorist Jean Baudrillard that refers to a world in which codes of reality are used to simulate reality in cases where there is no referent in the real world.

iconic sign: In semiotics, a sign that resembles the thing to which it refers.

indexical sign: A term in semiotics used by Charles Pierce to indicate those signs in which there is a physical causal connection between the signifier and the thing signified, because both existed at some point in the same physical space (ex. smoke and fire).

intertextuality: Referencing one text within another; the incorporation of meanings from one text within another in a reflexive fashion.

Loa: (also Lwa or L'wha) The spirits of the Vodou religion that exist between the mortal plain and Bondyè (God). Also referred to as Les Mystères and the Invisibles, these spirits are served by Vodou practitioners.

mambo: The term for a priestess in Haitian Voodoo, derived from the language of the African slaves who were imported into the Caribbean.

master narrative: A framework (also called metanarrative) that attempts to explain or give meaning to all aspects of our society (ex. religion, science, psychology etc.).

medium: A term for formatting systems that can hold and transmit information to an audience. (ex: television, radio, comics, etc.) A mode of expression.

myth: A term used by French social theorist Roland Barthes to refer to the ideological meaning of a sign that is expressed through connotation.

other, the: A term used to refer to the category of subjectivity that is set up in binary opposition to dominant subjectivity (ex: women are othered due the dominant subjectivity of men in our society.)

overdetermination: A term from Marxism describing an instance in which several different factors work together to make up the meaning of a particular social situation.

pastiche: A style of plagiarizing, quoting, and borrowing from previous styles with no reference to history or sense of rules.

Petro: A form of Vodou that originated in Haiti during the Haitian Revolution which was characterised by the worshipping of more agressive and proactive ("hot") lwa. This form of the religion was extremely connected with the overall passion of the slave revolution that lead to Haiti's national independence.

photographic truth: The untrue notion that images produced by mechanical photographic devices are unmediated copies of reality.

postmodernism/postmodernity: Mid-to-late 20th Century philosophical and artistic movement that challenges the ideas that there are metanarratives capable of describing the complexity of human experience. Postmodern techniques include self-referentiality, pastiche, simulation, parody, discontinuity, hyperreality, and multimodality.

pseudoindividuality: A term used to describe the way mass culture creates a false sense of individuality in cultural consumers, i.e. mass produced goods that purport to make you feel unique.

referent: A term, in semiotics, that refers to the object itself, as opposed to the representation of the object. (e.g. the word "pencil" is the representation, the physical thing made of wood and graphite is the referent)

reflexivity: The practice of making viewers aware of the material and technical means of production by featuring those aspects as the "content" of cultural production. (ex. In editing this glossary I keep comparing our definitions to the ones on Wikipedia)

reification: A term used by Karl Marx that describes the process by which abstract ideas are considered as if they were real and concrete. **representation:** The act of depicting, portraying, symbolizing, or presenting the likeness of something.

scopophilia: In psychoanalysis, the drive to look and the general pleasure in looking.

semiotics: The study of signs concerned with ways in which things (images, words, objects) are vehicles for meaning.

sequential art: The broad academic term for the medium more commonly termed comics in America, which includes traditional formats (the comic book, the comic strip) but can be associated with non-traditional forms of sequential image narrative, like gallery comics and cave paintings

sign: A semiotic term that defines the relationship between a vehicle of meaning such as a word, image, or object and its specific meaning within a particular context.

signified: In semiotics, the element of meaning within a sign.

signifier: In semiotics, the word, image, or object within a sign that conveys meaning.

simulation/simulacrum: Terms most famously used by French theorist Jean Baudrillard that refer to a sign that does not clearly have a real life counterpart.

social construction: A theory that gained primacy in the 1980s in a number of fields, social construction at its most general level asserts that much of what has been taken as fact is built through various subjective ideological forces in society. (ex. race is a social construction of the meaning of melanin content)

subculture: Distinct social groups within wider cultural formations that define themselves in opposition to mainstream culture.

surrealism: An art movement of the early twentieth century in literature and visual art that focused on the unconscious in representation and in dismantling the opposition between the real and the imaginary.

symbolic sign: A term in semiotics used by Charles Peirce to indicate those signs in which there is no connection between the signifier and the thing signified except that imposed by convention.

trope: A literary trope is a common pattern, theme, or motif in literature. In the more general sense, a trope is a characteristic of a genre. (ex. in action movies the good guy will always have a final showdown with the bad guy)

trans-coding: The practice of taking terms and meanings and re-appropriating them to create new meanings.

use value: The practical function originally assigned to an object; basically, what it does.

vévé: A unique religious symbol for a Vodou "loa" (or lwa) that serves as their representation during rituals and a means by which the spirits are summoned. Vévé are traditionally drawn in cornmeal, red brick, or other powders on the floor.

virtual reality: An electronic reality that seems to exist, but in no tangible or physical way.

I AM A LANGUAGE. AT TIMES A LANGUAGE OF REVOLUTION.

I'LL ALWAYS COME AROUND.

Selected Bibliography

Appignanes, Richard. *The End of Everything: Postmodernism and the Vanishing of the Human*. London: Totem Books, 2003.

Barthes, Roland and Lavers,Annette(Trans.). *Mythologies*. Cambridge,MA: The MIT Press, 1972.

Baudrillard, Jean and Graser,Sheila Faria (Trans.) *Simulation and Simulacra*. Ann Arbor, MI: University of Michigan Press, 1995.

Berger, John. *Ways of Seeing*. New York: Penguin, 1990.

Billson, Janet Mancini and Majors, Richard. *Cool Pose: Dilemmas of Black Manhood in America*. New York: Touchstone, 1993.

Bogle, Donald. *Toms, Coons, Mulattos, Mammies, and Bucks*. New York: Continuum International Publishing Group, 2003.

Browitt, Jeff. *Contemporary Cultural Theory: Third Edition*. London: Routledge, 2003.

Campbell, Joseph and Bill Moyers. *The Power of Myth*. New York: Anchor, 1991.

Cartwright, Lisa, and Marita Sturken. *Practices of Looking*. Oxford: Oxford University Press, 2001.

Cosentino, Donald J., ed. *Sacred arts of Haitian Vodou*. Los Angeles: UCLA Fowler Museum of Cultural History, 1995.

The Serpent and the Rainbow. Dir. Wes Craven. Perf. Bill Pullman, Cathy Tyson, and Zakes Mokae. Universal Pictures, 1988.

Crow, David. *Visible Signs*. London: AVA Publshing, 2003.

Davis, Rod. *American Voudou: Journey into a hidden world*. Denton: University of North Texas Press, 1998.

Davis, Wade. *The serpent and the rainbow*. New York: Warner Books, 1985.

Divine Horsemen: The living gods of Haiti. Dir. Maya Deren. Ed. Cherel Ito. 1961. Mystic Fire Video, 1985.

Elkins, James. *The Object Stares Back: On the Nature of Seeing*. Sand Diego,CA: Harcourt, 1997.

Ewen and Ewen. *Typecasting: On the Arts and Sciences of Human Inequality*. New York: Seven Stories, 2006.

Fernandez Olmos, Margarite, and Lizabeth Paravisini-Gebert. *Creole religions of the Caribbean*. New York: New York University Press, 2003.

Foster, Hal. *The Anti-Aesthetic: Essays on Postmodern Culture*. New York: The New Press, 2002.

Fukiyama, Francis. *Our Posthuman Future: Consequences of the Biotechnology Revolution*. New York: Picador, 2003.

Gates, Jr., Henry Louis. *The Signifying Monkey: A Theory of African-American Literary Criticism*. Oxford: Oxford University Press, 1989.

Gladwell, Malcolm. *The Tipping Point: How Little Things Can Make a Big Difference*. New York: Back Bay Books, 2002.

Goldberg, David Theo. *Racist Culture: Philosophy and the Politics of Meaning*. New York: Wiley, 1993.

Gombrich, E.H. *Art and Illusion: A Study in the Psychology of Pictorial Representation*. London: Phaidon Press, 2004.

Harris, Michael D. *Colored Pictures: Race and Visual Representation*. Chapel Hill: The University of North Carolina Press, 2006.

hooks, bell. *Black Looks: Race and Representation*. Boston: South End Press, 1992.

hooks, bell. *We Real Cool: Black Men and Masulinity*. London: Routledge, 1992.

Ingpen, Robert and Michael Page. *Encyclopedia of Things That Never Were*. New York: Studio Press, 1998.

Ingpen, Robert and Michael Page. *Encyclopedia of Things That Never Were*. New York: Studio Press, 1998.

James, Darius and John Straughsbaugh. *Black Like You: Blackface, Whiteface, Insult and Imitation in American Popular Culture*. New York: Tarcher Books, 2006.

Jenkins, Henry. *Convergence Culture: Where Old and New Media Collide*. New York: NYU Press, 2006.

Jensen, Robert. *The Heart of Whiteness: Confronting Race, Racism, andWhite Privelege*. San Francisco,CA: City Lights Books, 2005.

Jones, Gerard. *Killing Monsters: Why Children Need Fantasy, Super Heroes, and Make-Believe Violence*. New York: Basic Books, 2003.

Kitwana, Bakari. *Why White Kids Love Hip Hop: Wankstas, Wiggers, Wannabes, and the New Reality of Race in America*. New York: Basic Civitas, 2005.

Klein, Naomi. *No Logo: No Space, No Choice, No Jobs*. New York: Picador, 2002.

Klock, Geoff. *How to Read Superhero Comics and Why*. London: Continuum International Publishing Group, 2002.

Klosterman, Chuck. *Sex, Drugs, and Cocoa-Puffs: A Low Culture Manifesto*. New York: Scribner, 2004.

Kunstler, Mort. *It's A Man's World: Men's Adventure Magazines, the Postwar Pulps*. Los Angeles: Feral House, 2003.

Kweli, Talib. "Going Hard." *The Beautiful Struggle*. Rawkus/Umgd, 2004.

Lasn, Kalle. *Culture Jam: How to Reverse America's Suicidal Consumer Binge and Why We Must*. New York: Harper Paperbacks, 2000.

McAllister, Elizabeth. "Cellulose spirits and White racism: White fear and Black gods in film." Globalization of Yoruba Religious Culture Conf. Florida International University, Miami, FL. 9-12 Dec., 1999

McCloud, Scott. *Understanding Comics: The Invisible Art*. New York: Harper Paperbacks, 1994.

McGee, Patrick. *Ishmael Reed and the Ends of Race*. New York: Palgrave Macmillan, 1997.

Miles, Steve. *Consumerism: As A Way of Life*. Thousand Oaks, CA: Sage Publications, 1998.

Mitchell, William J. *Placing Words: Symbols, Space, and the City*. Cambridge,MA: The MIT Press, 2005.

Mitchell, W.J.T. *What Do Pictures Want?* Chicago: University of Chicago Press, 2006.

Mitchell, W.J.T. *Picture Theory*. Chicago: University of Chicago Press, 2006.

Morrison, Grant (w), Chris Weston (p), (i), Daniel Vozzo (c), and Clem Robins (l). "Season of Ghouls" *The Invisibles* v. 1, #6 (Jul., 1995), DC Comics.

Murphey, Joseph M. "Black Religion and Black Magic: Prejudice and Projection of Images in African-derived Religions." *Religion*, 20 (1990): 323-337.

Niedzviecki, Hal. *Hello, I'm Special: How Individuality Became the New Conformity*. San Francisco: City Lights Books, 2006.

Oguibe, Olu. *The Culture Game*. Minneapolis, MN : University of Minnesota Press, 2004.

Parenti, Michael. *The Culture Struggle*. New York: Seven Stories Press, 2006.

Angel Heart. Dir. Alan Parker. Perf. Mickey Rourke, Robert De Niro, and Lisa Bonet. TriStar Pictures, 1987.

Postman, Neil. *Amusing Ourselves to Death: Public Discourse in the Age of Show Business*. New York: Penguin, 2005.

Powell, Kevin. *Who's Gonna Take the Weight?* New York: Three Rivers Press, 2003.

Poynor, Rick. *Obey the Giant: Life in the Image World*. Birkhauser Basel, 2007.

London Voodoo. Dir. Robert Pratten. Perf. Doug Cockle, Sara Stewart, and Michael Nyqvist. Zen Films, 2004.

Quart, Allysa. *Branded: The Buying and Selling of Teenagers*. New York: Arrow Books Ltd. 2002.

Reed, Ishmael. *Mumbo Jumbo*. New York: Scribner, 1996.

Rushkoff, Douglas. *Coercion: Why We Listen to What "They" Say*. New York: Riverhead Hardcover, 1999.

Shaviro, Steven. *Connected: Or What It Means to Live in Network Society*. University of Minnesota, 2003.

White Darkness. Dir. Richard Stanley. Prod. Richard Stanley and Atif Ghani. Aimimage, 2002.

Stromberg, Fredrik. *Black Images in the Comics*. Seattle,WA: Fantagraphics Books, 2003.

Thompson, Robert Farris. *Flash of the Spirit: African and Afro-American Art and Philosophy*. New York: Vintage, 1984.

Twitchell, James B. *AdCult, USA*. New York: Columbia University Press, 1997.

Projects from the Desk
of Dr. Roberta Jensen, Ph.D
Dept. of Sociology/African American Studies
Baldwin State University, Freedom,NC

Brand Trickster Project

Corporate culture frequently appropriates and redefines folk culture for its own uses. This project is concerned with the types of corporate narratives generated by this practice.

Choose a trickster character from the list (or pick your own, if you can say why they're a trickster character). Research your trickster. Now make a franchise out of your character. A movie franchise, a television show, cartoons, action figures, fast food and soda tie-ins, you name it. Use the characteristics of your trickster to sell stories and products. What was the experience?

List of Tricksters

Legba, Loki, Coyote, Anansi, Hermes, Pan, Sun: the Enlightened One, Chu Cullain, Kappapua, High John the Conqueror

Gender Ad Project

Are gender roles sold to us? Do we buy them? Go to the book store, pick up a men's magazine and a women's magazines. Compare and contrast the advertisements in the two different magazines. Choose a product (e.g. toothpaste, hair gel, a candy bar) and make two ads for that product, one to sell to men and one to sell to women. What do the ads say about their target genders and the opposite sex? [Make ads selling femininity and masculinity to the opposite sex? Think of Men and Women as two opposing political candidates, create campaign posters?]

Creating Holes in Your Life

Pick four objects or media you're attached to and you use all the time (e.g. cell phone, i-pod, television). Stop using them for two weeks and record the experience in a diary. What do you miss? What do you do instead? What does this say about the objects? What does this say about you? What's eating you?

Stereotype Veve's

Create a veve using any means (e.g., hand drawn/photo collage/ reappropriated image). Make a symbol of the stereotypes of your ethnicity/race. Make a symbol for yourself. Make a short essay in comic form that features a conversation between the two symbols.

Damian Duffy is editor-in-chief of the Eye Trauma Comix online anthology. He is the writer and letterer of several graphic novels, including *Whisp* (2005) and *Urban Kreep* (2006). He has presented on comics at such conferences as the International Comic Arts Forum at the Library of Congress and the Symposium on African American Culture and Philosophy at Purdue University. His comics collaborations with fellow Eye Trauma founders John Jennings and *Whisp* artist Dann Tincher have appeared in art exhibitions throughout the nation.

John Jennings is an Assistant Professor of Graphic Design at the University of Illinois at Urbana-Champaign. Jennings frequently lectures on visual literacy, popular culture, and the visual communication found in Hip Hop culture. Jennings is also a co-founder of Eye Trauma, a web based collective of sequential artists, activists, and curators who seek to expand the public's perception of the comics medium. He is currently working on an upcoming book with Bakari Kitwana on Hip Hop for younger readers.

Jennings and Duffy are the curators of two comics art shows, *Other Heroes: African American comics creators, characters and archetypes,* (Jackson State University Art Gallery, April-June 2007) and *Out of Sequence: Underrepresented voices in American comics* (University of Illinois at Urbana-Champaign Krannert Art Museum, October 2008-Jan 2009).

About Front 40 Press

Front Forty Press creates and publishes materials and products on a variety of topics through unique relationships. A Front Forty Press project is one that embodies uninhibited creativity and deals with current topics. The work can be functional, political, ecological or simply expressive. What matters most is the cultivation and communication of ideas.

www.front40press.com